Group 2

Needles sing
oft; evergre
eciduous

Group 3

Group 6

Leaves fan-shaped,
imple, parallel veins

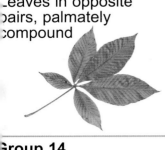

Note: Ginkgo only species in group.

Group 7

Leaves in opposite
pairs, simple, lobed

Group 10

Leaves in opposite
pairs, palmately
compound

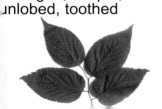

Group 11

Leaves in opposite
pairs, compound

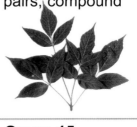

Group 14

Leaves alternately
arranged, simple,
unlobed, toothed

Group 15

Leaves alternately
arranged, simple,
unlobed, smooth edges

Philadelphia
TREES

This look of vitality comes partly from the vivid
palette from which the Tuliptree is colored. The
flowers which give it its name are yellow or orange
at base, a light greenish shade above. Almost as
brilliant are the leaves when they first appear.

Donald Culross Peattie
*A Natural History of Trees of Eastern
and Central North America*, 1948

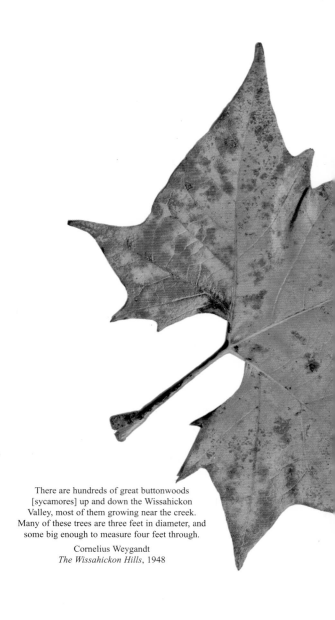

There are hundreds of great buttonwoods
[sycamores] up and down the Wissahickon
Valley, most of them growing near the creek.
Many of these trees are three feet in diameter, and
some big enough to measure four feet through.

Cornelius Weygandt
The Wissahickon Hills, 1948

Morris Arboretum
UNIVERSITY *of* PENNSYLVANIA
Official arboretum of the Commonwealth of Pennsylvania

Philadelphia
TREES

A Field Guide to the City and the
Surrounding Delaware Valley

Written and illustrated by
Paul W. Meyer
Catriona Bull Briger
Edward Sibley Barnard

Columbia University Press New York

Morris Arboretum
UNIVERSITY *of* PENNSYLVANIA
Official arboretum of the Commonwealth of Pennsylvania

Text, Design, & Photography
Paul W. Meyer
Catriona Bull Briger
Edward Sibley Barnard

Contributing Writer and Consultant
David Hewitt

Horticultural Editors
David Hewitt
Joel T. Fry
Ken LeRoy

Maps
Catriona Bull Briger

Copy Editor
Jane E. Boyd

Columbia University Press
Publishers Since 1893
New York Chichester, West Sussex
cup.columbia.edu
Copyright © 2017 Edward Sibley Barnard and the Morris Arboretum
All rights reserved

ISBN 978-0-231-15249-5 (pbk. : alk. paper)
Library of Congress Control Number: 2016960913

Columbia University Press books are printed on permanent
 and durable acid-free paper.
Printed in China

p 10 9 8 7 6 5 4 3 2 1

Cover photo by Paul W. Meyer

Introduction

Trees make the place! In fact, in our state, trees are so much a part of the natural history and culture that they are part of the name. After all, they don't call it "Penn's Sylvania" for nothing. In Latin, "sylvania" means "forested land."

Even in some of the most densely developed parts of Philadelphia, we truly live in an urban forest. We have inherited a wonderful legacy of trees, planted and nourished by earlier generations. But we cannot take this for granted. In many of our communities our trees are aging and dying, suffering from virulent pests, diseases, and years of deferred maintenance. It is time to rededicate ourselves to replanting this "green infrastructure" that is so vital to the health, quality of life, and sense of place in our city.

We do indeed need trees—not only their beauty, but the oxygen they produce, the cooling they give, and the protection they afford to our watersheds. And, in our communities, trees need our help. We need to plant them, water and nourish them, and prune and protect them as they mature. Without our efforts, older trees will pass on and our urban forest will begin to fade away.

With this book we celebrate the diversity of trees commonly planted throughout our metropolitan region. Through the photos and illustrations, we hope to help readers see trees more clearly and appreciate the distinctive character of each individual species. I believe if we truly see and are aware of our neighborhood trees through the changing seasons, we are more likely to be sensitive and responsive to their vital needs.

This book is designed to be pocket-sized and easy to carry. Take it with you as you head out into your neighborhood, and get to know—really know—your green neighbors. Be ready to lend trees a neighborly hand. The simple act of planting and tending a tree can have a profound and positive impact on your environment for generations to come.

Paul W Meyer

Paul W. Meyer
The F. Otto Haas Executive Director
Morris Arboretum of the University of Pennsylvania

Contents

> Many times I thought that if the particular tree, commonly an elm, under which I was walking or riding were the only one like it in the country, it would be worth a journey across the continent to see it.
>
> Henry David Thoreau, *Journal,* January 18, 1859

Tree Guide

Sources and Resources

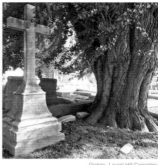

Ginkgo, Laurel Hill Cemetery

Dawn redwoods, Morris Arboretum

Upright European hornbeam, Center City

Preface

This book is a key to Philadelphia's astonishing world of trees. If you aren't a tree lover now, this book will make you one. Slip it into your pocket or purse and take it with you as you walk in Philadelphia's parks, gardens, cemeteries, and streets. Every tree species has a history. Every individual tree has a story. This book chronicles some of those histories and tells some of those stories. If you don't know many trees by name, this book will introduce you to them. Trees are among nature's most exquisite creations. This book will sharpen your eyes by making you look carefully at trees—at the arrangements and shapes of their leaves, at the textures of their bark, at the colors and forms of their flowers and fruits, at the contours of their trunks and branches.

Once you become fully aware of the trees around you, no landscape with trees in it will ever look quite the same. You will enjoy subtle contrasts of hue and form where once you saw only masses of green. You will perceive a multitude of changes as the seasons progress that you overlooked before. When you have identified the trees in Philadelphia's streets, parks, and cemeteries, they will become part of your mental landscape, your property in a way.

Philadelphia is a city with a great many exceptional trees: old trees with illustrious histories; beautiful exotic trees imported over the centuries by Philadelphia plantsmen; impressive tree collections assembled by wealthy tree enthusiasts; and extensive tracts of wild forest offering glimpses of what Penn's colonists saw when they first set foot in Penn's woods—King Charles II's grant of twenty-eight million acres to William Penn in 1681. No other North American city contains such a wealth of fine old specimen trees or is surrounded by so many arboreta, botanical gardens, lushly planted estates, cemeteries, parks, and preserves. Philadelphia was from its very beginning a city of trees and botanists, and it remains today America's premier horticultural city.

My daughter-in-law Catriona Briger and I are relative newcomers to Philadelphia. When we arrived in the city a few years ago, we had experience in landscape design and in writing and editing books on natural history but little knowledge about specific Philadelphia trees. Fortunately, however, early on I met our co-author Paul W. Meyer, F. Otto Haas Executive Director of the Morris Arboretum, and he was enthusiastic about producing a book on Philadelphia trees similar in format to a guidebook titled *New York City Trees* that I wrote while living in Manhattan. Not long after beginning work on *Philadelphia Trees*, I also had the good fortune to go on a brief tour of the botanical collections of the Academy of Natural Sciences of Drexel University led by David Hewitt, president of the Philadelphia Botanical Club. David holds a PhD in botany from Harvard and has a deep knowledge and interest in the flora of Philadelphia and the Delaware Valley. Over several years, David took Catriona and me and several other tree enthusiasts to many parks, gardens, and cemeteries to look at trees. We spent hours in the field exploring and became familiar with many of the city's notable trees, some tucked away in smaller cemeteries, on side streets, and in out-of-the-way neighborhood parks.

The job of producing *Philadelphia Trees* has been an exciting journey of discovery. Every time we take a field trip to visit a park, botanical garden, or arboretum, we come away amazed by the trees we encounter. This city is chock-full of sylvan wonders, and this book cannot possibly mention every one of them. We hope that we inspire you to look more carefully at the trees around you in this city of beautiful trees and in the surrounding countryside, so full of extraordinary gardens, parks, and arboreta.

Edward Sibley Barnard

Philadelphia's Arboreal Heritage
David Hewitt

When William Penn founded the city of Philadelphia in 1682, it was set in a land rich with trees—oaks, chestnuts, maples, and so many more. As far as one could go, one would see forest upon forest densely packing the landscape. Penn was fully aware of the potential value of these woodlands. In 1683, he wrote back to England to attract settlers to Pennsylvania to populate his vast land holdings. He praised the diversity of resources available to build a new world—the food, fruits, fuel, wood, and wildlife that the trees provided, fed and protected. Even the name that Charles II gave to the colony, Pennsylvania ("Penn's Woods"), reflects this recognition of the value of trees.

Of course, people had inhabited the region for millennia when William Penn arrived. The Lenape lived here for thousands of years, hunting, growing crops, and burning back the forests, thereby keeping areas open or held back to younger stages of forest succession. There had also been Europeans here prior to Penn—the Dutch and the Swedish, who arrived in the first half of the 17th century built houses, farmed fields, cut wood, and modified the landscape.

Even prior to human habitation, the local ecology and its flora were never static. During the last glacial period, there were hardly any trees in Pennsylvania. When the glaciers receded, the area filled in primarily with conifers—spruce, pine, fir—and occasional patches of early colonizing broadleaf trees. By about nine thousand years ago, the woods were evolving into the predominantly broadleaf forest that William Penn encountered. This forest remains today, dominated by oak and, up until about a hundred years ago, by American chestnuts.

By the time of Penn's arrival, the native forests of Pennsylvania already had trees that were introduced from the Old World. When Penn wrote home to England, he noted that the white mulberry and peach were here. The white mulberry is not native to North America; it was brought here as growing stock for silkworms. The peach is also a native of the Old World. It was introduced in the South by the Spanish and then most likely brought north by Native Americans, who recognized its fine fruiting qualities.

After Colonization

In the 18th and 19th centuries, Philadelphia was the center of the botanical world. When anyone wanted to see the green splendors of America, they came to Philadelphia. When Meriwether Lewis, captain with William Clark of the Corps of Discovery expedition, needed to study botany, he came to Philadelphia. And Lewis and Clark sent plants

back from their western explorations to Philadelphia to be researched and described in the scientific literature. The Osage-orange, a tree still commonly planted in and around Philadelphia, was a plant first sent east by Lewis and Clark. In addition, the Corps of Discovery documented hundreds of other plants and sent specimens to Philadelphia, where they are still held today at the Academy of Natural Sciences of Drexel University.

Philadelphia in the 18th century was a hub for botanical knowledge, a place where numerous botanists and nurserymen lived and worked. One prominent plant enthusiast and explorer was John Bartram. A Quaker farmer with an eye for plants, Bartram documented many of the trees found in Philadelphia and elsewhere in eastern North America. He also sent many plant specimens to England, where they entered into the European horticultural trade. Plants Bartram introduced to the Old World include the striped maple (of special note for its Latin name, *Acer pennsylvanicum*), the pawpaw, and the paper birch. John Bartram's sons, John Jr. and William, took on the work of the farm and nursery beside their father and continued it after his death. The enterprise stayed in the family until it went out of business in 1850. Eventually Bartram's Garden passed to the city of Philadelphia. Open to the public to this day, it continues to celebrate the legacy of one of the great botanical families of all time.

Plants were not sent to Philadelphia just for science or commerce but also to beautify the landscape. Beginning in the 18th century,

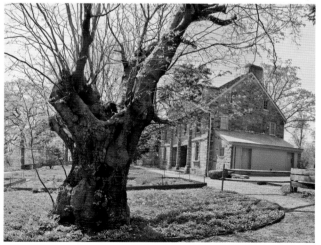

After 2010 storm damage, an old American yellowwood in Bartram's Garden is sprouting new branches. Once 60 feet tall, it may grow tall again. André Michaux, the French botanist, sent it to William Bartram about 1800.

magnificent estates filled with trees were built in and around Philadelphia. The Woodlands, William Hamilton's estate just up the Schuylkill River from Bartram's Garden, was one of the finest. It was the site of the first introduction of several trees common in and around Philadelphia today. The ailanthus tree ("tree of heaven"), the ginkgo, and the sycamore maple first came to North America through Hamilton. He passed away in 1813, and The Woodlands was turned into a cemetery in 1840. Today it remains a fine example of land-scaping in the rural cemetery style, with winding paths and bucolic plantings. There are still some trees from Hamilton's time to see. Of special note is a rare Caucasian zelkova developed from a root suck-er of a tree likely planted by Hamilton.

Industrial Philadelphia, Botanical Philadelphia

During the course of the 19th century, Philadelphia's water quality worsened as factories and residences dumped waste into the city's waterways. The Fairmount Water Works, with pumps that pulled water from the river, was downstream from some of the most inten-sive manufacturing and residential development in the city. In

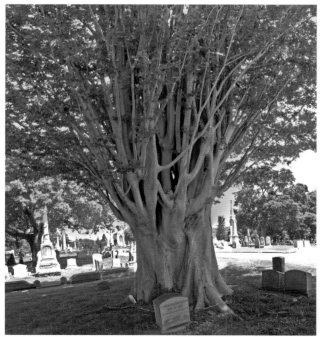

The Caucasian zelkova of West Philadelphia's Woodlands Cemetery is likely the only one of its kind in the Delaware Valley. Its fastigiate growth habit of upright, partially fused branches resembles an upended broom.

response to pressure on its municipal water quality, the city bought land upstream from the Fairmount Water Works, beginning in 1844 with the purchase of Lemon Hill, an estate near where the Philadelphia Museum of Art now stands. In succeeding decades land was acquired up and down the Schuylkill, Wissahickon Creek, and Cresheim Creek to help protect the city's water supply. This land became a substantial part of the forests, parks, and meadows that we now call Fairmount Park. Those forests contain many kinds of trees—beeches, oaks, pines, maples—that were here when William Penn arrived, as well as such trees as the American holly and the white pine, which were likely not native to Philadelphia. Today Fairmount Park is one of the largest urban park systems in the country, encompassing 10,200 acres spread across the city. It includes Pennypack and Poquessing Creeks in the northeast, Cobbs Creek along the western boundary of the city, and about sixty other parks and green spaces, all rich with trees to see and enjoy.

Numerous smaller parks were also developed in the city, many through the efforts of Thomas Meehan. Trained at the Royal Botanic Gardens, Kew, Meehan started what became a very successful eponymous nursery. An avid developer of parks throughout the city, he was a founding member of the Philadelphia Botanical Club and a Philadelphia city councilman. Known for rediscovering the pink dogwood, Meehan corresponded with Charles Darwin, Asa Gray, and other scientific luminaries of the 19th century.

In the 1880s and 1890s, Meehan worked industriously to make sure that communities had access to green spaces. Some of the parks we have today due to Meehan's work include Vernon Square in Germantown, Stenton Park in North Philadelphia, McPherson Square in Kensington, and Weccacoe Square in South Philadelphia.

There are two parks of particular botanical interest that we have to thank Meehan for—one of them, Fotterall Square, was situated near Bernard McMahon's former garden at the intersection of Broad Street and Germantown Avenue. (McMahon was a prominent nurseryman and seedsman of the early 19th century, a correspondent of Thomas Jefferson, and a recipient of materials from the Corp of Discovery expedition.) Thomas Meehan developed a second park of major botanical significance: Bartram's Garden, where John Bartram, William Bartram, and Ann Bartram Carr had brought Philadelphia's horticultural standing to a global stage. Philadelphia was once called the "Workshop of the World" because of its industrial output, but the economic contributions of its plant and seed production were also substantial.

Some large, open green spaces in the city are not part of Philadelphia's Parks and Recreation system, but they play a role in the rich history of urban green spaces. Many of them were historic estates that have been preserved for public use. The Awbury Arboretum in Germantown is the ancestral home of the Copes, an old Philadelphia Quaker family. Their love for plants persists to this day in a verdant setting, providing a peaceful retreat amid a busy city landscape.

Another historic estate is the magnificent Morris Arboretum, the official arboretum of the Commonwealth of Pennsylvania. Originally the home of John and Lydia Morris, brother and sister in a prominent Quaker family, the arboretum is a testament to the siblings' love of plants. The Morrises traveled far and wide throughout Asia, Europe, and North America, bringing back plants for their estate. Ardent arboreal admirers, they worked diligently to make sure their plant collection flourished, enriching the soil and tending each tree. This splendid site became part of the University of Pennsylvania in 1932, and as the Morris Arboretum, it continues the Morrises' tradition of exploration, dedication to horticulture, and botanical research.

The longstanding tradition of horticulture in Philadelphia extends well beyond the city limits. The horticultural wonders of Longwood Gardens and Winterthur are the legacies of members of the du Pont family. Bowman's Hill Wildflower Preserve in Bucks County, the Scott Arboretum of Swarthmore College in Delaware County, and Jenkins Arboretum in Chester County also boast magnificent collections of trees and other plants.

17th-Century Trees, 20th-Century Forests, 21st-Century Solutions
The arrival of William Penn in 1682 shaped Philadelphia. In the midst of forests, marshes, streams and creeks, he laid out a city of houses on gridded streets. Long after Penn's death in 1718, we see his legacy around us. His goal of a "Greene Country Towne" is reflected not only in the continued existence of the four green squares (Rittenhouse, Washington, Franklin, and Logan) in Center City but also in the large number of parks spread throughout the city.

Some trees left in Philadelphia have a direct connection to William Penn himself. The American elm under which Penn was said to have signed his peace treaty with the Lenape was located where Penn Treaty Park in Fishtown is now. That great tree stood there until 1810, when it was blown down in a storm. Cuttings were taken that preserved the DNA of this historic tree, and its clonal descendants can be seen growing today at Haverford College next to Founder's Hall, at the University of Pennsylvania in front of College Hall, and at Pennsylvania Hospital.

In the first half of the 20th century, a striking change took place in

the forests of Philadelphia and in other forests of eastern North America. A fungal disease, the chestnut blight, infected nearly every American chestnut tree, and the species went from being by far the dominant canopy tree in eastern forests to near extinction. As our forests lost their chestnuts, other trees that had historically been outcompeted by the chestnut took their place. Oaks and maples, common before the chestnut blight, now occupy the niche once occupied by the American chestnut. Its presence in the region has been reduced to rare sprouts, which can sometimes be seen along the Wissahickon.

Philadelphia faces an array of challenges in the 21st century, but some are quite similar to those the city faced in past eras. Water quality is still a high priority, and some solutions may be provided by its population of trees. Much as Fairmount Park was founded to preserve water quality, contemporary water quality concerns due to storm water runoff have led to the Philadelphia Water Department's "Green City, Clean Waters" program. Instead of storm water going down a drain to be treated at a wastewater treatment plant or running directly into a creek or river, trees are being planted to help absorb storm water before it gets to a storm drain. Three hundred years later, William Penn's "Greene Country Towne" is still finding solutions to problems in its rich heritage of trees.

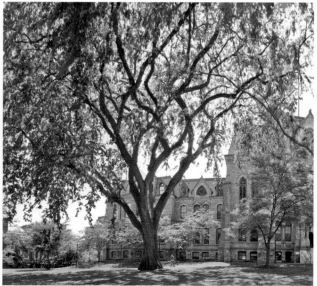

Planted in 1896, this American elm on the campus of the University of Pennsylvania is reputed to be a second-generation scion of the tree under which William Penn signed his 1683 treaty with Native Americans.

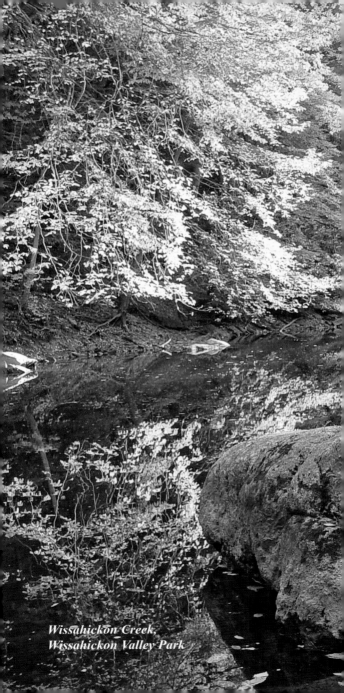

Wissahickon Creek,
Wissahickon Valley Park

The Best Places
to See Trees

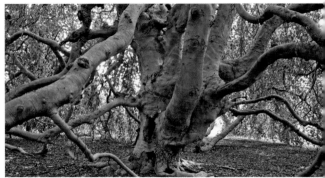
Weeping European beech, Nemours Estate

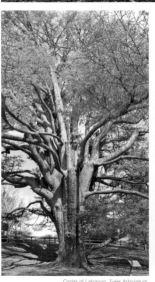
Cedar of Lebanon, Tyler Arboretum

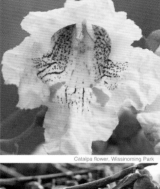
Catalpa flower, Wissinoming Park

Pawpaw flowers, Peale house, La Salle University

Exploring the Best Places to See Trees

More than 60 botanical gardens, city parks, arboreta, and historic estates with interesting trees and tree collections are described on the following pages. Half of the gardens covered here are part of a nonprofit consortium called Greater Philadelphia Gardens. These places showcase horticultural treasures in and around "America's Garden Capital." Additional locations are mostly public parks, often part of the 10,200-acre Fairmount Park, but include colleges, cemeteries, and other public landscapes as well.

"The Best Places to See Trees" is organized geographically. The City of Philadelphia is split into four regions: Center City and South

Chinese chestnut flowers, Carson Valley Children's Aid

Franklinia flower, Pennsylvania Hospital

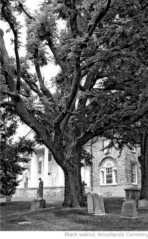
Black walnut, Woodlands Cemetery

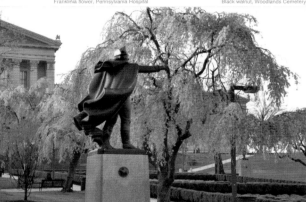
Weeping Higan cherry, Philadelphia Museum of Art

Philadelphia, West Philadelphia, North and Northwest Philadelphia, and Northeast Philadelphia. Sites in adjacent counties in Pennsylvania are also covered, including Bucks County, Montgomery County, Chester County, and Delaware County. The section ends with gardens in nearby Delaware and New Jersey.

Descriptions of ten gardens, parks, cemeteries, and arboreta are accompanied by maps with keys showing the locations and names of specific trees. We encourage you to use these maps as tools to improve your field identification skills or to help you get to know familiar places in new ways. Philadelphia and its surrounding countryside are filled with sylvan gems. We hope this section will increase your knowledge of and appreciation for our wonderful trees.

Rittenhouse Square

Walnut and 18th Streets
Philadelphia, PA 19103

In 1683, William Penn's surveyor Thomas Holme designed the original layout for the city of Philadelphia, dividing the city into four quadrants, each with a public park or square. The plan was anchored in the middle by a fifth public square that is now the site of Philadelphia's City Hall. Today the busiest of these original five squares is Rittenhouse Square at 18th and Walnut Streets. Originally named Southwest Square, the seven-acre public park was renamed in 1825 after David Rittenhouse, astronomer, clockmaker, and patriot of the Revolutionary era. Rittenhouse Square is a bustling center of activity at any time of year, with its shady bench-lined paths, lawns, and nearby sidewalk cafés.

The square is framed by London planetrees to the north, young red maples to the south, honeylocusts to the east, and a mix of honeylocusts and red maples to the west. Diagonal walking paths meet in the middle of the park at a central fountain amid green lawns planted with over a hundred mature deciduous trees. London planetrees, red oaks, a few maples, lindens, ginkgos, and elms offer shade for office workers as they rest on benches or eat their lunches on the grass. In the center of the park, an allée of horsechestnuts lines one axis, while the other axis boasts an allée of willow oaks. The central fountain, including the statues *Duck Girl* and *Lion Crushing a Serpent*, is framed by crape myrtles on all sides. The *Billy Goat* statue near the southwestern entrance is popular with children; it is close to a Kentucky coffee-tree. At the southeastern entrance to the square is a particularly beautiful Chinese scholartree.

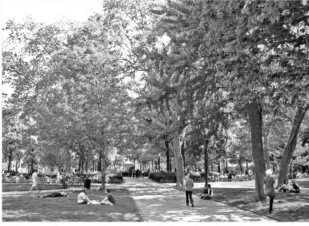

A London planetree and ginkgo flank the right side of the path leading to the statue Lion Crushing a Serpent *at the center of the square.*

Tree Map: Rittenhouse Square

Rittenhouse Square is a great place in Center City to practice identifying common urban trees. Start with the sycamores, honeylocusts, and red maples that surround the park, and walk through the lovely horsechestnut allées to the center of the square. Here willow oaks and crape myrtles surround the central plaza. A few American elms can be found in the southern section. Specimens in the southwestern corner include an American yellowwood, a Kentucky coffeetree, and an Amur corktree.

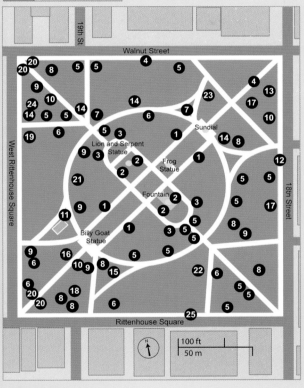

KEY TO TREES ON MAP:

1. Horsechestnut allées.
2. An allée of willow oaks defines the center of the square.
3. Crape myrtles frame the central plaza.
4. London planetrees line the outer sidewalks on Walnut Street, and an allée welcomes visitors at the northeast entrance.
5. London planetree.
6. American elm.

7. Silver maple.
8. Saucer magnolia.
9. Linden.
10. Ginkgo.
11. Sugar maple.
12. Honeylocusts line the sidewalk along 18th Street.
13. Sycamore maple.
14. Red oak.
15. Cherry.
16. Kentucky coffeetree.
17. Tuliptree.
18. Amur corktree.

19. Redbud.
20. Holly.
21. American yellowwood.
22. A large, lovely Chinese scholartree.
23. Swamp white oak.
24. Katsuratree.
25. Young red maples have been planted along the north and west outer sidewalks of the square.

Washington Square

Walnut and N. 6th Streets
Philadelphia, PA 19106

One of William Penn's five original public squares in his 1683 plan for Philadelphia, Washington Square is now part of Independence National Historical Park. Originally called Southeast Square, the 6.4-acre park was used in the 18th century as pasture for grazing animals. It was also a burial ground for victims of the yellow fever epidemics and for fallen soldiers of the Revolutionary War. In the early 1800s, the square was renamed Washington Square in honor of George Washington. In 1957, a memorial was erected in the central plaza with a large fountain surrounded by honeylocusts. Adjacent, the Tomb of the Unknown Revolutionary War Soldier is flanked by two large London planetrees.

Similar to Rittenhouse Square with its crisscrossing paths and shady lawns, Washington Square is quieter but has a greater diversity of trees. A tree-planting program in 1816 involved over seventy species, many of which were supplied by Bartram's Garden. The legacy of this effort can be seen today in the large variety of mature shade trees present in the square. Lindens and London planetrees are interspersed with tuliptrees, elms, maples, oaks, catalpas, and sweetgums.

Washington Square is a premier place in Philadelphia to see lindens, including the American linden (basswood), littleleaf linden, and silver linden. The surrounding sidewalks are lined by ginkgos planted as street trees. A sycamore along 6th Street is particularly large, and a young sycamore in the northeast corner is a "moon tree," a clone of a tree whose seed was carried to the moon on the Apollo 14 mission in 1971. There is also a very large London planetree near Walnut Street.

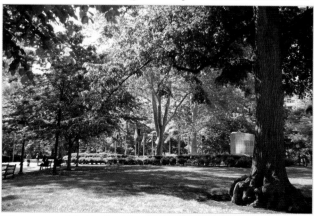

Flags surround the Tomb of the Unknown Revolutionary War Soldier, completed in 1957. It is framed by two stately London planetrees.

Tree Map: Washington Square

Walk through the square behind Independence Mall and enter Washington Square at the northeast corner. On your left is an Amur corktree next to the "moon tree." Walk toward the central plaza past a Chinese scholartree, a swamp white oak, two American lindens, and a large American elm cultivar. The central fountain is surrounded by honeylocusts. Groupings of lindens can be found at the entrances to the square. London planetrees, tuliptrees, and red oaks abound.

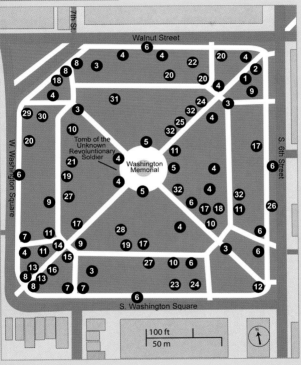

KEY TO TREES ON MAP:

1. Moon tree.
2. Amur corktree.
3. Look in this area for lindens, including the American (basswood), littleleaf, and silver.
4. London planetree.
5. Honeylocusts surround the central plaza and fountain.
6. Ginkgos line the outer sidewalks and are also found singly in the square.
7. Saucer magnolias.
8. Hollies frame the northwest and southwest entrances.

9. Catalpa.
10. Littleleaf linden
11. American elm cultivar.
12. Baldcypress.
13. Two Yoshino cherries greet visitors at the southwest entrance.
14. Shingle oak.
15. River birch.
16. Sawtooth oak.
17. Red oak.
18. Sweetgum.
19. White ash.
20. Tuliptree.

21. Two American yellowwoods.
22. A pair of hawthorns.
23. Two young sugar maples.
24. Chinese scholartree.
25. Swamp white oak.
26. Very large sycamore.
27. Turkey oak.
28. White oak planted in 1945.
29. Sweetbay magnolia.
30. Japanese tree lilac.
31. Huge London planetree.
32. American linden (basswood).

Independence Natl. Historical Park
Walnut btw. 2nd and 6th Sts.
Philadelphia, PA 19106

Independence National Historical Park encompasses several sites from the American Revolution, including Independence Hall and the First and Second Banks of the United States. This 55-acre park in Old City and Society Hill is administered by the National Park Service. The park today comprises the three blocks of Independence Mall and four landscaped blocks between Chestnut and Walnut Streets. It also includes Washington Square and the Magnolia Garden at 5th and Locust Streets.

Independence Mall was redesigned in the early 2000s and has many new plantings. Oaks, tuliptrees and other large shade trees line the pedestrian paths that wind between Independence Hall and the National Constitution Center, where a planting of river birches welcomes visitors. Across from the Liberty Bell, the seating areas are surrounded by flowering dogwoods, redbuds, hawthorns, and crabapples, which are a lovely sight in spring.

In front of Independence Hall are three elms (two English and one larger American). Independence Square, south of Independence Hall, originally had a double allée of American elms planted in the 1780s framing the building entrance. Today there is one large American elm that was planted in 1896, along with a few smaller elms and many London planetrees. There are two young American chestnut hybrids near the center of the square.

A group of oaks just south of the American Philosophical Society Library includes a willow oak (*Quercus phellos*), post oak (*Quercus stellata*), Spanish oak (*Quercus falcata*), red oak (*Quercus rubra*), pin oak (*Quercus palustris*), and white oak (*Quercus alba*). The Magnolia Garden has 13 saucer magnolias to represent the 13 original colonies.

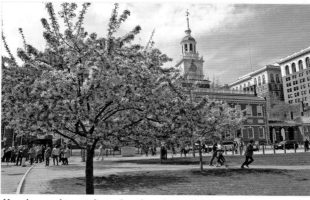

Hawthorns, dogwoods, and crabapples are blooming on the mall in front of Independence Hall on a pleasant morning in late April.

Logan Circle

Race and N. 19th Streets
Philadelphia, PA 19103

Originally named Northwest Square in William Penn's 1683 plan for Philadelphia, Logan Square was renamed after the colonial politician James Logan in 1825. In the 1920s, the square was made into a circle inspired by the Place de la Concorde in Paris. Today more often called Logan Circle, it is part of Benjamin Franklin Parkway, which connects the Philadelphia Museum of Art to City Hall. Logan Circle has the Swann Memorial Fountain in its center, surrounded by royal paulownias, or empress trees. In 2005, clonal trees from Longwood Gardens replaced the original planting of royal paulownias.

Royal paulownias were first planted at Logan Square in the 1920s. Now young clones of the old trees display their purple blossoms in early May.

FDR Park

S. Broad St. and Pattison Ave.
Philadelphia, PA 19145

Franklin Delano Roosevelt Park encompasses 348 acres in south Philadelphia along the Delaware River. Originally designed by the Olmsted brothers in the early 1900s, the park has been altered by an elevated interstate highway and sports complex and now includes a golf course. However, some of the historic design can still be seen in the managed parkland with picnic areas and a boathouse. Remnants of the marshlands once covering the site are now ponds and lagoons that are home to water-loving trees such as river birches, sweetgums, and willows. Beautiful old specimen trees, including Chinese scholartrees, lindens, oaks, and zelkovas are plentiful. The golf course has impressive rows of river birches, a Bartram oak, and a large hackberry. Rows of willow oaks line the boathouse parking lot.

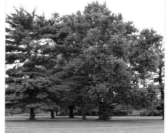

An eastern white pine and a Bartram oak stand in FDR Park's golf course.

East Fairmount Park

East of the Schuylkill River
Philadelphia, PA 19130

Fairmount Park, which encompasses over 10,200 acres, is the largest park within the Philadelphia Parks and Recreation system. Many of the squares and gardens described in this book are part of Fairmount Park. East Fairmount Park stretches from the Benjamin Franklin Parkway in Center City along the Schuylkill River to the confluence of the Wissahickon Creek. Benjamin Franklin Parkway is shaded by red oaks, red maples, and sweetgums. It connects City Hall to Eakins Oval where bosques of London planetrees stand in front of the Philadelphia Museum of Art. Behind the museum, the Anne

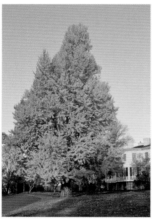

d'Harnoncourt Sculpture Garden features a beautiful selection of young trees including parrotias, redbuds, and yellowwoods as well as a honeylocust bosque. Between the museum and the Azalea Garden is an impressive row of sawtooth oaks and swamp white oaks. The Azalea Garden has many gems: fringetrees, lindens, magnolias, and dogwoods.

A pedestrian and bike path—the Schuylkill River Trail—runs along Kelly Drive to Northwest Philadelphia past a planting of Yoshino cherries. A drive along meandering roads on the bluff

A gorgeous golden ginkgo catches afternoon light at Lemon Hill.

above Kelly Drive takes you past seven historic mansions, including Lemon Hill. A grand ginkgo and row of dogwoods welcome visitors to this historic site. A large hackberry, an ash, a copper beech, an ailanthus, a red oak, and London planetrees surround the house.

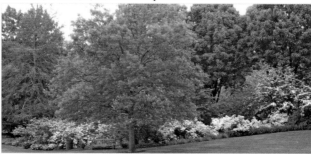

The Azalea Garden between the Philadelphia Museum of Art and the river is best visited in May when its trees and shrubs are in full bloom.

West Fairmount Park

Belmont Avenue and Montgomery Drive
Philadelphia, PA 19131

Along the western edge of the Schuylkill River, between the Spring Garden Street Bridge and the Falls Bridge, West Fairmount Park includes the site of the 1876 Centennial Exposition. To celebrate the 1976 Bicentennial, the Fairmount Park Horticulture Center was built on the site of the Centennial's Horticultural Hall. The Horitculture Center's grounds include the 27-acre Centennial Arboretum, a greenhouse, a pinetum and display gardens.

The Centennial Arboretum is home to the Michaux Grove, a collection of oaks planted in the 1870s in memory of botanists and plant explorers André and François André Michaux. The grove is overgrown with invasive shrubs and weeds but includes amazing large oak specimens that for years were largely forgotten. The arboretum also has many mature shade trees. Highlights are big specimen oaks, including a row of willow oaks and a pin oak allée, a magnolia grove, and a Japanese maple collection.

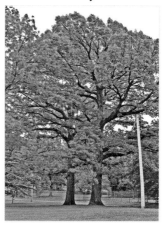

A scarlet and white oak stand side by side at the Centennial Arboretum.

Nearby, the Shofuso Japanese House was moved to its current location in 1958, the site of other Japanese structures and landscapes dating back to the 1876 Centennial. In spring, hundreds of cherries bloom in the arboretum, creating a spectacular backdrop for the annual cherry blossom festival.

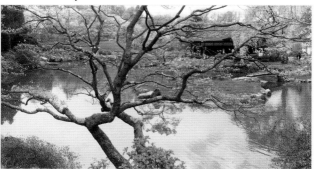

A beautiful and tranquil oasis in the city, the Shofuso Japanese House and Garden is in the style of a 17th-century Japanese viewing garden.

Bartram's Garden

Lindbergh Avenue and 54th Street
Philadelphia, PA 19143

A National Historic Landmark located in southwest Philadelphia by the Schuylkill River, Bartram's Garden is the historic house and 45-acre garden of John Bartram (1699–1777). Bartram was a Quaker farmer and botanist. He and his son William (1739–1823) dedicated their lives to exploring eastern North America and collecting native plants. Bartram purchased the land in 1728, built a farmhouse, and began his garden, which grew as he and his descendents ran a nursery on the site into the 1850s. John Bartram collected over 200 species of native plants, and by 1807 his sons were growing and selling over 1,500 species of plants from the United States and around the world.

Today Bartram's Garden includes the historic gardens, a meadow, a community garden, and an orchard, along with a trail overlooking the Schuylkill River. The eight-acre historic garden has a significant collection of native trees of historic importance. West of the house stands a Bartram oak (*Quercus × heterophylla*), a rare but naturally occurring hybrid of a red oak and a willow oak discovered by John Bartram on William Hamilton's nearby estate, The Woodlands. The ginkgo east of the barnyard is believed to be the oldest in North America, sent from London in 1785 by William Hamilton and given to William Bartram. The American yellowwood near the house was a gift from French botanist François André Michaux to William Bartram around 1802.

Among the garden's notable trees is a newly planted franklinia, a species discovered by John and William Bartram in 1765. William Bartram named the tree *Franklinia alatamaha* after Benjamin Franklin and the Altamaha river in Georgia, where the tree was found. The plant is thought to be extinct in the wild; all currently known specimens descend from trees grown by the Bartrams.

Other important older specimens include a state champion river birch, a sassafras grove, an American chestnut, some bottlebrush buck-

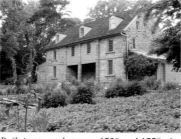

eyes, a large London plane-tree, an American beech, two grand old willow oaks, and several mature silverbells. Along the River Trail, sweetgums, black tupelos, sycamores, silver maples, boxelders, river birches, alders, black cherries, willow oaks, baldcypresses, and other riparian trees abound.

Built in stages between 1728 and 1770, the John Bartram House with its carved stone columns looks out over the Schuylkill River.

Tree Map: Bartram's Garden

The tree walk begins at the Bartram House, where an old yellowwood planted around 1800 stands by the kitchen garden. Walk around to the back of the house to see the Bartram oak near a large cucumber magnolia. Directly in front of the house, a franklinia stands with oak-leaf hydrangeas and buckeyes collected by William Bartram between 1773 and 1777. Stroll through the native plant area past the bog gardens and down to the River Trail. Don't miss the Hamilton ginkgo south of the barnyard.

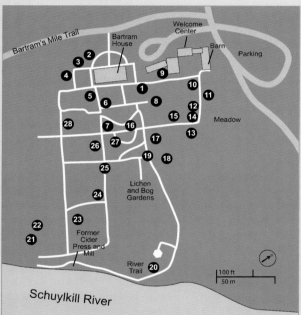

KEY TO TREES ON MAP:

1. Yellowwood: one of the garden's oldest trees is recovering from recent storm damage.
2. Bartram oak: a naturally occurring hybrid of a red oak and a willow oak discovered by John Bartram.
3. Panicled goldenraintree.
4. Cucumber magnolia.
5. Black maple.
6. The franklinia is the garden's signature tree.
7. Black tupelo.
8. Southern magnolia.
9. Southern magnolia.
10. Linden.
11. Sassafras.
12. Hamilton ginkgo.
13. Kentucky coffeetree.
14. Hophornbeam.
15. Beautiful yellowwood.

16. American beech.
17. London planetree.
18. Hybrid buckeye.
19. Baldcypress.
20. The River Trail is a good place to see sweetgums, silver maples, boxelders, sycamores, river birches, slippery elms, baldcypresses, mulberries, tuliptrees, and willows.

21. State champion river birch.
22. Multi-stemmed black cherry.
23. Willow oak.
24. Tuliptree.
25. Grove of silverbells.
26. Willow oak.
27. American chestnut.
28. Pawpaw patch.

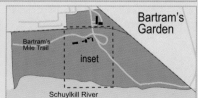

Woodlands Cemetery

Woodland Avenue and 40th Street
Philadelphia, PA 19104

Situated on the western banks of the Schuylkill River, Woodlands Cemetery was founded in 1840 on 53 acres of William Hamilton's former estate. A descendant of a prominent Philadelphia family of politicians and lawyers, Hamilton inherited The Woodlands from his father. After the American Revolution, he remodeled it in the English architectural and landscape styles of the time. A botanist and plant collector, Hamilton amassed more than 10,000 plants on The Woodlands' grounds and in his greenhouse; many were plant species new to the United States. During a trip he made to England in 1784–85, he shipped to The Woodlands the ginkgo, ailanthus, sycamore maple, and Lombardy poplar, along with numerous other exotic plants. Hamilton shared his interest in botany with his nearby neighbors the Bartrams, as well as with founding fathers Jefferson, Madison, and Washington.

Today the cemetery includes not only Hamilton's neoclassical mansion but also remnants of his gardens and plant collections. Until recently, a grove of seven grand English elms stood near the house. Three died in 2014, and the remaining four died of Dutch elm disease in 2016. A large fastigiate Caucasian zelkova is a rarely planted and remarkable-looking tree, likely descended from rootstock dating to Hamilton's time. Nearby, a pair of beautiful black walnuts stand across from the house, probably the result of squirrel distribution. The cemetery also boasts lovely examples of sassafras, flowering dogwoods, yews, ginkgos, sycamore maples, and a Kentucky coffeetree. There are a few very large white ashes and hackberries. A baldcypress and a state champion London planetree are not to be missed. An old white mulberry behind the house, near the river, is an unusually large specimen.

A pair of beautiful black walnuts stand near the circular drive in front of William Hamilton's former house, near a rare Caucasian zelkova.

Tree Map: Woodlands Cemetery

The tree walk begins at the Woodlands Mansion and meanders among over 750 tree specimens in the cemetery. The driveway winds past William Hamilton's carriage house and around the perimeter of the cemetery toward a central circle, where flowering dogwoods, sassafras, and a chestnut oak stand. The black cherry near the entrance has an exceptionally wide spread for its species. Several state champion trees were lost to storm damage in the early 2000s.

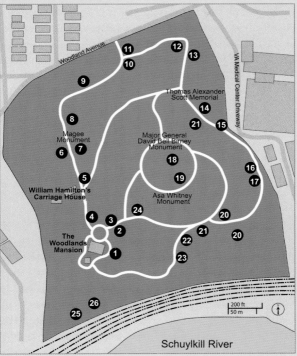

KEY TO TREES ON MAP:

1. Ginkgo pair.
2. Kentucky coffeetree.
3. This fastigate Caucasian zelkova is a state champion.
4. Black walnut pair.
5. Japanese snowbell.
6. Yew.
7. Japanese falsecypress.
8. Black cherry.
9. Red oak.
10. Okami Formosan cherry.
11. Amur corktree.
12. White ash.
13. Black oak.
14. Tuliptree.
15. Baldcypress.
16. Hackberry.
17. A former state champion sweetbay magnolia was very large for its species but has suffered some storm damage.
18. Chestnut oak.
19. Cluster of sassafras trees.
20. Pin oak.
21. White ash.
22. Hackberry.
23. London planetree, a state champion.
24. Sycamore maple.
25. Persimmon.
26. Mulberry.

Philadelphia Zoo

3400 W. Girard Avenue
Philadelphia, PA 19104

The 42-acre Philadelphia Zoo includes the historic summer residence of John Penn (William Penn's grandson) and has a wealth of ornamental and shade trees. There is a state champion English elm that may be the largest and oldest English elm in North America. Two old gink-

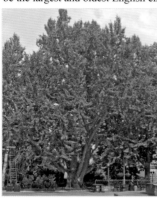

gos near the front entrance are spectacular, with many massive branches. Penn's house, The Solitude, still stands on the site, with an especially large hedge maple gracing its lawn. Honeylocusts abound, as well as London planetrees, oaks, maples, birches, tuliptrees, horsechestnuts, beeches, yellowwoods, and eastern white pines. *To the left of the zoo's entrance is an old ginkgo with eight trunks.*

University of Pennsylvania

Philadelphia, PA 19104

Since the 1870s, when West Philadelphia was open fields, the University of Pennsylvania's 5-acre campus has grown into a lovely 300-acre campus arboretum. The central axis of the campus, Locust Walk, is lined with large Japanese zelkovas mixed with London planetrees and oaks. North of College Hall, a glorious second-generation Penn Treaty Elm (*Ulmus americana*) graces the lawn. Behind the Wistar Institute, there are some marvelous southern magnolias. Amur

corktrees line the south side of the Duhring Wing of the Fisher Fine Arts Library. Nearby, an American yellowwood stands in front of the Arthur Ross Gallery. Behind the Richards Medical Research Laboratories is the James G. Kaskey Memorial Park (also called the BioPond), a botanical research garden opened in 1897. Renovated in 2000, it is a small oasis with a diversity of trees, including a willow oak, a white ash, an American holly, a hackberry, a cherry birch, a European hornbeam, a catalpa, a ginkgo, lindens, and beeches.

Zelkovas line Locust Walk at the University of Pennsylvania. Some are more than 60 feet tall.

Laurel Hill Cemetery

A 78-acre National Historic Landmark founded in 1836 by Quaker John Jay Smith, Laurel Hill Cemetery sits above Kelly Drive, overlooking the Schuylkill River. Laurel Hill was built on the site of merchant Joseph Sims' landscaped estate, and some of its plantings were incorporated in the cemetery. Among the first cemeteries of its kind in the United States and the first in Philadelphia, Laurel Hill created a nonsectarian burial place outside of the city—a place for contemplation in a bucolic landscape with views of the river to calm the spirit. Laurel Hill was likely the inspiration for the preservation of The Woodlands as a cemetery. Cemeteries are often repositories of unique botanical specimens, and Laurel Hill is no exception.

A towering Kentucky coffeetree and a pollarded magnolia near the gatehouse welcome visitors to the cemetery. Beyond, there is an extensive collection of venerable specimen trees. A tall cucumber magnolia is located in the northwest section of the cemetery, not far from a large copper beech. A impressive old English elm exhibits the spreading habit of an open-grown tree. Beautiful large London plane-trees, sugar maples, ginkgos, lindens, eastern white pines, oaks, yews, elms, and hollies are spread across the grounds. Particularly memorable are a yellowwood, a cutleaf linden, and a lovely bur oak with a habit resembling an American elm's.

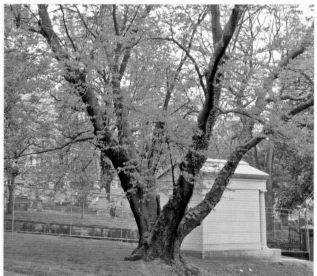

An old, 50-foot-tall yellowwood at Laurel Hill Cemetery has four large limbs spreading outward low on its trunk, which measures 70 inches in diameter.

Morris Arboretum

100 E. Northwestern Avenue
Philadelphia, PA 19118

Morris Arboretum of the University of Pennsylvania offers visitors beautiful vistas from the top of a hill where Lydia and John Morris's summer house once stood. The Morris siblings, avid travelers and plant collectors, bought the property in 1887. When Lydia died in 1932, the estate was left in trust to the University of Pennsylvania. It is now the official arboretum of the Commonwealth of Pennsylvania, and is listed on the National Register of Historic Places. Designed primarily in the English landscape style with an Asian influence, it contains a number of specialty gardens, including the formal Rose Garden, the Swan Pond, and the Japanese Hill Garden, as well as several lovely naturalistic areas along Wissahickon Creek and its tributaries.

The Arboretum's exceptional living plant collection, assembled by the Morrises on their travels and by Arboretum horticulturists on many expeditions around the world, consists of 2,500 plant types and over 12,000 individually labeled and catalogued specimens, with a particular focus on Asian species and their North American counterparts.

Visit the Arboretum in spring, drive through sweeping meadows, and ascend a winding drive bordered by flowering magnolias. You will feel how special this botanical garden is before you even reach the parking lot. Some of the most exquisite tree specimens are the magnificent katsuratree planted in the early 1900s, a rare, spectacular Engler beech that is a Pennsylvania state champion, and a great Bender oak, perhaps 250 years old, near the visitor parking area.

The Arboretum houses collections of maples, magnolias, flowering cherries, witchhazels, roses, hollies, and conifers. The dawn redwoods bordering the East Brook are among the largest specimens to be found anywhere, and a nearby grove of Chinese toon trees is

A 100-year-old male katsuratree is the signature tree of the Morris Arboretum.

perhaps unique in North America. An Atlas cedar and a Lebanon cedar planted by the Morrises have attained monumental proportions. Bark Park showcases trees with beautiful bark and is best enjoyed during a winter visit. Nearby, a huge Chinese elm grows next to the Swan Pond and a rare trident maple stands close to the Overlook Garden.

Tree Map: Morris Arboretum

The tree walk begins at the parking lot on the hill near the site of the original Morris house. Stop by the Bender oak, then meander down the hill past the weeping beech, Atlas cedar, and giant sequoias. Visit the various specialty gardens along the way. Cross the East Brook to see rare trees such as the Engler beech and Tatar wingceltis. Finish at the dawn redwood grove or continue to the wetland area near the entrance if you desire a longer walk.

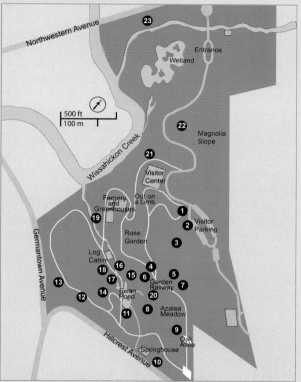

KEY TO TREES ON MAP:

1. A Bender oak (*Quercus × benderi*) is a naturally occurring hybrid between scarlet oak (*Q. coccinea*) and red oak (*Q. rubra*).
2. A female ginkgo was planted by the Morrises.
3. A weeping European beech was planted before 1909.
4. Atlas cedar.
5. Giant sequoia.
6. 'Edith Bogue' southern magnolia.
7. This katsuratree was planted circa 1901 by the Morrises and is one of the largest in North America.
8. Lacebark pine.
9. Hardy cedar of Lebanon.
10. Japanese zelkova.
11. A rare weeping Canadian hemlock is 100 years old.
12. Trident maple.
13. The Tatar wingceltis (*Pteroceltis tatarinowii*) is one of the rarest plants at the Arboretum.
14. The Engler beech (*Fagus engleriana*) from China is rare in North America.
15. Chinese elm.
16. Tabletop Scotch elm.
17. Yellow buckeye.
18. Look for stewartias and maples in Bark Park.
19. The dawn redwood grove has trees over 110 feet tall.
20. Yoshino cherry.
21. White oak.
22. American beech.
23. English oak.

Wissahickon Valley Park

Valley Green Road
Philadelphia, PA 19128

As you walk, run, or bike along trails in Wissahickon Valley Park, you are bound to notice the smooth, silvery bark of beech trees, the bone-white upper branches of sycamores, and the towering, straight trunks of tuliptrees. This is scenery that poets, painters, and nature lovers alike have delighted in for centuries. Wissahickon Valley Park is a 1,800-acre preserve with 50 miles of trails. It encompasses a deep, wooded valley along seven miles of the Wissahickon Creek that flows down to the Schuylkill River. It is a unique slice of wilderness in the city.

The Wissahickon Valley was once blanketed by a richly diverse forest of oaks, hemlocks, American chestnuts, hickories, ashes, and maples. From the time of the first European settlers, however, the valley underwent a series of changes. Trees were first cleared for farming and cut for lumber. Then mills were built along the creek, and intensive urban development transformed the countryside surrounding the valley. What "wilderness" still existed along the creek in the mid-1800s became a destination for visitors as taverns and inns were built along the gravel road paralleling the creek—the road known today as Forbidden Drive. In the late 1860s, the city purchased the first section of Wissahickon Valley Park and incorporated it into the Fairmount Park System to preserve open space and protect water quality.

Remnants of old mills, the Thomas Mill Covered Bridge, and the Valley Green Inn are reminders of the Wissahickon's rich history. Today's forest is different from the woods early settlers encountered. The chestnut blight in the early 1900s and insect infestation by the hemlock woolly adelgid, combined with stresses from urban development and increasing deer populations, have changed the forest. Visitors today still find native sycamores and American beeches, oaks, ashes, and hickories, but there are probably more tuliptrees, chestnut

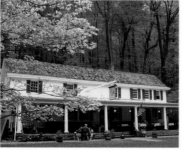

oaks, and maples than there once were. Exotics such as the Norway maple are now widespread. The park's northern section, once part of the Andorra Nursery and now known as the Andorra Natural Area, still contains nursery species such as European beeches, Japanese maples, Chinese toon trees, and Korean evodias.

Since the 1850s, the Valley Green Inn on Forbidden Drive has offered visitors a resting spot while they explore the park.

Tree Map: Andorra Natural Area of Wissahickon Valley Park

This tree walk covers the park's northern edge from Northwestern Avenue to Bell's Mill Road. The area around the Wissahickon Environmental Center was the Andorra Nursery from the 1880s until 1961. In this forest, now called the Andorra Natural Area, nursery remnants grow among native species. European beeches, Chinese toon trees, Korean evodias, and Japanese and Norway maples mix with native tuliptrees, sugar maples, American beeches, cherry birches, and oaks.

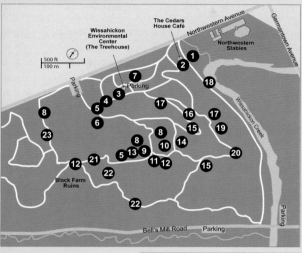

KEY TO TREES ON MAP:

1. Sugar maples along Forbidden Drive are tapped yearly to make maple syrup.
2. Enormous cucumber magnolia.
3. Saucer magnolia.
4. Chinese toon trees.
5. Black locusts.
6. State champion European beech planted over 150 years ago by Richard Wistar.
7. Large Kentucky coffeetree.
8. Naturalized Japanese maples create unique groves among the native trees.
9. Multi-stemmed linden.
10. Large bur oak.
11. Cucumber magnolia.
12. Horsechestnut.
13. Bigleaf magnolias.
14. Bottlebrush buckeyes.
15. Black oak.
16. Cherry birch.
17. American beeches.
18. Sycamores along the creek.
19. Regenerating natives such as sugar maples, hickories, and sassafras under older cherry birches and tuliptrees.
20. A big group of Korean evodias.
21. European beeches.
22. Norway maples.
23. Rows of European beeches (mostly copper) were likely planted by Richard Wistar in 1850.

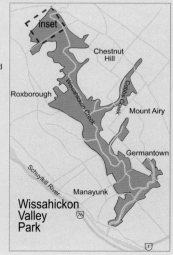

Wissahickon Valley Park

Awbury Arboretum

One Awbury Road
Philadelphia, PA 19138

With the help of renowned horticulturalist William Saunders, the 55-acre Awbury Arboretum was designed in the English landscape tradition with open expanses of lawn and groves of trees. Henry Cope, a Quaker shipping merchant, bought the land in 1852. Originally intended to be a summer home, the property eventually became a year-round residence for Cope's extended family. Many houses were built on the site between 1860 and 1930, and all except the Francis Cope House are now privately occupied. The Cope family established the Arboretum in 1916 to preserve the land for public use. Woods, ponds, meadows, wetlands, and open lawns provide important green space in a dense urban area of Philadelphia.

The arboretum has more than 200 species of trees. Germantown has a number of bottlebrush buckeye (*Aesculus parviflora*) plantings, and Awbury boasts a particularly fine one. Some of the largest river birches in the city grow in the wetland and meadow area, as well as a notable black walnut and overcup oak. Be sure to see the number two Pennsylvania state champion river birch near the Washington Lane double gate. Visitors who take the time to walk around this lovely English landscape park will see black gums, a bur oak, a shagbark hickory, and an enormous American linden. A large pagoda dogwood and a large American holly stand near the Francis Cope House. Behind the house is an impressive willow oak and a red oak. Also worth noting are a baldcypress grove, a few Chinese chestnuts, persimmons, katsuratrees, and an American sycamore reported to be 300 years old. A rarely planted *Styrax obassia* has naturalized in the Secret Garden.

A sugar maple in front of the Francis Cope House at the Awbury Arboretum shows off its spectacular orange and red fall color.

Wyck	*6026 Germantown Avenue* *Philadelphia, PA 19144*

From 1690, when the original log house was built, to 1973, nine generations of one Philadelphia family lived and farmed at Wyck. The Milans, Jansens, Wistars, and Haineses, most of whom were Quakers, preserved their family home, and 2.5 acres of the original property are now open to the public. The site features the colonial Haines house with its historic furnishings, perennial gardens, woodlot, fruit trees, and vegetable and herb gardens. Today Wyck is an historic museum and working urban farm with community education programs and an active farmer's market. Community members can stroll through the grounds and learn about the history of this Germantown family.

For a small property there are quite a few trees to see. The tallest is, not surprisingly, a tuliptree, since it is the largest of our native trees. There are also two horsechestnuts, a big American beech, a royal paulownia, a lovely franklinia, and a Carolina silverbell. The property has a number of ashes, sugar maples, and black walnuts as well. The woodlot in front of the house includes a pawpaw grove.

Wyck is home to the oldest rose garden in the United States still in its original plan; many roses thought to be extinct have been found here. In the rose garden near the house, a saucer magnolia cut down around 2010 because of internal rot is regrowing from its stump. This magnolia is believed to be one of the first planted in the United States and could even be a clone of the original Soulange hybrid saucer magnolia created in France in the 1820s. In another interesting botanical side note, the Wistar family was related to the physician and anatomist Caspar Wistar, after whom the genus *Wisteria* is named.

Two ashes look over the rose garden behind the Wyck House. The rose garden is thought to be one of the oldest in the United States.

Pennypack Park

8500 Pine Road
Philadelphia, PA 19111

Named after the Lenape Indian word for "slow-moving water," Pennypack Park comprises more than 1,300 acres along Pennypack Creek as it meanders from Montgomery County down to the Delaware River. Established in 1905 to preserve the water quality in the creek by protecting the surrounding land, the park is currently part of the Philadelphia Parks and Recreation system. The land along Pennypack Creek was acquired by William Penn from the Lenape Indians in 1683, and remnants of historic structures such as mills and mill races can still be seen today. Explore the woods, wetlands, and meadows on the park's extensive hiking trails, bike paths, and equestrian paths.

The native woodlands of Pennypack Park are comprised mostly of tuliptrees mixed with shagbark and pignut hickories, large stands of American beeches, red oaks, white ashes, and sugar maples. Sycamores, boxelders, pin oaks, and silver maples line the creek. The park has eight state champion trees, including the tallest state champion pin oak, located south of the Pine Road parking lot. Other state champions include two tuliptrees, two pignut hickories, a black walnut, a red maple, and a black oak.

John James Audubon and Alexander Wilson bird watched along Pennypack Creek, and the park is still home to a large variety of migratory and nesting birds. For more information about the park's ecology, visit the nearby Pennypack Environmental Center. The center was first established in 1958 as a bird sanctuary but has grown in mission to include environmental and recreational programming.

A backwoods trail at Pennypack Park shows the yellow fall color of the tuliptrees that dominate the native woodlands around Philadelphia.

Greenwood Cemetery

930 Adams Avenue
Philadelphia, PA 19124

Chartered in 1869 by the Knights of Pythias, the 43-acre grounds of Greenwood Cemetery were designed by Thomas S. Levy. The cemetery had a period of neglect but has been recently restored and houses a lovely collection of trees. In the late 1700s, the property was owned by Benjamin Rush, one of the signers of the Declaration of Independence. Rush, an abolitionist, advocated growing sugar maples for maple syrup to decrease American reliance on sugar produced by slave labor in the West Indies. Several extraordinarily large sugar maples at Greenwood Cemetery still stand as a testament to Rush's beliefs. There is also an enormous American sycamore that, based on its size, was probably planted in the mid-19th century.

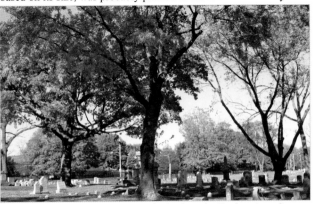

Large sugar maples could date as far back as the Declaration of Independence. They bloom a spectacular orange and red in fall.

Wissinoming Park

5801 Frankford Avenue
Philadelphia, PA 19135

Wissinoming Park is a 42-acre park north of Frankford. Surrounded by cemeteries, on the former estate of early photographer Robert Cornelius, Wissinoming boasts a pair of the largest Spanish oaks (*Quercus falcata*) in the city, as well as two beautiful large ginkgos and a big English oak (*Quercus robur*). An unusual row of catalpas (*C. speciosa* and *C. bignonioides*) join the riparian area along Charles Street with the rest of the park.

This large Wissinoming Park ginkgo exhibits the spreading habit of an open grown tree.

Henry Schmieder Arboretum

700 East Butler Avenue
Doylestown, PA 18901

The Henry Schmieder Arboretum consists of 40 acres on the campus of Delaware Valley University. Originally founded in 1896 as an agricultural school, today the arts and sciences university uses the arboretum and its learning gardens as outdoor classrooms. For the tree enthusiast, the main quadrangle of the campus boasts

three different allées: honeylocust, ginkgo, and flowering dogwood. An enormous American sycamore near Lake Archer is more than 20 feet in circumference, and there is a large, impressive red oak west of the library.

A formal allée of ginkgos frame one axis of the central quadrangle.

Bowman's Hill Wildflower Preserve

1635 River Road
New Hope, PA 18938

The 134-acre Bowman's Hill Wildflower Preserve is a great place to learn about the Delaware Valley's native plants. The land at the preserve was agricultural until 1920. Its 2.5 miles of walking trails meander along Pidcock Creek through a second-growth deciduous oak and hickory forest. The preserve installed a deer fence in 1993, and the difference in the forest composition inside and outside the fence is striking. Without deer, the plants are more diverse and regeneration is apparent in the herbaceous, shrub, and juvenile tree layers. Within the preserve, the 9-acre Penn's Woods arboretum, established in 1944, includes 46 species of native trees from across Pennsylvania. A self-guided tour of the collection provides an opportunity for visitors to compare tree species. Each specimen is labelled

and easily visible from the path. There are mockernut and shagbark hickories, many oaks, red and sugar maples, cherry birches, tuliptrees, hackberries, umbrella and cucumber magnolias, striped maples, pawpaws, and sycamores. Redbuds line the winding roads through the preserve. In the meadow are red cedars, river birches, black walnuts, more tuliptrees and sycamores. There is a sassafras grove by the picnic area.

The Marshmarigold woodland trail looks over Pidcock Creek.

Andalusia

*1237 State Road
Andalusia, PA 19020*

Andalusia is the historic home and estate of Nicholas Biddle, a prominent American financier whose Greek Revival mansion is beautifully sited overlooking the Delaware River. The nearly 100-acre estate once had cattle, stables, and hothouses growing table grapes. The remains of the hothouse walls frame the rose garden and are covered with 100-year-old wisteria. There is a gorgeous old saucer magnolia near the pool. The estate also has persimmons, beeches, a paperbark maple, serviceberries, and an alternating beech and carpinus hedge.

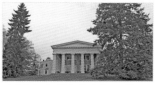

A spruce and hemlock frame the Greek revival mansion at Andalusia.

Hortulus Farm Garden and Nursery

*60 Thompson Mill Road
Newtown, PA 18940*

The 100-acre Hortulus Farm Garden and Nursery is an 18th-century dairy farmstead owned since 1980 by garden and event designer Renny Reynolds and garden writer Jack Staub. A lovely series of twenty-four gardens, along with a retail nursery and museum, are open seasonally to the public. Visitors can begin a tour by proceeding down an allée of birches toward the Woodland Walk with its magnolias, maples, locusts, and dogwoods to a pond surrounded by black walnuts. A leisurely walk might then continue through the artful vegetable and herb gardens, past perennial borders with many flowering crabapples and cherries. If you walk past the Pool Garden through an allée of white pines juxtaposed with native dogwoods, you will end up at the Urn Garden with its fastigiate (upward-branching) copper beeches.

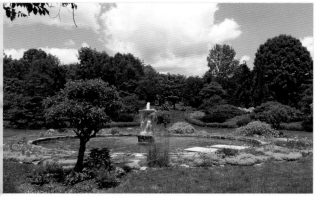

The pool garden south of the pine and dogwood allée is landscaped to look more like a garden fountain than the swimming pool that it is.

PHS Meadowbrook Farm

1633 Washington Lane
Meadowbrook, PA 19046

Gifted to the Pennsylvania Horticultural Society (PHS) in 2004 by J. Liddon Pennock, Jr., Meadowbrook Farm is a 25-acre historic estate and garden with a retail nursery and gift shop. The original 150-acre farm was a wedding gift to Pennock and his wife, Alice Herkness, in 1936. Pennock, a renowned floral designer, operated his grandfather's floral business until 1966. In 1971, he opened the greenhouse at Meadowbrook Farm to the public, starting the retail nursery that continues there today. He lived for 67 years at Meadowbrook Farm, creating the series of private gardens that remain for visitors to enjoy. Pennock was closely involved with the Philadelphia Flower Show for many years, and Meadowbrook Farm greenhouses still provide plants for the Flower Show.

Eighteen acres of Meadowbrook are woodlands, reclaimed from previous pasture and fields. Canopy trees include eastern white pines, tuliptrees, black walnuts, oaks, and maples. The remaining seven acres of the site encompass the house and private gardens, as well as the nursery and display gardens. The visitor parking lot sits beside a vegetable garden and perennial garden. A path to the house passes by Atlas cedars, deodar cedars, a crape myrtle, magnolias, and dogwoods. Near the house, along a path to the formal gardens, there is a large franklinia surrounded by four smaller specimens. A series of garden rooms run parallel to the back of the house. Statuary, fountains, and gazebos provide focal points. Beautiful southern magnolias thrive on the southern side of the house; one of them, espaliered against a wall, is spectacular. Dawn redwoods and a lovely paperbark maple also stand out.

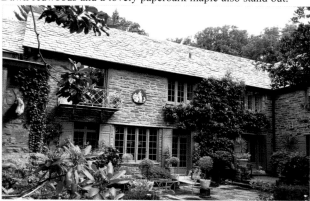

A large espaliered southern magnolia grows up the south side of J. Liddon Pennock's English Cotswolds–style house at Meadowbrook Farm.

Ambler Arboretum of Temple University *580 Meetinghouse Rd. Ambler, PA 19002*

The Ambler Arboretum of Temple University was founded in 1911 by Jane Bowne Haines as the Pennsylvania School of Horticulture for Women. The school merged with Temple University in 1958, and today the Ambler campus is home to Temple's Department of Landscape Architecture and Horticulture. Over the past hundred years, students and professors studying plants and landscape design have created a campus with beautiful specimen trees. The arboretum mission describes its focus areas as the history of women in horticulture and design, sustainability, and the health benefits of gardens. The Louise Bush-Brown Formal Perennial Garden is the central historic garden on campus, but there are others to explore: a wetland garden, a dwarf conifer garden, a healing garden, an herb garden, and several native-species plantings. Many were either designed by or are dedicated to influential women in horticulture.

Visitors walking into the campus through the arbors designed by John Collins are greeted by a large sycamore in front of the historic Haines House. A former chair of the Department of Landscape Architecture and Horticulture, Collins redesigned the Formal Native Perennial Garden with his students in 1993, using an allée of black tupelos to great effect. The Colibraro Conifer Garden near the Greenhouse showcases dwarf conifer cultivars. Behind the Healing Garden is a splendid walnut and pecan allée, which predates the road that cuts through it. Other trees of note are a large weeping hemlock and weeping cherry by Widener Hall and a Chinese tuliptree near the Fisher Garden. There are also redbuds, ginkgos, sawtooth oaks, chestnut oaks, scarlet oaks, cedars, crape myrtles, Japanese zelkovas, Norway spruces, eastern white pines, and styraxes.

The Ernesta Ballard Healing Garden, adjacent to an historic allée of pecan and walnut trees, features native species and a labyrinth.

The Barnes Arboretum

300 North Latch's Lane
Merion, PA 19066

The world-famous Barnes Collection of impressionist, post Impressionist, and early modern paintings no longer resides at its original location in Lower Merion. However, the Barnes residence and 12 acre arboretum are still home to the foundation's horticulture school and the grounds are open to the public a few days a week during spring and summer. No other arboretum packs so much into such a small space. The tree collection is spectacular, with trees of the same genus often planted side by side for easy comparison.

A gorgeous bank of alternating pink and white magnolias is comprised entirely of Asian species. A few stewartias with characteristic peeling bark are planted beside an equally impressive Japanese clethra tree, also bearing flaking bark. Several Japanese and Chinese tree lilacs grace the lilac collection that has May color from white to pink to violet. There is an especially large and lovely Persian ironwood. A grouping of *Aesculus* species includes five North American, one Asian, and thirty-nine European specimens. A trio of cedars, two large Atlas cedars and a cedar of Lebanon, stand along the arboretum's southern edge.

The arboretum has almost forty state champion trees, many of them unusual or rare species. The Barnes is one of the few arboreta in the northeast to have succeeded in raising a coast redwood (*Sequoia sempervirens*), and it is a state champion. A state champion Japanese wheel tree (*Trochodendron aralioides*) was planted in 1950. Multiple species of Amur corktrees, a lacebark pine, and a gorgeous dove tree, or handkerchief tree, are also well worth seeing.

The Barnes' magnolia display includes Magnolia × *'Wadas Memory,'* Magnolia sprengeri *'Diva,' and* Magnolia × *'Royal Crown.'*

Valley Forge Natl. Historical Park

1400 North Outer Line Drive
King of Prussia, PA 19406

Valley Forge National Historical Park is the 3,500-acre site of the 1777–78 winter encampment of the Continental Army. Visitors learn about perseverance while enjoying a beautiful commemorative landscape that preserves significant natural resources. During the encampment, every tree for miles was cut down for firewood and cabins. Today the park is half forest and half warm-season meadows. An allée of massive white oaks lines Route 23. The upland forests are comprised of hickories, chestnut oaks, black oaks, white oaks, and scarlet oaks. Along the Schuylkill River and Valley Creek, floodplain forests include sycamores, green ashes, silver maples, red maples, and boxelders. A state champion black walnut and a possible encampment-era sycamore grow near the Covered Bridge. A second massive sycamore with ground-sweeping branches stands on the Pawling Farm.

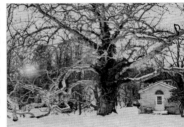

A large, ancient sycamore grows by the Pawling Farm Springhouse.

The Highlands Mansion and Gardens

7001 Shaeff Lane
Fort Washington, PA 19034

A fine example of a Pennsylvania country estate, the Highlands Mansion and Gardens offers 44 acres for exploration. Originally built for Anthony Morris in 1794, the estate was improved by subsequent owners and includes a greenhouse, gardener's cottage, and barn. The two-acre formal garden, the Sinkler Garden, features statuary and high, impressive crenellated stone walls. The garden had fallen into disrepair, and a restoration endeavor begun in 2005 is still underway. Tree enthusiasts will find a few large sugar maples, a white oak, black walnuts, dogwoods, a weeping willow, horsechestnuts, and magnolias.

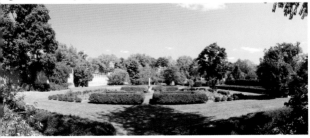

From the porch of the Highlands' Georgian mansion, there is a sweeping view of the Sinkler Garden's formal layout and crenellated stone walls.

West Laurel Hill Cemetery

215 Belmont Avenue
Bala Cynwyd, PA 19004

Founded in 1869, West Laurel Hill Cemetery occupies 187 acres by th
Schuylkill River, across and upstream from Laurel Hill Cemetery, it
older sibling. Like Laurel Hill Cemetery, it has a pastoral feel reminis
cent of English landscape design—bucolic rolling hills dotted wit
remarkable tree specimens of interesting varieties. Look for larg
English yews, magnolias, ginkgos, cherries, crabapples, sycamore
oaks, Japanese zelkovas, maples, and hornbeams, among many other
Spectacular copper beeches are in good company with other Europea
beech cultivars, including weeping varieties. Many conifers are als
represented: firs, Douglas-firs, Norway spruces, Atlantic cedars, an

dawn redwoods, to nam
a few. An old America
holly near the Conserv
atory stands with
Japanese cutleaf maple, a
Atlas cedar, a weepin
European birch, and
double-trunked sassafras
A sugar maple allée run
along Memorial Drive.

A Japanese maple burns bright red among
the gravestones as it leafs out in the spring.

Welkinweir

1368 Prizer Roac
Pottstown, PA 1946.

Welkinweir, "where sky meets water," is an historic estate and 55
acre arboretum set among 197 acres of lovely woodlands, wetlands
and meadows in Chester County. Owners Everett and Grac
Rodebaugh preserved the property as an environmental sanctuar
with a conservation easement in 1976. The Rodebaughs also found
ed the Green Valleys Watershed Association, a nonprofit that work
to preserve water resources in northern Chester County and run
its programs from Welkinweir. The arboretum has an azale

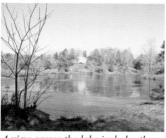

collection, dogwoods, magno
lias, redbuds, and a pinetum
with dwarf conifers. A part o
Pennsylvania's Hopewell Bi
Woods, much of the property i
a second-growth, mixed hard
wood forest with chestnut, red
and white oaks intersperse
with American beeches, tulip
trees, and red maples.

A view across the lake includes the
historic house on a promontory.

Jenkins Arboretum and Gardens
631 Berwyn Baptist Road
Devon, PA 19333

Starting with the dogwoods, magnolias, and sourwoods in the parking lot, there is much to see at this 48-acre woodland botanical garden. Specializing in rhododendrons and azaleas, Jenkins Arboretum and Gardens opened to the public in 1976 on the former property of H. Lawrence and Elisabeth Phillippe Jenkins. The site includes the John J. Willaman Education Center, a building designed for environmental sustainability.

A remnant hardwood forest takes up most of the property, with large groves of black oaks mixed with chestnut, red, and white oaks. Other canopy trees include hickories, white ashes, tuliptrees, and black gums with spicebushes, dogwoods and redbuds below. The largest tree on the property is an eastern white oak with very long horizontal branches along Trout Creek. The woodland garden has several old flowering dogwoods that predate the arboretum, and a big Kwanzan cherry overlooks the pond. A fine hophornbeam specimen stands on the edge of the woodland path.

Created in 1975, the pond has a beautiful grove of baldcypresses along its banks. With much moisture and sunlight, they have grown quickly. The pond's eastern edge has a planting of eastern white pines mixed with pawpaws and franklinias; one franklinia is almost 30 feet tall. The other bank boasts a large eastern cottonwood and an impressive royal paulownia. An open-grown tree with a wide silhouette, the paulownia is old for its species and does not flower as lavishly as it once did. A sizeable 'Edith Bogue' southern magnolia grows on the Stream Walk, as well as a 30-year-old striped maple (*Acer pensylvanicum*), a species not often seen this far south.

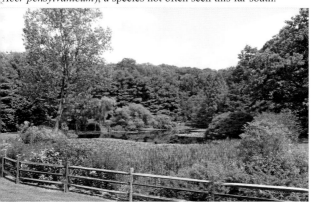

A walk down the hill through the wood rewards visitors with a view of a pond rimmed with cattails, wildflowers, and impressive specimen trees.

Longwood Gardens

1001 Longwood Road
Kennett Square, PA 19348

Once a working farm purchased by George Peirce in 1700, Longwood Gardens was begun as a fifteen-acre arboretum by Peirce's descendants in 1798. In 1906 Pierre S. du Pont bought the property and expanded the site into one of the premier botanical gardens in the United States. Currently, Longwood consists of over 1,000 acres of woodlands, meadows, and formal gardens that include twenty outdoor gardens and twenty indoor gardens.

Longwood Gardens' tree collection is outstanding and can only begin to be described here. The grounds are home to 143 Pennsylvania state champion trees. From the moment you walk down the honeylocust-lined walk in the parking lot, there is much to discover. The overflow parking lot boasts a champion Kwanzan cherry that is approximately sixty years old. A beautiful champion surviving American elm and several impressive kousa dogwoods greet visitors as they exit the visitor center and begin to explore the gardens. Allées of flowering dogwoods, royal paulownias, European elms, copper beeches, and baldcypresses connect different parts of the grounds.

Near the house and in Peirce's Park are many large trees dating back to the 1800s, including lindens, sugar maples, hemlocks, cherry birches, a pagoda dogwood, sourwoods, and a cucumber magnolia. Several are state champions. A tuliptree along the Forest Path is 164 feet tall and is the tallest recorded of its species in the Northeast. Several large franklinias stand next to the Peirce-du Pont house. Two ginkgos south of the house are thought to be contemporaries of Bartam's ginkgo. Nearby, a tall champion Chinese scholartree overlooks the Open Air Theatre. Near Oak Knoll are a grove of gorgeous American beeches beside a state champion elm, *Ulmus × hollandica* 'Major' and a grove of beautiful hybrid chestnuts. Conifer Knoll is home to champion firs, a grouping of large persimmons, and a group of large Atlas cedars, one of which is a state champion.

There is a fine view of the Topiary Garden from the royal paulownia allée.

Tree Map: Longwood Gardens

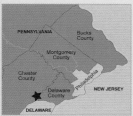

An abundance of tree specimens awaits you at Longwood Gardens, where even the overflow parking area has state champion trees. Only some of the garden's state champions are shown here—especially in the Oak and Conifer Knolls. Many champions near the Peirce-du Pont House are also historic tree specimens planted by Peirce himself. There is an impressive allée of smoothleaf elms (Ulmus carpinifolia) along Conservatory Road to the west, not pictured on this map.

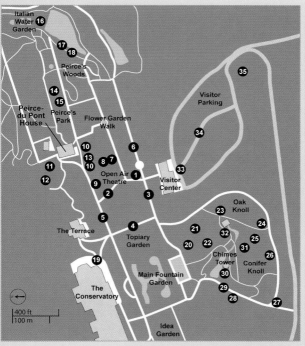

KEY TO TREES ON MAP:

1. American elm.
2. Kousa dogwoods.
3. White oak allée.
4. Royal paulownia allée.
5. Impressive row of copper beeches.
6. Baldcypress allée includes no. 2 on the state champion list.
7. State champion Chinese scholartree.
8. Original Peirce specimen Carolina silverbell.
9. Original Peirce specimen sugar maple.
10. Two large ginkgos date back to Peirce's time.
11. Group of franklinias.
12. Grove of sawtooth oaks.
13. National champion cucumber magnolia var. *subcordata.*
14. Cucumber magnolia.
15. Peirce's Park has hemlocks, sugar maples, cherry birches, Kentucky coffeetrees, and tuliptrees, among others.
16. Littleleaf linden allée.
17. State champion dawn redwood.
18. Large white ash.
19. English yew.
20. Rare grouping of large American beeches.
21. Group of large chestnuts.
22. State champion Dutch elm 'Major.'
23. Shumard oak.
24. Huge European beech.
25. State champion white spruce.
26. Momi fir in group of momi firs is a state champion.
27. Group of large Atlas cedars; one is a state champion.
28. Paperbark maple.
29. Group of river birches on either side of the path.
30. Canadian hemlock.
31. Dawn redwood.
32. Group of weeping Higan cherries.
33. Row of katsuratrees.
34. Honeylocust allée.
35. State champion Kwanzan and Higan cherries in the overflow parking lot.

Scott Arboretum

500 College Avenue
Swarthmore, PA 19081

The Scott Arboretum of Swarthmore College was established on the college campus in 1929 as a memorial to Arthur Hoyt Scott. John Caspar Wister, the first director of the arboretum from 1929 to 1969 created one of the most spectacular college landscapes in the United States. The arboretum comprises over 300 acres, showcasing 4,000 kinds of plants suitable for Delaware Valley gardens. It has collections of tree peonies, quinces, cherries, roses, viburnums, maples, witch hazels, crabapples, hollies, conifers, lilacs, azaleas, and rhododendrons.

The outstanding magnolia collection, the majority of which are located near the Benjamin West House, includes 130 different taxa and is in peak bloom in the first two weeks of April. The cherry border, first planted in 1931, now includes over 50 types of ornamental cherries and provides a long-blooming sequence beginning in early April. A pinetum includes pines, spruces, firs, and cedars. Two huge deodar cedars, an Atlantic cedar, and a cedar of Lebanon planted in close proximity near Sharples Dining Hall make for easy comparison. The other side of the building has a group of beautiful paperbark maples.

Magill Walk, the central axis from the train station into the campus, is impressive with its allée of swamp white oaks, originally planted in 1881. Nearby are a weeping katsuratree and a Kentucky coffee tree. An allée of dawn redwoods next to the Lang Performing Arts Center is underplanted with white flowering shrubs and perennials and is splendid in fall. A mature canopy of tuliptrees creates a high ceiling for campus performances and events at the Scott Amphitheater, with a surrounding evergreen screen of hollies, spruces, and red cedars. Behind the amphitheater, Crum Woods offers walking trails through 200 acres of native woodlands along Crum Creek. Several specialty gardens and courtyards house lovely tree specimens, including a katsuratree in the Isabelle Cosby Courtyard and 'Heritage' river birches in the Harry Wood Courtyard Garden. There are striking, mature specimens of many other tree species to discover as well: parrotias, black tupelos, ginkgos, beeches, larches, Austrian pines, golden larches, bur oaks, lindens, Japanese zelkovas, and American elms.

Trees in a dawn redwood allée, planted in 1997, zigzag a bit to dodge utility lines.

Tree Map: Scott Arboretum

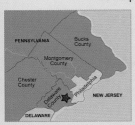

The tree walk begins as one proceeds from the SEPTA Swarthmore station up Magill Walk through the allée of swamp white oaks. To the west and around Sharples Dining Hall are superb conifer collections. Walk through the yellow magnolias and tree peonies toward Scott Amphitheater with its towering tuliptrees. From there you are close to the impressive dawn redwood allée. Pick up more information at the Arboretum offices near the flowering cherry border.

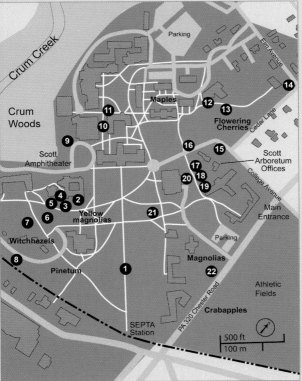

KEY TO TREES ON MAP:

1. Allée of swamp white oaks originally planted in 1881.
2. Silver linden, 1886 class tree.
3. Pin oak planted in 1932 by Jane Addams.
4. Japanese nutmeg tree.
5. Ginkgo.
6. Kentucky coffeetree planted in 1946.
7. Himalayan pine.
8. State champion American elm.
9. State champion tuliptree.
10. Dawn redwood allée.
11. Scarlet oak.
12. Weeping Higan cherry in cherry border.
13. Black oak likely over 100 years old.
14. State champion Chinese toon tree planted in 1932.
15. Austrian pines.
16. Red oak planted in 1919.
17. American elm planted in 1879.
18. Mossy-cup oak, 1876 class tree.
19. American linden, 1874 class tree.
20. American elm.
21. State champion Japanese maple var. *dissectum*.
22. Northern catalpa.

Tyler Arboretum

515 Painter Road
Media, PA 19063

One of the oldest arboreta in the Northeast, the 650-acre Tyler Arboretum was part of a land purchase from William Penn in 1681 by English Quaker Thomas Minshall. The wooded land interspersed with meadows and wetlands was in the Minshall-Painter-Tyler family for eight generations. Beginning in 1825, the Painter brothers, Jacob and Minshall, laid the foundation for the arboretum by planting many varieties of trees and shrubs on the property. Twenty-two of the almost 2,000 plants the Painter brothers planted are still alive today and five are state champions. In 1944 the estate was bequeathed to the public. John Caspar Wister, director of the nearby Scott Arboretum, became the director of the Tyler Arboretum as well. John and his wife Gertrude maintained and improved the natural areas at Tyler and began the spectacular rhododendron collection, as well as collections of magnolias, cherries, crabapples and lilacs.

The Painter collection of trees behind the Barn and Lachford Hall includes a spectacular cedar of Lebanon and a very large ginkgo. A nearby Atlas cedar is also impressive. Four native trees from the Painter era or earlier remain today: two giant tuliptrees and two white oaks. The 85-acre Pinetum includes good specimens of spruces, hemlocks, larches, golden-larches, cedars, firs, and pines. The giant sequoia near the Pinetum was planted by the Painter brothers and is a state champion. Twenty species and varieties of ornamental cherries, most donated by the Scott Arboretum, are gorgeous in spring, especially the Yoshinos along Painter Road. The crabapple collection boasts over fifty trees of more than thirty species and varieties. The magnolia collection also includes many lovely specimens that contribute to the abundance of spring blossoms. In addition, the Arboretum has hundreds of acres of native woodlands accessible by trails and is contiguous with Ridley Creek State Park.

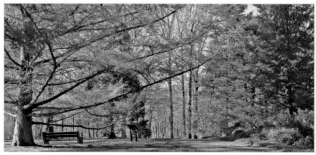

A beautiful, wide-limbed golden-larch provides glorious fall color along the Scenic Loop in the Pinetum of the Tyler Arboretum.

Tree Map: Tyler Arboretum

PENNSYLVANIA

Bucks County

Montgomery County

Chester County

Philadelphia

Delaware County

NEW JERSEY

DELAWARE

*This tree walk centers around the amazing Painter collection behind Lachford Hall, the Painter Library, and the Barn. Trees with a **P** next to them were planted by the Painter brothers. A number are state champions and some are outstanding specimens. Walk through the extensive Pinetum and finish with the special lilac, magnolia, cherry, and crabapple collections near the visitor center.*

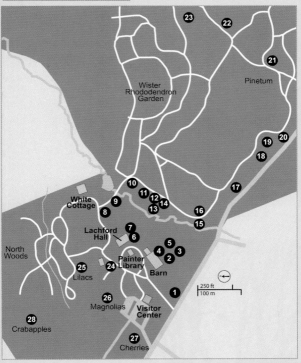

Wister Rhododendron Garden

Pinetum

White Cottage

Lachford Hall

North Woods

Painter Library

Barn

Lilacs

Magnolias

Visitor Center

Cherries

Crabapples

250 ft
100 m

KEY TO TREES ON MAP:

1. Large tuliptree.
2. Atlas cedar.
3. Sweetbay magnolia.
4. Huge cedar of Lebanon. *P*
5. Oriental spruce. *P*
6. Ginkgo. *P*
7. Yulan magnolia. *P*
8. Tuliptree.
9. Baldcypress. *P*
10. American linden. *P*
11. Pear. *P*
12. Fraser magnolia. *P*
13. Yellow buckeye. *P*
14. Tuliptree.
15. Pair of white oaks; could pre-date Painters.
16. Grouping of spruces.
17. Eastern white pines planted along Painter Rd. *P*
18. London planetree.
19. Baldcypress.
20. Giant sequoia. *P*
21. Larch.
22. Japanese white pine.
23. Deodar cedars.
24. Weeping Sargent's hemlock.
25. Lilac collection.
26. Magnolia collection.
27. Cherry collection.
28. Crabapple collection.

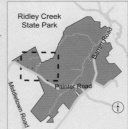

Ridley Creek State Park

Barren Road

Middletown Road

Painter Road

Tyler Arboretum

Chanticleer

786 Church Road
Wayne, PA 19087

Chanticleer is a horticultural gem, a beautifully planted and expertly maintained 35-acre garden in Wayne. Once the private residence of the Rosengarten family, it was opened to the public in 1993 and can be enjoyed from April through October. The horticultural artistry and whimsy on display at Chanticleer are remarkable. There is always something new to see—from innovative new plantings to garden art and garden furniture built by the staff. There are ecological innovations as well, such as a path made of shredded tires.

Chanticleer is known for its perennial and annual displays, but since the 1990s hundreds of trees have been planted around the property and in the surrounding neighborhood. Black walnuts, which predate the Rosengartens' ownership of the property beginning in 1912, mark an old farm road. A pair of katsuratrees planted side by side near the cutting garden provide a special example of male and female trees. From a magnificent Chinese dogwood below the Chanticleer House to a large multi-trunked sweetbay magnolia in the Tennis Court Garden, flowering trees abound. The Orchard has magnolias, crabapples, and flowering cherries among thousands of daffodils that bloom in April.

Minder Woods has red oaks, a grove of eastern white pines, falsecypresses, firs, and hemlocks. Across from the Ruin Garden is a mature grove of sourwoods. The Asian Woods consists

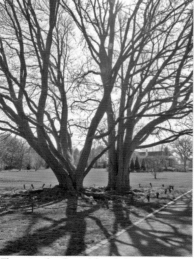

mostly of non-native understory and groundcover plants beneath a canopy of American natives such as tuliptrees, red maples, sycamores, ashes, and beeches. Bell's Woodland is also comprised of eastern North American tree species, including sweetgums, beeches, flowering dogwoods, and redbuds. Near the Cut Flower Garden, a grove of flowering cherries stands by the visitor picnic tables.

The pair of male and female katsuratrees
flower in April before their leaves unfold.

Haverford College Arboretum

370 Lancaster Avenue
Haverford, PA 19041

In 1834, an English gardener named William Carvill designed a plan for the grounds of Haverford College based on English landscape design practices of the time. Today the entire 216-acre campus is an arboretum reflecting his vision. The arboretum's special attractions are the allées of trees lining roads and paths and the swaths of lawn dotted with spectacular specimen trees. A few original trees planted by Carvill still exist on the campus today—in particular a swamp white oak near Roberts Hall and a beautiful, big bur oak by Magill Library, dating back to 1834. Upwards of 1,500 trees are labeled across the college campus, which includes a Pinetum, a duck pond, a 2.2-mile nature trail encircling the campus, and many specialty gardens.

The most historically significant tree on campus is a Penn Treaty Elm that looks out over the Duck Pond behind Barclay Hall. It is a direct descendant of the elm under which William Penn reportedly made a treaty with the Lenape Indians in 1682. Cuttings from this Haverford tree were used to grow the American elm now planted near the location of the original tree at Penn Treaty Park in Philadelphia.

Begun in 1928, Haverford's Ryan Pinetum boasts over 300 specimens of conifers: cedars, spruces, pines, larches, junipers, arborvitae, and yews, to name a few. Many of Haverford's fourteen state champion trees can be found in the Pinetum. The campus has in total six state champion spruces. The state champion red oak by Stokes Hall has impressive girth and is 100 feet tall. The champion Hinoki falsecypress by Barclay Hall is 75 feet tall. A rare *Hemiptelea* by the Duck Pond is also a state champion.

Among other particularly notable trees are a mature allée of century-old ginkgos and a mature allée of swamp white oaks. The college entrance is lined with red oaks mixed with scarlet oaks, sugar maples, sweet gums, and an occasional black walnut.

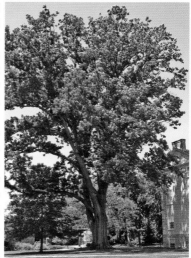

The scarlet oak next to Founders Hall is 98 feet tall with a 73-inch diameter trunk.

Taylor Arboretum

10 Ridley Drive
Wallingford, PA 19086

The Taylor Arboretum of Widener University (formerly the Taylor Memorial Arboretum) is a 30-acre horticultural garden situated on Ridley Creek downstream from Ridley Creek State Park. It was originally a private estate gifted to the public in 1946. Most of its specimen trees were planted in the 1950s by Anne Rulon Gray and her husband Joshua C. Taylor. Not a formal or very manicured garden, it has collections of hollies, Japanese maples, and magnolias, as well as a number of other specimen trees. These include a stewartia, a paperbark maple, a lacebark elm, witchhazels, a Pfitzer juniper, ginkgos, an

American hornbeam, and a lacebark pine. There are native pawpaws, hickories, and sycamores as well as a state champion sawtooth oak. A vernal pond with baldcypresses experienced a hydrological change when a dam was removed. Water is now pumped in to mimic the previous hydrology.

Baldcypresses with knees–woody projections that grow up from their roots–cluster by a small vernal pond.

Brandywine River Museum of Art

1 Hoffman's Mill Road
Chadds Ford, PA 19317

Opened in 1971 by the Brandywine Conservancy, the Brandywine River Museum of Art occupies an old grist mill on the Brandywine River. The Conservancy's buildings adjacent to the museum are surrounded by native plant gardens. A walk beginning at the museum leads visitors along the banks of the river through a riparian woodland. Sycamores mingle with silver maples, river birches, and boxelders, mixed with occasional swamp white oaks, ashes, black walnuts, elms, and hickories. Look for a large, beautiful black tupelo.

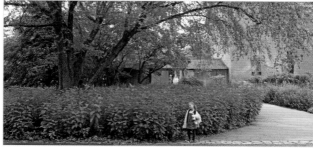

A river birch greets visitors to the Brandywine River Museum of Art. Riverine trees such as sycamores and boxelders are common here.

Ridley Creek State Park

1023 Sycamore Mills Road
Media, PA 19063

Ridley Creek State Park comprises 2,600 acres of meadows and woodlands in Delaware County. Old-growth and second-growth forests, wetlands, and the riparian corridor along Ridley Creek offer many opportunities for hiking and tree exploration. The park is primarily a red oak and mixed hardwood forest dominated by oaks, beeches, and hickories. Successional forests include tuliptrees and red maples. Sycamores and silver maples can be found in wet areas. The park includes the historic Jeffords estate with Hunting Hill Mansion and formal Olmsted-designed gardens: a rose garden, topiary garden, and fountain garden surrounded by junipers. A huge pin oak welcomes visitors at the gate to the mansion. Large yews, sycamores, and oaks stand behind the house. The park is also home to the state champion black oak.

The fountain garden is framed by lines of closely planted junipers to great effect.

Cabrini University

600 King of Prussia Road
Radnor, PA 19087

Originally a Roman Catholic liberal arts college founded in 1957, Cabrini University encompasses 112 acres surrounded by native woodland in the Main Line suburb of Radnor. Located on the former estate of John Dorrance of the Campbell Soup Company, Cabrini includes the turn-of-the-century Woodcrest Mansion designed by Horace Trumbauer. The college campus has more than fifty species of trees, some considered state champions. The most impressive are a group of majestic oaks west of the Woodcrest Mansion: a chestnut oak (*Quercus montana*), a white oak (*Quercus alba*), and a black oak (*Quercus velutina*). Three huge English yews grace the lawn in front of the house.

West of Woodcrest Mansion are a very large chestnut oak, a white oak, a black oak, and a black tupelo that turns to gorgeous reds and golds in fall.

Winterthur

5105 Kennett Pike,
Winterthur, DE 19735

Winterthur, the former estate of Henry Francis du Pont, a collector and horticulturalist, is one of the premier museums of American decorative arts in the country. The surrounding landscape and gardens are equally important as works of art themselves. The 60-acre garden near the house blends into the thousand acres of wild woodlands, meadows, and streams of the surrounding Brandywine Valley. While there are formal garden rooms and sequences, most of the tended grounds are designed to feel "wild." Exotics are planted in masses among native plants as if they occurred naturally.

From the visitor center, begin your explorations in the eight-acre Azalea Woods. The canopy consists of many mature and some very old white oaks, tuliptrees, and American beeches. The understory of flowering dogwoods, azaleas, and rhododendrons are often planted in gaps left when American chestnut trees died during the chestnut blight in the early 20th century. Since du Pont chose plants with color in mind, the succession of spring and summer flowers at Winterthur is spectacular. While some of the most showy plantings are bulbs, perennials, and shrubs, you will find an abundance of flowering trees such as dogwoods, redbuds, crabapples, and magnolias throughout the grounds.

Across from the saucer magnolias at Magnolia Bend are two gorgeous old Sargent cherries. At the Pinetum there are a state champion Nikko fir and dawn redwood, and a number of impressive cedars, spruces, arborvitaes, and falsecypresses. A massive 200-year-old London planetree stands at the base of Sycamore Hill. At the top of the hill beyond a split-rail fence is a glorious serviceberry allée. On the near side of the fence are Japanese maples and kousa dogwoods. There are large old tuliptrees throughout the estate; one along Conservatory Road is a state champion. Near the Enchanted Woods there is a former state champion pawpaw. Other notable trees include goldenraintrees, royal paulownias, a Chinese scholartree, a beautiful, large Atlantic cedar, and the first dove tree (*Davidia involucrata*) to flower in the United States.

Some of the saucer magnolias at Magnolia Bend were planted in 1875.

Tree Map: Winterthur

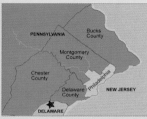

A tree walk might start with the stately eastern white pines around the parking lot and the Japanese maple at the visitor center. Visitors often board a trolley for the garden tour. A stop after Magnolia Bend provides a view of two venerable Sargent's cherries before the Pinetum. Stroll through Sycamore Hill with its beautiful kousa dogwoods, Japanese maples, and buckeyes. Don't miss the serviceberry allée nearby.

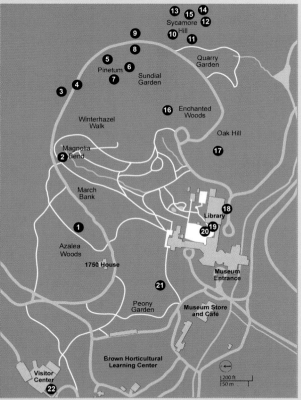

KEY TO TREES ON MAP:

1. Native white oaks, tulip-trees, and American beeches dominate the Azalea Woods.
2. Saucer magnolia varietals.
3. Two old Sargent cherries.
4. Higan cherry.
5. State champion Nikko fir.
6. Open-grown Atlas cedar.
7. The Pinetum has Oriental spruce, cedars, falsecypresses, and white firs, among others.
8. State champion dawn redwood.
9. Two old gnarly paulownias.
10. Beautiful sycamore.
11. Redbuds.
12. Buckeye and fringetree.
13. Kousa dogwoods and Japanese maples.
14. Serviceberry allée.
15. Falsecypress.
16. Past champion pawpaw.
17. Oak Hill has white, scarlet, and Bartram oaks.
18. Norway maples.
19. Dove tree.
20. Weeping Norway spruce.
21. A state champion tulip-tree stands among many other large specimens.
22. Japanese maple.

Mt. Cuba Center

3120 Barley Mill Road
Hockessin, DE 19707

A profusion of flowering trees and wildflowers make Mt. Cuba Center a must-see in spring. The former home of Pamela C. and Lammot du Pont Copeland, the 583-acre center offers 20 acres of mostly naturalistic gardens showcasing the native plants of the Piedmont region. Mt. Cuba focuses on land stewardship and conservation through preservation of native plants. A trial garden and research program promote gardening with native plants by encouraging them in the nursery trade.

The Copelands' brick Colonial Revival mansion still sits atop the hill, welcoming visitors. It is surrounded by formal gardens designed by Thomas Sears and Marion Coffin. Two lovely willow oaks grace the east terrace. On the south terrace, two espaliered Southern magnolias and two hophornbeams look out over the formal garden toward a 'Winter King' hawthorn that is nearly ten years old. Two allées of scarlet oaks frame these formal gardens; one is recently planted. A healthy ten-year-old franklinia grows near a sourwood along the front drive.

Cultivated on former cornfields that surrounded the house, the woodland gardens are a preserve for native trees and wildflowers. The canopy is primarily tuliptrees with some oaks and hemlocks (although many of these are succumbing to the woolly

adelgid, an aphid-like insect). The woodland understory layers are spectacular. Smaller trees, including umbrella magnolias, stewartias, redbuds, pawpaws, and a dogwood collection, are accompanied by a proliferation of shrubs and wildflowers. The trillium garden has two Carolina silverbell species that bloom along with thousands of rare and common trilliums in spring. Along the West Slope Path, three eastern white pines have multi-trunked "witches' broom" habits.

The Woods Path winds beneath tall tuliptrees and past a succession of wildflowers and shrubs such as oakleaf hydrangea.

Nemours Estate

850 Alapocas Drive
Wilmington, DE 19803

Industrialist, financier, and philanthropist Alfred I. du Pont's former mansion and gardens, Nemours, share the 300-acre grounds with the Alfred I. duPont Hospital for Children. Du Pont named his estate after his family's ancestral home in France. In keeping with its name, the mansion resembles a chateau with the gardens modeled after those around the Petit Trianon at Versailles. The formal French gardens include a parterre garden, reflecting pool, grotto, maze garden, fountains, and promenades framed by allées of trees. The central axis of the estate leading from the house toward the Temple of Love near the visitor center is an impressive ⅓-mile long. The most formal elements of the gardens are along this axis and near the house. Evergreen screens and English cottage perennial plantings provide transitions into the surrounding second-growth woods.

The recently built visitor center is landscaped with native trees. Red maples and redbuds line the entrance drive along the stone wall. As the drive swings toward the house, it proceeds through an allée of red maples. Norway spruces, mixed with dogwoods, cherries, crabapples, and dawn redwoods, create an evergreen border between the garden and the hospital. Oriental spruces screen the drive from the Temple of Love that is itself framed by pin oaks and Sargent's cherries. A triple allée between the house and the reflecting pool is comprised of cryptomeria flanked by red horsechestnuts and pin oaks. There is a linden and horsechestnut allée, a narrow linden allée, and a Chinese elm allée near the house.

Next to the parterre garden is an old tuliptree known as Alfred's poplar tree. His childhood favorite, it is said to have determined the location of the house. South of the Temple, a spectacular weeping beech grows close to a large tuliptree. A singular giant sequoia is located near the greenhouses. Beyond in the Brandywine Woods are native beeches, tuliptrees, oaks, and here and there naturalized stands of Japanese maples.

The main axis of the garden is framed by a triple allée of cryptomeria, horsechestnuts, and pin oaks.

Goodstay Gardens

2700 Pennsylvania Avenue
Wilmington, DE 19806

Goodstay Gardens, now a part of the University of Delaware, is another historic du Pont family garden open to the public. It is worth a stop to see this lovely example of a small early colonial garden divided into garden rooms by old boxwood hedges. There is a peony garden, an iris garden, and a rose garden, along with a less manicured wooded "park" and a magnolia walk. A few beautiful large trees remind the visitor of the garden's age: a ginkgo as old as the house shades the terrace and a great white ash towers next to the sculpture studio. There are also beeches, sycamores, elms, southern

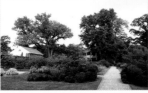

magnolias, and black tupelos. The peony garden has a large redbud, and the knot garden also has tree peonies. Most of the 30 magnolias along the magnolia walk to the reflecting pool were replaced with *Magnolia* × *soulangeana* 'Verbanica' in 2009.

A white ash and a large ginkgo frame the house at Goodstay.

Hagley Museum and Library

200 Hagley Creek Road
Wilmington, DE 19807

Home to fifteen Delaware state champion trees, Hagley Museum and Library encompasses 235 acres on the banks of the Brandywine River. The site of the du Pont family's original ancestral home and gunpowder works, this is where the DuPont Company began. A glimpse of the industrial history of the United States is found alongside the native trees of the Brandywine. Oaks, sycamores, tuliptrees, American

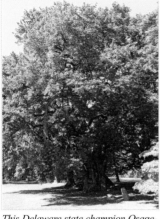

beeches, hickories, ashes, red and black oaks, sassafras, and black walnuts abound. The gardens near the house have remnants of formal plantings from the past century. A beautiful old sweetgum allée is left over from the original entry road to the estate near a grove of four majestic willow oaks, European beeches, and an enormous hemlock hedge. Chinese chestnuts line the barn road near a tremendous Osageorange. Espaliered fruit trees surround the E. I. du Pont Garden.

This Delaware state champion Osageorange is 100 inches in diameter.

Rockwood Park and Museum

4651 Washington St. Extension
Wilmington, DE 19809

The six acres of gardens at Rockwood Mansion (now a museum) were originally planted by Quaker Joseph Shipley and are part of the 72-acre Rockwood Park. The house and gardens were in the Shipley and Bringhurst families from 1851 to 1965. The families had a tradition of planting trees to commemorate birthdays, resulting in an eclectic collection of historic trees. The north lawn has many very old tree specimens that have grown to impressive size. A big female ginkgo, an Atlas cedar, and an eastern hemlock stand on the lawn along with a state champion black tupelo. The tupelo is a spectacular specimen that was apparently hit by lightning but is still standing in all its glory. Old photographs show the tupelo being planted with a horse and buggy nearby.

The kitchen garden has climbing roses planted in the 1920s, as well as a bigleaf magnolia, an umbrella magnolia, and an impressive weeping hemlock. Three yew varieties—*Taxas baccata* 'Repandens,' 'Adpressa,' and 'Fastigiata'—are planted in close proximity allowing for easy comparisons. A large American holly grows nearby on the edge of the north lawn.

As you walk around the house, past the conservatory and toward the south lawn, an eastern hemlock and a Carolina hemlock are planted side by side with a big eastern white pine. The south lawn is surrounded by a southern magnolia and a number of conifers: a deodar cedar, an American holly, and a Nordmann fir, along with an upright yew and a weeping hemlock.

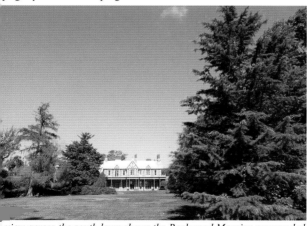

A view across the south lawn shows the Rockwood Mansion surrounded by some of its heritage conifers. A southern magnolia and larch are planted close to the house with a deodar cedar in the foreground.

N.J. Pinelands National Reserve

15 Springfield Road, #C
Hammonton, NJ 08037

The New Jersey Pinelands National Reserve, comprising most of the area known as the Pine Barrens, is the largest open space on the Mid-Atlantic seaboard between Boston and Richmond, Virginia. It encompasses 1.1 million acres of farms, pine and oak forests, wetlands, and bogs interspersed with historic villages and suburbs. Parts of it are less than an hour from downtown Philadelphia. Established in 1978, the reserve includes five state forests, several wildlife management areas, and the largest pitch pine lowland in the world. The 122,880-acre Wharton State Forest is a good place to start exploring. You will find over 80 miles of marked trails for hiking, hundreds of miles of sand roads, and a number of rivers for canoeing through the forest.

The Pine Barrens is characterized by nutrient-poor, sandy, acidic soils. Frequent fires have created a unique ecosystem dominated by pine and oak trees adapted to these conditions. Dwarf pine forests of pitch pine and blackjack oak thrive where fires are most frequent. Resins in the pines make the trees very flammable, and they reproduce best after fire. In areas with less fire, often because of proximity to development, forests are dominated by black, scarlet, chestnut, white, and post oaks, along with pitch and shortleaf pines.

The low elevation and therefore closeness to the water table means that almost one-quarter of the New Jersey Pinelands is comprised of wetlands, bogs, and swamps along shallow, tannin-stained rivers. Farming in the Pine Barrens historically consisted of cranberry bogs at lower elevations and blueberry fields at higher elevations. At Black Run Reserve, visitors can see a former cranberry bog that is now a cedar swamp forest dominated by Atlantic white cedar with red maples, sweetbay magnolias, pitch pines, sassafras, sweet gums, gray birches, and black tupelos.

Historic Batsto Village was a bog-iron and glass manufacturing center. It has a visitor center and nearby wooded trails.

Extensive portions of the Pine Barrens are covered with pines and oaks, such as pitch pines and scrub oaks, interspersed with vernal grassy meadows.

Grounds For Sculpture

80 Sculptors Way
Hamilton Township, NJ 08619

No garden in the area comes close to Grounds For Sculpture for its imaginative use of trees. Since its founding in 1992 by J. Seward Johnson, more than 2,000 trees have been planted on the 42-acre site that was once the New Jersey State Fairgrounds. The park showcases contemporary sculpture and is also an arboretum. In some instances, the plantings are as much works of art as the sculptures themselves. Plantings of species in groups, often arranged geometrically, create some spectacular effects. A bosque of crabapples straddles the parking lot close to the museum. The courtyard near the café is a magical grove of Japanese maples. A densely and narrowly planted allée of red maples creates a tunnel that is best experienced in its red fall

glory. Baldcypresses and dawn redwoods are used to great effect in a grove nearby; their fall color is also unmatched. There is a river birch allée, a circle of columnar sweetgums, and a circle of maples. Look for spruces, birches, Atlas cedars, cherries, beeches, sycamores, cryptomeria, elms, honeylocusts, and a variety of weeping cultivars.

A William T. Wiley sculpture sits in a baldcypress and dawn redwood grove.

Barton Arboretum of Medford Leas

1 Medford Leas
Medford, NJ 08055

Barton Arboretum and Nature Preserve comprises over 250 acres of a retirement community located on two campuses in Medford and Lumberton. Trees are labeled and visitors are welcome to walk through the campuses. There are ginkgos, pines, river birches, dogwoods, horsechestnuts, elms, and baldcypresses, among others.

Perhaps the most interesting part of the site is the woods on the Medford Campus, located in a transitional area between the fertile inner coastal plain and sandy outer coastal plain. Walk through a remnant of a beech, oak, and hickory forest with a sweetgum stand where a farmhouse used to be.

Woodland trails at Medford Leas cross tributaries of Rancocas Creek.

Additional Sites

There are many more green spaces in Philadelphia and the surround
ing counties to explore. For the avid tree lover, we add these twent
sites to the previous forty-nine. Some are small pocket parks with on
specimen tree that makes a stop worthwhile, while others are schoo
campuses, historic estates, or large natural areas with woods for hik
ing, mountain biking, or picnics. Let the tree explorations continue!

Name	Size	Description
Philadelphia		
Belfield Estate *2100 Clarkson Avenue* *Philadelphia, PA 19144*	104 acres	Formerly the home of artist Charles Willson Pea the Belfield Estate is now part of the La Salle University campus. Look for bottlebrush buckeye and a dawn redwood south of the house.
Clifford Park *6100 Wissahickon Avenue* *Philadelphia, PA 19104*	6 acres	Thomas Mansion's gardens at Clifford Park have fallen into disrepair, but a lovely quercetum remai along the entry drive. There is a swamp white oa a katsuratree, and a birch near the house.
Cobbs Creek Golf Course *7400 Lansdowne Avenue* *Philadelphia, PA 19151*	400 acres	This public golf course has large Chinese elms, huge hemlock, a pitch pine, and big black cherrie Near the golf shop there is a Turkey oak more th 4 feet in diameter and a line of chestnut oaks.
Cobbs Creek Park *63rd and Catharine Streets* *Philadelphia, PA 19143*	850 acres	The park follows 11.8 miles of Cobbs Creek in West Philadelphia with many trails for hiking through a second-growth riparian forest. Adjace Morris Park has American chestnuts.
Hunting Park *Old York Road and West Hunting Park Avenue* *Philadelphia, PA 19140*	87 acres	This North Philadelphia park has a very large wil oak located on Old York Road near the park entrance. A number of other specimen oaks and exceptional black tupelo make a visit worthwhile.
Jefferson Square Park *4th Street and Washington Avenue* *Philadelphia, PA 19147*	3 acres	Used as an encampment site in the Civil War, Jefferson Square was renovated in the 1870s along with Rittenhouse Square. Look for an esp cially magnificent Kentucky coffeetree.
John F. Collins Park *1707 Chestnut Street* *Philadelphia, PA 19103*	<1 acre	Designed in the 1970s by John F. Collins, this delightful pocket park is an oasis in Center City. has pawpaws, a pagoda dogwood, a franklinia, redbuds, and a spicebush.
John Heinz National Wildlife Refuge *8601 Lindbergh Boulevard* *Philadelphia, PA 19153*	1,000 acres	Run by the U.S. Fish and Wildlife Service, this refuge preserves the largest remaining freshwat tidal marsh in Pennsylvania and has woods, ponds, and meadows to explore.
Marconi Plaza *W. Oregon and W. Moyamensing Avenues* *Philadelphia, PA 19112*	19 acres	An English elm 5 feet in diameter and an allée c lindens grace this South Philadelphia park that was designed in 1904. The surrounding sidewal are lined with large maple tees.
Stenton *4601 N. 18th Street* *Philadelphia, PA 19140*	3 acres	This historic house and garden was the founding site for the Garden Club of America in 1913. The colonial revival garden has a large yellowwood a a very large, impressive American sycamore.
Tacony Creek Park *Ramona Avenue and I Street* *Philadelphia, PA 19120*	302 acres	This narrow park straddles the banks of Tacony Creek on its way to Frankford Creek. Look for American plum trees, some especially fine black tupelos, and a *Chionanthus virginicus*.
Bucks County		
Five Mile Woods Nature Preserve *1305 Big Oak Road* *Yardley, PA 19067*	285 acres	This preserve crosses the fall line between the Piedmont Plateau and the Coastal Plain, resulti in a unique plant community. A good place to se sweetgums and willow oaks in the wild.
Tyler Formal Gardens *275 Swamp Road* *Newtown PA 18940*	1 acre of 200-acre campus	At Bucks County Community College, this four-tiered garden has white oaks and espaliered pears on the upper terrace. There are hollies, dogwoods, magnolias, and lindens below.

A large, open-grown elm at Marconi Plaza stands by itself in the western half of the park. It is 70 feet tall and 5 feet in diameter.

Name	Size	Description
Montgomery County		
Appleford 770 Mt. Moro Road Villanova, PA 19085	24 acres	A 300-year-old farmstead is currently an arboretum and bird sanctuary. Look for birches, Norway spruces, and an allée of dogwoods. There is a big red oak behind the house.
Delaware County		
The American College of Financial Services 270 S. Bryn Mawr Avenue Bryn Mawr, PA 19010	5 landscaped acres	The campus is owned by Jack M. Barrack Hebrew Academy. A path behind the college has a copper beech, a catalpa, a dawn redwood, and a franklinia. American beeches line the creek.
The Grange Estate 143 Myrtle Avenue Havertown, PA 19083	10 acres	An historic mansion begun in the 1700s has had many owners through the years. The estate has a large stand of pawpaws, a *Pterostyrax*, plentiful *Staphylea*, and a very large copper beech.
Henry Foundation for Botanical Research 801 Stony Lane Gladwyne, PA 19035	50 acres	In 1948, botanist Mary Gibson Henry founded this unique botanical garden to house specimens from her plant explorations. There are native magnolias, stewartias, Carolina silverbells, and more.
Delaware		
University of Delaware Botanic Gardens 531 South College Avenue Newark, DE 19716	20 acres of the campus	Specialty gardens, a wetland, and a fragment of woods make up this botanical garden. The native garden has bur oaks, baldcypresses, dogwoods, river birches, sassafras, and red maples.
New Jersey		
Camden Children's Garden 3 Riverside Drive Camden, NJ 08103	4.5 acres	A theme garden offers educational play for kids with a backdrop of lovely plantings. Look for zelkovas, serviceberries, dawn redwoods, river birches, weeping willows, a paperbark maple, and more.
The Lawrenceville School 2500 Main Street Lawrenceville, NJ 08648	700 acres	This park-like campus was designed in 1883 by Fredrick Law Olmsted, and some of the trees he planted survive today. Pick up a copy of the guide *The Trees of Lawrenceville* at the school library.

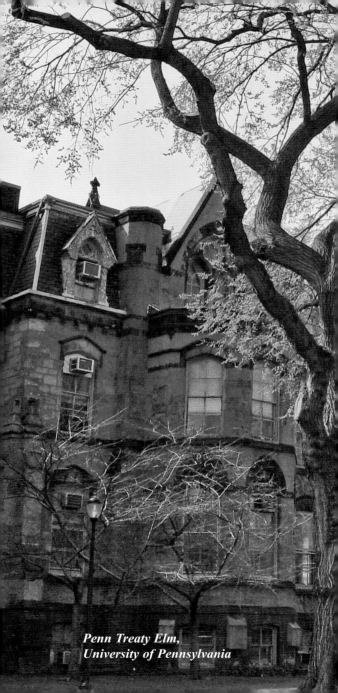

Penn Treaty Elm,
University of Pennsylvania

Fifty Philadelphia
Great Trees

Fifty Philadelphia Great Trees

Among Philadelphia's thousands of trees, there are a few with unusual sizes, ages, forms, rarity, or historic associations that distinguish them from the rest. The Pennsylvania Forestry Association has an online list titled "Champion Trees of Pennsylvania" describing the largest specimens in the state. Using the association's excellent list and adding specimens encountered during our tree explorations, we have come up with our own list of fifty noteworthy trees, all located within the boundaries of the city. Among them are some of the first exotic tree species imported into this country, as well as native species that have always grown here. A few are very rare; some are quite common. One listed tree, Penn Treaty Elm, serves as a living reminder of earlier times because it carries DNA from a specific tree alive before the American Revolution (see p. 14). All our listed trees grow in botanical gardens, parks, cemeteries, and along streets. Our list includes just 50 trees. We readily admit that it is somewhat subjective, based in part on our personal preferences.

Center City and South Philadelphia

Name	Diam. (in.) / Ht. (ft.)	Location and Other Details
American Elm *Ulmus americana*	72/87	This state champion American elm at Girard College is one of the largest and most spectacular in the metropolitan area.
American Sycamore *Platanus occidentalis*	56/83	On 6th Street along Washington Square stands a fine example of an American sycamore, probably the biggest in Center City.
Franklinia *Franklinia alatamaha*	NA/25.5	Planted in 1951, the franklinia in the garden on the Pine Street side of Pennsylvania Hospital is one of the largest in the region.
London Planetree *Platanus × acerifolia*	61/104	This large London planetree in Washington Square near Walnut Street rivals the state champion in size.
Osage-oranges *Maclura pomifera*	35+/40+	The Osage-oranges in St. Peter's Episcopal Church's cemetery at 3rd and Pine Streets constitute the city's largest grouping.
Swamp White Oak *Quercus bicolor*	48/63	One of two huge swamp white oaks at FDR Park, this tree is on the banks of the Meadow Lake to the west of the boathouse.
Yoshino Cherry *Prunus × yedoensis*	20+/23+	The gorgeous Yoshinos between Kelly Drive and the Schuylkill River are among the oldest specimens in the city.

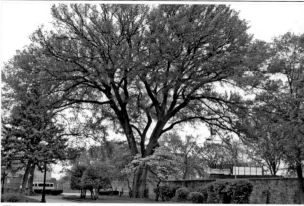

This spectacular state champion American elm at Girard College stands next to the wall along Ridge Avenue near West Thompson Street.

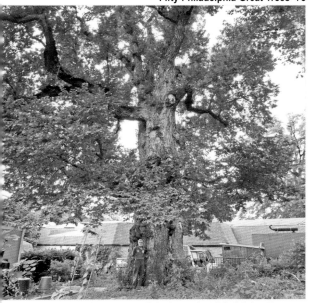

This enormous state champion English elm at the Philadelphia Zoo is said to have been planted by John Penn and could be over 200 years old.

West Philadelphia

Name	Diam. (in.) / Ht. (ft.)	Location and Other Details
American Yellowwood *Cladrastis kentukea*	55/31	A 200+-year-old tree at Bartram's Garden was the first in Philadelphia; it is recovering from 2010 storm damage.
American Elm *Ulmus americana*	59/81	This beautiful American elm planted in 1896 on the College Green at the University of Pennsylvania is a Penn Treaty Elm.
Bartram Oak *Quercus × heterophylla*	31/70	This species of hybrid oak at Bartram's Garden was discovered by John Bartram on William Hamilton's nearby Woodlands estate.
Caucasian Zelkova *Zelkova carpinifolia*	64/85	This rare state champion zelkova stands near Hamilton Mansion at the Woodlands Cemetery. Its habit is striking and unique.
Chinese Scholartree *Styphnolobium japonicum*	73/65	The huge Chinese scholartree at 2535 Hobson Street in Southwest Philadelphia is a remnant of the Robert Buist nursery.
English Elm *Ulmus procera*	83/94	This magnificent state champion elm is hidden between the Small Mammal and Reptile Houses at the Philadelphia Zoo.
Franklinia *Franklinia alatamaha*	NA/27	On the corner of 42nd and Spruce Streets, this state champion franklinia is one of the largest in existence.
Ginkgo *Ginkgo biloba*	45/69	Planted in 1785 at Bartram's Garden, this large, magnificent staminate ginkgo may be the oldest specimen in the country.
Ginkgo *Ginkgo biloba*	80/76	One of the largest ginkgos in the city is next to the main fountain at the Philadelphia Zoo; it has seven big leaders.
Hackberry *Celtis occidentalis*	48/81	There are a few large hackberries at the Woodlands Cemetery. This tree is located along the drive on the eastern edge.
Japanese Zelkova *Zelkova serrata*	30+/60+	Locust Walk at the University of Pennsylvania is lined with zelkovas to great effect. A few are especially large specimens.
London Planetree *Platanus × acerifolia*	60/91	A fine specimen, this London planetree near the Hamilton Mansion at the Woodlands Cemetery is a state champion tree.
Mulberry *Morus sp.*	47/40	An enormous old mulberry can be found near the Hamilton Mansion at the southwest corner of the Woodlands Cemetery.
River Birch *Betula nigra*	31/58	This large, open-grown river birch on the south end of Bartram's Garden by the river is a state champion.
Turkey Oak *Quercus cerris*	60/88	An impressive Turkey oak stands near the golf shop at the Cobbs Creek Golf Course in West Philadelphia.
White Oak *Quercus alba*	55/86	A large white oak stands out at Saunders Park, a small pocket park near the University of Pennsylvania.

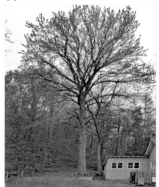

This huge cucumber magnolia is on Forbidden Drive in the Wissahickon.

An enormous royal paulownia stand near the center of McMichael Park

North and Northwest Philadelphia

Name	Diam. (in.) / Ht. (ft.)	Location and Other Details
Ailanthus *Ailanthus altissima*	48/69	The great old state champion ailanthus towers over the Community Center on Germantown Avenue in Chestnut Hill.
American Linden *Tilia americana*	92/85	A beautiful multi-trunked American linden in the English Landscape Park at the Awbury Arboretum is a state champion
American Yellowwood *Cladrastis kentukea*	70/47	Near the gate along Hunting Park Avenue at Laurel Hill Cemetery stands a very large, low-branching yellowwood.
Atlas Cedar *Cedrus atlantica 'Glauca'*	51/66	A state champion Atlas cedar at the Morris Arboretum exhibits the wide-spreading habit of an older, open-grown specimen.
Black Tupelo *Nyssa sylvatica*	34/55	A striking black tupelo at Hunting Park stands near the track behind the recreation center. It is especially beautiful in fall.
Bur Oak *Quercus macrocarpa*	55/80	A very large bur oak in Wissahickon Valley Park is tucked up the ridge between Northwestern Avenue and Bell's Mill Road.
Chestnut Oak *Quercus montana*	74/71	This spectacularly large chestnut oak is hidden in Howell Park on Greene Street in Germantown, behind the post office.
Chestnut Oak *Quercus montana*	49/95	This venerable native is featured in the "Out on a Limb" canop walkway at the Morris Arboretum. It dates to the mid 1700s.
Cucumber Magnolia *Magnolia acuminata*	56/78	A large cucumber magnolia stands near the river in Laurel Hil Cemetery, along with two beautiful sugar maples.
Cucumber Magnolia *Magnolia acuminata*	52/91	A state champion native cucumber magnolia in Wissahickon Valley Park dwarfs the Cedars House Café beside it.
Dawn Redwood *Metasequoia glyptostroboides*	57/118	A special grove of dawn redwoods at the Morris Arboretum flanks the creek that runs along the bottom of the hill.
European Beech *Fagus sylvatica*	81/102	This state champion beech is up the hill from the Wissahickon Environmental Center near Northwestern Avenue.
Ginkgo *Ginkgo biloba*	80/91	A magnificent state champion ginkgo at Philadelphia Universit stands near the admissions office on Schoolhouse Lane.
Hybrid Oak *Quercus sp.*	48/70	A large oak near the Hunting Park Avenue gate at Laurel Hill Cemetery is likely a cross between a scarlet and a black oak.
Japanese Zelkova *Zelkova serrata*	48/67	Stately zelkovas edge Winston Park on Ardleigh Avenue in Chestnut Hill—one is a particularly impressive specimen.
Katsuratree *Cercidiphyllum japonicum*	88/60	The signature tree of the Morris Arboretum, this amazing katsuratree has many large leaders and is a state champion.
Kentucky Coffeetree *Gymnocladus dioicus*	42/90	An unusually large Kentucky coffeetree graces the Lutheran Theological Seminary campus on Germantown Avenue.
Panicled Goldenraintree *Koelreuteria paniculata*	40/41	A venerable panicled goldenraintree in the meadow of the Awbury Arboretum is one of the oldest of its species in the area
River Birch *Betula nigra*	60/70	A state champion river birch in the wetlands of the Awbury Arboretum is the largest on record in Philadelphia.
Royal Paulownia *Paulownia tomentosa*	80/72	A very old and large paulownia is in decline in McMichael Park in East Falls, just off Henry Avenue along Coulter Street.
Tuliptree *Liriodendron tulipifera*	74.5/104	Three huge tuliptrees on Mount Pleasant Ave. near Crittenden Street in Mount Airy have very large and low lateral branches.
Willow Oak *Quercus phellos*	77/80	A most spectacular and venerable willow oak stands along Ol York Road near the entrance to Hunting Park.

The ancient panicled goldenraintree at the Awbury Arboretum blooms in June when its branches are tipped with clusters of small yellow flowers.

Northeast Philadelphia

Name	Diam. (in.) / Ht. (ft.)	Location and Other Details
American Sycamores *Platanus occidentalis*	63/85	The northeast corner of historic Palmer Cemetery in Fishtown has a few large American sycamores, all about the same size.
Catalpas *Catalpa sp.*	34+/67+	Northern and southern catalpas, *C. bignonioides* and *C. speciosa*, in Wissinoming Park are all roughly the same size.
Pin Oak *Quercus palustris*	49/104	This tall state champion pin oak stands south of the Pine Road parking lot between the trail and the creek in Pennypack Park.
Sugar Maple *Acer saccharum*	58/85	Greenwood Cemetery boasts one of the biggest and loveliest open-grown sugar maples; its fall color is unmatched.
Tuliptree *Liriodendron tulipifera*	76/129	This state champion tuliptree is on the north side of the creek between Pine and Veree Roads in Pennypack Park.

Southern and northern catalpas are lined up side by side at Wissinoming Park, providing visitors an opportunity to compare the two species.

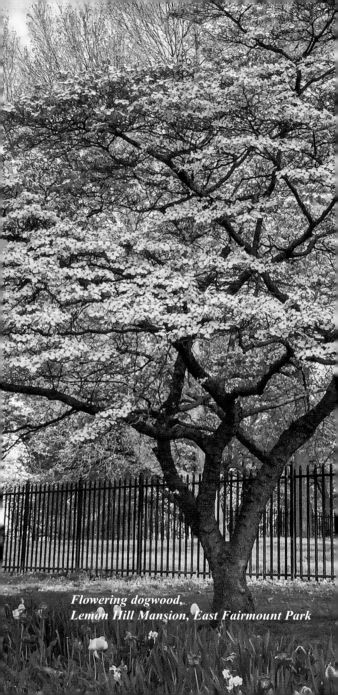

*Flowering dogwood,
Lemon Hill Mansion, East Fairmount Park*

Tree Guide

Using the Tree Guide

The tree species described in the entries on the following pages are divided into two broad categories: conifers and broadleaf trees. Within these two categories, the tree species are broken down into 15 groups based on the shape and arrangement of their scales, needles or leaves. Within each of these 15 groups, the species are usually listed in alphabetical order by their scientific names.

SCALES

SINGLE, FLAT NEEDLES

SINGLE NEEDLES IN TUFTS

NEEDLES IN BUNDLES

How to Identify a Tree by its Leaves

To narrow down the identity of a tree with the Tree Group Key, turn to the inside front cover. Compare the scales, needles, or leaves of a tree you want to identify with the illustrations in the Tree Group Key.

If the tree has scales or needle-like leaves, it is a *conifer* (a tree bearing uncovered or naked seeds in cones) and belongs to one of the first five groups. If the tree has scales, it belongs to Group 1. If it has needles, it belongs to Group 2, 3, 4, or 5. Look at the needles on your tree. Are they flat and soft, or stiff and four-sided? Are they arranged singly on twigs or in tufts of a dozen or more, or in bundles of 2, 3 or 5? The answers to these questions place a conifer in its proper group.

If the tree has wide, flat leaves, it is a *broadleaf* tree. If its leaves are *fan-shaped*, the tree belongs to Group 6 and is a ginkgo. (Group 6 consists of only one species.) If the leaves are not fan-shaped, the tree belongs to Group 7, 8, 9, 10, 11, 12, 13, 14, or 15. Look at the form of the leaves. Are they *simple*, consisting of just one undivided leaf blade? If so, the tree belongs to Group 6, 7, 8, 9, 13, 14, or 15. Or are the leaves *pinnately compound* or *palmately compound*, consisting of two or more leaflets attached to a central leaf stalk? If so, the tree belongs to Group 10, 11, or 12.

How are the leaves on your tree arranged on

SINGLE, STIFF, 4-SIDED NEEDLES

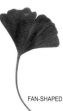

FAN-SHAPED

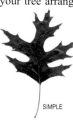

SIMPLE

their twigs? Do the leaf stems occur in *opposite pairs* on their twigs or branches? If so, the tree belongs to Group 7, 8, 9, 10, or 11. Or are the leaves *alternately arranged* with only one leaf at any one position on a twig or branch? If so, the tree belongs to Group 12, 13, 14, or 15.

Once you have determined whether your tree's leaves are simple or compound and whether they are in opposite pairs or alternately arranged, you may be able to narrow the tree to one group. More often, however, you must also look at the shape of the leaf and its edges. Is it *lobed*, with large projections and notches in between? Or is it unlobed and *toothed*, with small sharp or rounded projections? Or does it have *smooth edges*, with no lobes or teeth? The answers to these questions place your broadleaf tree in its proper group.

Leaf shape and arrangement are generally the best indicators of a tree's species, but the leaf shapes of some species can vary widely even on one tree. So in addition to examining a tree's leaves, you should consider its bark, flowers, and fruit if they are available and compare them with the photographs in the Tree Guide entries.

Another problem with using leaves to identify trees is that some conifers and most broadleaf trees described in this book are *deciduous*, which means that they shed their needles or leaves in the fall. Of course, you will have difficulty identifying a deciduous tree by its needles or leaves in the winter, unless you can find a few still on the tree or on the ground beneath the tree. Buds may be the best clues to a deciduous tree's identification in winter, but there is not enough space in this book to cover them thoroughly.

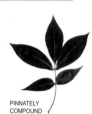
PINNATELY COMPOUND

PALMATELY COMPOUND

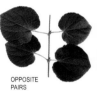
OPPOSITE PAIRS

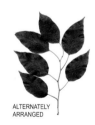
ALTERNATELY ARRANGED

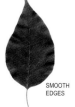
SMOOTH EDGES

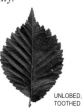
UNLOBED, TOOTHED

LOBED

Common Names and Scientific Names

Every entry in the Tree Guide is headed with a green Title Bar containing the species' common name in large bold type. Most tree species have more than one common name, but this book lists only one in the Title Bar. Others may be mentioned in the text.

Beneath the common name in the Title Bar is a two-word scientific name in italic letters. The binomial system of Latin scientific names has followed standard usage since the mid-1700s, when the Swedish botanist Carolus Linnaeus (1707–1778) published his monumental treatise *Species Plantarum*.

The first word of a scientific name denotes the genus and the second word, the specific epithet. For example, the scientific name of the American elm is *Ulmus americana*. The first word, *Ulmus,* is the genus name and is the Latin word for elm, indicating that botanists place this tree in the elm genus. The second word, *americana*, the Latinized word for "American," is the specific epithet. This particular two-word scientific name is exclusive to the American elm and is the same for botanists around the world.

Sometimes an entry in the Tree Guide covers several species in a genus. For example, the entry for "Foreign Elms" covers six species. In this case, there isn't room in the title bar to list six separate scientific names, so the scientific name listed is *Ulmus spp.* The abbreviation *spp.* stands for "species" in the plural, indicating that more than one species of elm is being described.

Abbreviated Names of Botanists

In addition to the two-word scientific name, the complete designation for a species includes the full or abbreviated name of the person or persons who named the species. For example, the full scientific designation for Eastern white oak is *Quercus alba* L. The abbreviation "L." stands for Carolus Linnaeus, who named the majority of the trees in this book. Frequently a scientific name is followed by a name in parentheses, followed by another name or names. For example, the complete designation for baldcypress is *Taxodium distichum* (L.) L. Rich. The "(L.)" denotes the fact that Linnaeus originally gave the baldcypress its scientific name, and the "L. Rich." indicates that L. Richard later reclassified the species. Occasionally a scientific name is followed by abbreviated names of two persons, as in the scientific name for the katsuratree, *Cercidiphyllum japonicum* Sieb. & Zucc. The two abbreviated names indicate that the species was described by two botanists, Siebold and Zuccarini. Books with lists of botanists who named species in this book are cited in the Bibliography on pages 272–274.

The Tree Guide Entries

The Tree Guide entries describe 168 tree species, including exotics sometimes omitted from North American tree guides. A species entry typically consists of one page or two facing pages of text, photos, and artwork. Included in each entry is a "Where to Look" section listing places to see each tree in Philadelphia or within an hour's drive. Abbreviations used in the "Where to Look" sections include: **PCS** (Center City and South Philadelphia), **PW** (West Philadelphia), **PNW** (North and Northwest Philadelphia), **PNE** (Northeast Philadelphia), **BC** (Bucks County), **MC** (Montgomery County), **CC** (Chester County), **DC** (Delaware County), **DE** (Delaware), and **NJ** (New Jersey). Elements in a typical Tree Guide entry are indicated below.

Title Bar contains the species' leaf type, a photo of its leaves, its common and scientific names, and mature height.

Leaf Portraits illustrate leaves' details and are accompanied by captions describing the leaves' special characteristics.

Tree Silhouette pictures the species in winter growing in the open without competition.

Where to Look tells you where to find the species in the region.

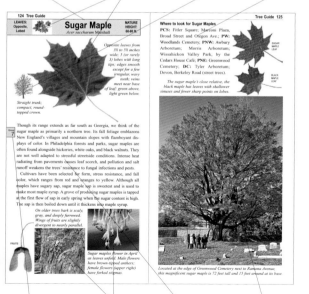

Tree Group Number refers to one of 15 groups on the inside front cover.

Botanical Close-ups zero in on fruits, flowers, seeds, and bark to confirm species identification.

Main Text contains facts about the species.

Tree Portraits illustrate trees located in the parks and along the streets of the metropolitan area.

The following text appears within the example entry image:

124 Tree Guide

LEAVES: Opposite, Lobed

Sugar Maple
Acer saccharum Marshall

MATURE HEIGHT: 60–80 ft.

Opposite leaves from 3½ to 5½ inches wide; 5 (or rarely 3) lobes with long tips; edges smooth except for a few irregular, wavy teeth; sinuses meet near base of leaf; green above, light green below.

Straight trunk; compact, round-topped crown.

Though its range extends as far south as Georgia, we think of the sugar maple as primarily a northern tree. Its fall foliage emblazons New England's villages and mountain slopes with flamboyant displays of color. In Philadelphia forests and parks, sugar maples are often found alongside hickories, white oaks, and black walnuts. They are not well adapted to stressful streetside conditions. Intense heat radiating from pavements causes leaf scorch, and pollution and salt runoff weakens the trees' resistance to fungal infections and pests.

Cultivars have been selected for form, stress resistance, and fall color, which ranges from red and oranges to yellow. Although all maples have sugary sap, sugar maple sap is sweetest and is used to make most maple syrup. A grove of producing sugar maples is tapped at the first flow of sap in early spring when the sugar content is high. The sap is then boiled down until it thickens into maple syrup.

On older trees bark is scaly, gray, and deeply furrowed. Wings of fruits are slightly divergent to nearly parallel.

FRUITS

Sugar maples flower in April as leaves unfold. Male flowers have brown-tipped anthers; female flowers (upper right) have forked stigmas.

Tree Guide 125

Where to look for Sugar Maples
PCS: Fitler Square; Marconi Plaza, Broad Street and Oregon Ave.; PW: Woodlands Cemetery; PNW: Awbury Arboretum; Morris Arboretum; Wissahickon Valley Park, by the Cedars House Café; PNE: Greenwood Cemetery; DC: Tyler Arboretum; Devon, Berkeley Road (street trees).

The sugar maple's close relative, the black maple has leaves with shallower sinuses and fewer sharp points on lobes.

SUGAR MAPLE LEAF

BLACK MAPLE LEAF

Located at the edge of Greenwood Cemetery next to Ramona Avenue, this magnificent sugar maple is 72 feet tall and 15 feet around at its base.

LEAVES: Scales, Evergreen	# Falsecypress *Chamaecyparis* spp.	MATURE HEIGHT: 3-75 ft.

SEED CONES

Range from squat, often pyramidal bushes to slim spires or irregular columnar trees.

Evergreen leaves opposite, scale-like, oval to rhombic, pointed or obtuse, flattened or pressed tightly against twigs; range in color from dark green to yellow green, sometimes with white stomatal bands underneath.

Group 1

Though they are part of the cypress family, species in the genus *Chamaecyparis* are commonly called falsecypresses to distinguish them from species in other genera of cypresses. Falsecypresses are widely used as evergreen hedges and screens. Most commonly planted are North American natives *C. lawsoniana* and *C. thyoides* as well as *C. obtusa* and *C. pisifera* from Japan. The landscape trade includes endless numbers of cultivars: dwarf, upright, globular, yellow, silver, and blue, to name just a few. In Japan, the wood of *C. obtusa* is cultivated for timber to build temples and shrines.

Where to look for Falsecypresses

PNW: Wissahickon Valley Park, Andorra Natural Area; West Laurel Hill Cemetery (*C. pisifera* near I. W. Morris's grave); **PNE:** Greenwood Cemetery; **DC:** Chanticleer; Haverford College; **DE:** Winterthur; University of Delaware Botanic Gardens.

Lumpy, scaly C. pisifera *cones up to ⅓ inch wide mature in fall. Smooth, reddish-brown bark peels off in thin strips.*

SEED CONES

A multi-trunked Chamaecyparis pisifera *grows next to Fournier Hall at Chestnut Hill College.*

| MATURE HEIGHT: 20-60 ft. | # Eastern Redcedar | LEAVES: Scales, Evergreen |

Juniperus virginiana L.

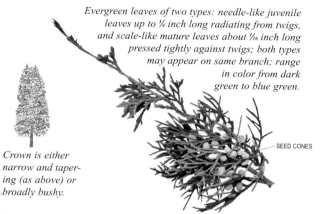

Evergreen leaves of two types: needle-like juvenile leaves up to ¼ inch long radiating from twigs, and scale-like mature leaves about ¹/₁₆ inch long pressed tightly against twigs; both types may appear on same branch; range in color from dark green to blue green.

SEED CONES

Crown is either narrow and tapering (as above) or broadly bushy.

Not really a true cedar but a juniper, the eastern redcedar has been highly valued since colonial times for its fine-grained, decay-resistant wood used to panel closets and make fence posts, pails, lead pencils, and chests. The volatile cedrine camphor oil in the wood has been proven to kill the larvae of some moths that feed on wool. This hardy, medium-sized tree is often among the first to spring up in abandoned pastures, where its seeds are spread by cedar waxwings and other birds that feed on its fleshy, bluish seed cones. It is notably tolerant of heat and drought.

Group 1

Where to look for Eastern Redcedars

PCS: Schuylkill River Trail, near Azalea Garden; **PW:** Bartram's Garden; Cobbs Creek Golf Course; **PNW:** Laurel Hill Cemetery; Morris Arboretum ('Glauca' variety); **MC:** Valley Forge Natl. Historical Park; **DC:** Haverford College.

Berry-like ¼-inch cones turn from green to blue as they ripen. Reddish bark may become fibrous and ashy-gray with age.

A 40-foot eastern redcedar towers over a walking path at the Morris Arboretum.

Eastern Arborvitae
Thuja occidentalis L.

MATURE
HEIGHT:
40-50 ft.

UNRIPE SEED CONES

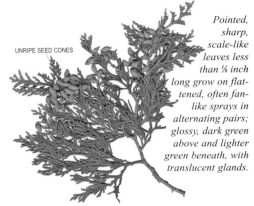

Pointed, sharp, scale-like leaves less than ⅛ inch long grow on flattened, often fan-like sprays in alternating pairs; glossy, dark green above and lighter green beneath, with translucent glands.

The conical crown is supported by a bole that may be buttressed at the base.

Group 1

Also known as the northern white cedar, the eastern arborvitae takes its common name from a Latin word meaning "tree of life," given to the tree by French explorer Jacques Cartier. On his second expedition to Canada in 1536, Cartier and his crew contracted bad cases of scurvy but were cured by their Huron guides, who taught the Frenchmen how to make a vitamin C–laden tea from arborvitae leaves. The many cultivars of the eastern arborvitae available in the landscape trade include dwarf, shrub, and columnar varieties.

Where to look for Eastern Arborvitae
PW: Woodlands Cemetery; Bartram's Garden; **PNW:** Morris Arboretum; **MC:** West Laurel Hill Cemetery; **DC:** Tyler Arboretum; Chanticleer; Haverford College; Brandywine River Museum.

Bark of older trees is grayish brown and furrowed; bark of younger trees is reddish and fibrous. Erect ⅜-inch cones release their seeds in the fall.

UNRIPE CONES

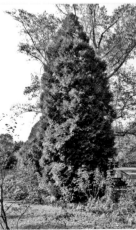

A 20-foot eastern arborvitae at the Tyler Arboretum exhibits the species' typical conical habit.

**URE
GHT:**
300 ft.

Giant Sequoia
Sequoiadendron giganteum (Lindl.) J. Buchholz

**LEAVES:
Scales Short,
Evergreen**

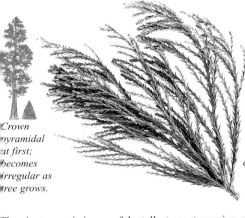

*Crown
pyramidal
at first;
becomes
irregular as
tree grows.*

*Triangular ⅛-
to ½-inch-
long needles
arranged
spirally, 19 to
28 per stem,
with sharp
points angled
toward stem
tip; range in
color from dull
gray green to
blue green.*

The giant sequoia is one of the tallest, most massive, and oldest living things on earth. In the wild it can attain more than 325 feet in height, as much as 32 feet in diameter, and well over 3,000 years of age. Although its natural range is restricted to just 75 groves on the western slopes of the Sierra Nevadas, the giant sequoia is sometimes grown as an ornamental in the Philadelphia area. Closed mature cones remain on the tree for twenty years, releasing their seeds when scorched by fire.

Group
1

Where to look for Giant Sequoias
PNW: Morris Arboretum, southeast of the parking lot; **CC:** Longwood Gardens; **DC:** Haverford College Arboretum; Tyler Arboretum (state champion tree in the Painter brothers' collection).

A young tree's bark is flaky and peeling. Under each scale of the 2- to 3-inch cones are five to seven seeds.

MATURE
UNOPENED
CONE

*Over 90 feet tall, the Tyler
Arboretum's giant sequoia is one
of the two tallest in the East.*

| LEASES: Needles Single, Flat | **Dawn Redwood** *Metasequoia glyptostroboides* Hu & W. C. Cheng | MATURE HEIGHT 50-130 f |

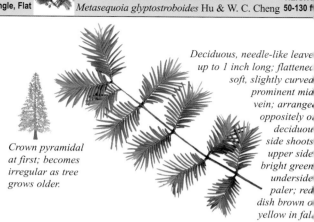

Crown pyramidal at first; becomes irregular as tree grows older.

Deciduous, needle-like leaves up to 1 inch long; flattened soft, slightly curved prominent mid vein; arranged oppositely on deciduous side shoots upper side bright green underside paler; reddish brown or yellow in fall

Known only from fossils until 1943, the dawn redwood grows naturally in small and localized mountainous areas of central China. However, this ancient relative of the giant sequoia and the coast redwood (*Sequoia sempervirens*) is now thriving as a landscape tree in temperate regions around the world. A deciduous conifer, it looks very much like the baldcypress. It grows fast and tolerates a wide range of soil conditions. Planted in Europe and North America since 1947, some trees are well over 100 feet tall.

Group 2

Where to look for Dawn Redwoods

PCS: Independence Natl. Historical Park, Rose Garden; **PW:** Fairmount Park, Horticulture Center; U. Penn., James G. Kaskey Memorial Park; **PNW:** Morris Arboretum; **CC:** Longwood Gardens; **DC:** Scott Arboretum (allée); Chanticleer.

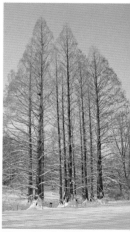

The bark of younger trees is reddish brown. The solitary, round, 1-inch cones hang on the ends of side twigs.

MATURE UNOPENED CONE

Planted in the 1950s, some Morris Arboretum dawn redwoods tower over 110 feet.

| MATURE HEIGHT: 50-80 ft. | **Douglas-fir** *Pseudotsuga menziesii* (Mirb.) Franco | | LEAVES: Needles Single, Flat |

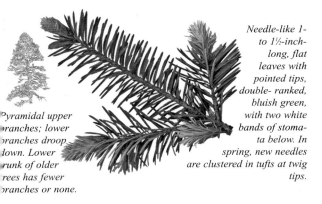

Pyramidal upper branches; lower branches droop down. Lower trunk of older trees has fewer branches or none.

Needle-like 1- to 1½-inch-long, flat leaves with pointed tips, double- ranked, bluish green, with two white bands of stomata below. In spring, new needles are clustered in tufts at twig tips.

The taxonomic history of the Douglas-fir would daunt all but the most serious botanist. Not a real fir, hence the hyphenation in the name, the Douglas-fir has its own genus, *Pseudotsuga*. Because it grows fast and its wood is dense and durable, it is one of the most important timber trees in the United States. It is also grown for sale as a Christmas tree. Native American folklore includes tales of mice hiding in Douglas-fir trees. Look closely and you can see bracts like tiny hind legs and tails protruding from scales of Douglas-fir cones.

Group 2

Where to look for Douglas-Firs
PCS: Old St. Mary's Churchyard, 4th Street between Locust and Manning Sts.; **MC:** West Laurel Hill Cemetery; **DE:** Winterthur, Pinetum.

The 2- to 3-inch pendant cones have bracts. Bark is smooth on young trees, becoming ridged and reddish brown or gray with advancing age.

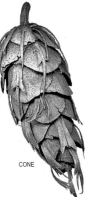

CONE

A Douglas-fir at the Tyler Arboretum is starting to lose its lower branches as it ages.

| LEAVES:
Needles
Single, Flat | 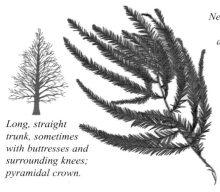 | **Baldcypress**
Taxodium distichum (L.) Rich. | MATURE
HEIGHT:
50-80 ft. |

Long, straight trunk, sometimes with buttresses and surrounding knees; pyramidal crown.

Needle-like leaves less than 1 inch long on alternately arranged deciduous shoots; flattened, soft, bluntly pointed at the tips; upper sides yellowish-green; undersides whitened; mid-vein prominent; orange brown before they drop off in fall.

Group 2

The baldcypress is a quintessential southern tree, native to bayou of the Gulf and swampy areas of the East Coast from Delaware to Florida. However, it is tolerant of cold and has been planted as far north as Ontario and Maine. Its ability to grow in water-saturated low-oxygen environments makes it successful as a park and street tree in urban settings, where compacted soil is common.

The baldcypress is a conifer, but it is also deciduous, shedding shoots with needle-like leaves every fall. A relative of the giant sequoia, it can attain a height of nearly 140 feet and a diameter of more than 12 feet, making it one of the largest trees in terms of bulk and height growing naturally east of the Mississippi. The baldcypress may be the oldest eastern tree, too. A few venerable individuals in North Carolina are estimated to be 1,000 to 1,700 years old. At first glance, baldcypresses are often mistaken for dawn redwoods. An easy way to distinguish the two is to remember that dawn redwood leaves are opposite, while baldcypress leaves are alternate.

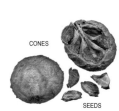

CONES

SEEDS

Spherical cones an inch in diameter contain winged seeds.

Fall color distinguishes the baldcypress from most conifers.

Reddish-brown, fibrous bark tends to be uniform in color.

Where to look for Baldcypresses

CS: Independence National Historical Park, Rose Garden; **PW:** Bartram's Garden; Woodlands Cemetery; **PNW:** Awbury Arboretum; 19th Street and Cheltenham Avenue; Morris Arboretum (near the swan pond, with *Taxodium ascendens);* **PNE:** Friends Hospital; **CC:** Longwood Gardens; **DC:** American College of Financial Services.

Baldcypresses develop knees—woody knobs extending from the roots—in wet locations.

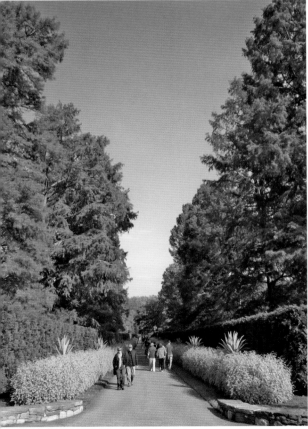

This impressive allée of baldcypresses is at Longwood Gardens in the Brandywine Valley. Planted ornamentally away from water, these trees lack the buttresses and knees typical of trees growing in swamps.

| LEAVES:
Needles,
Single, Flat | | **Yews**
Taxus spp. | MATURE
HEIGHT:
30-50 ft. |

Evergreen needle-like leaves are ½ inch to 1¼ inch long and up to ¼ inch wide; spiral arrangement can appear double-ranked, especially when shoots grow in shade; shiny, dark green above, lighter yellow green below, tapering to a horny point, convex with a midrib.

Usually small tree or large shrub with dense branching. Large specimens may have a pyramidal form (left), but fastigiate forms are often planted (right).

Group 2

Once used to make longbows in England, the **English yew**, *Taxus baccata*, is steeped in lore. The English yew is known as the "tree of death" for its toxic foliage and ubiquity in churchyard cemeteries, but it is also a symbol of eternal life due to its longevity. Magnificent old specimens found in England can be over 1,000 years old and over 50 feet tall. All *Taxus* species are toxic to people and livestock alike; ingestion of small amounts of leaves, bark, or seeds can be fatal to horses and cattle. It has been proposed that churchyard planting was simply a way to grow yews in an enclosed area while protecting livestock from their toxic shoots. Alternatively, yews may have deterred farmers from letting livestock graze on sacred ground.

Cultivars are derived from the English yew or **Japanese yew**, *Taxus cuspidata*, or are a hybrid of the two, *Taxus × media*. A fastigiate, clonal form of English yew is known as the **Irish yew**. Yews range from small shrubs to tall columnar varieties. Taxol—used to treat breast, ovarian, and lung cancer—is derived from the **Pacific yew**, *Taxus brevifolia*, and the **Canadian yew**, *Taxus canadensis*.

Bark on an English yew is a handsome reddish brown, thin and flaky. It often exfoliates in strips. ¼-inch red, berry-like arils surround each poisonous seed.

Where to look for Yews

W: Woodlands Cemetery; Mount Moriah Cemetery, Yeadon side; **PNW:** Laurel Hill Cemetery; **PNE:** Friends Hospital; **MC:** West Laurel Hill Cemetery near Righter's Ferry Road, in front of the crypts (an especially large English yew); **CC:** Longwood Gardens; **DC:** Cabrini University.

A large English yew at West Laurel Hill Cemetery shows the fluted trunks yews often develop with age.

A large, spreading English yew stands among gravestones near the western edge of Laurel Hill Cemetery, overlooking the Schuylkill River.

| LEAVES:
Needles
Single, Flat | | # Eastern Hemlock
Tsuga canadensis (L.) Carrière | MATURE
HEIGHT:
60-100 ft. |

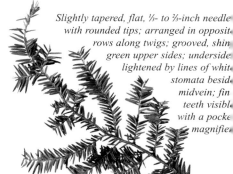

*Slightly tapered, flat, ⅓- to ⅔-inch needle
with rounded tips; arranged in opposite
rows along twigs; grooved, shin
green upper sides; underside
lightened by lines of white
stomata beside
midvein; fin
teeth visible
with a pocke
magnifie*

*Tapered, straight
trunk and
conical crown
that becomes
ragged with age.*

Also commonly known as the Canadian hemlock, the eastern hem
lock is the state tree of Pennsylvania and a major component of it
native forests. Unlike most conifers, the eastern hemlock establishe
best only after more shade-intolerant trees, such as birches, poplars
maples, and beeches, have created a shady, moist, and cool environ
ment. The hemlock's growth is slow, but eventually it will crowd ou
many of its hosts, reaching heights of 80 feet or more.

Group 2

Fifty years ago the cool north- and east-facing slopes of the
Wissahickon were often covered in solid stands of hemlocks. Unde
healthy trees, the ground, bare of other vegetation, was covered wit
a carpet of needles. Tragically, these serene groves have mostly bee
destroyed by the hemlock woolly adelgid, a minute insect, original
ly from Japan, that infests the tender bark of hemlock twigs, suck
their sap, and slowly kills the trees.

There are numerous *Tsuga canadensis* cultivars in the landscap
trade, including dwarf, weeping, fastigiate, and variegated forms.

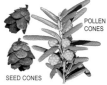

POLLEN
CONES

SEED CONES

*On older trees, the
gray bark is thick
and deeply fissured
with broad ridges.*

*Hemlock seed cones
are only ½- to ¾-inch
long; pollen cones
with globular pollen
packets are about ⅛-
inch across.*

*Hemlock twigs infected by
tiny aphid-like woolly
adelgid insects may
become lined with white
cottony egg masses, most
noticeable in early spring.*

Where to look for Eastern Hemlocks

CS: Old Swedes' Church; **PW:** Bartram's Garden; Cobbs Creek Golf Course; **PNW:** Morris Arboretum; Wissahickon Valley Park; Pastorius Park; **MC:** Green Lane Park, hemlock look-out; **CC:** Longwood Gardens; **DC:** Scott Arboretum; Tyler Arboretum; Chanticleer.

Tsuga canadensis 'Pendula' is a slow-growing, weeping form that grows 10 to 15 feet high.

The hemlock was historically one of the dominant species in the Wissahickon Valley. Remnants of large stands can still be found, but the trees tend to look scraggly and sickly because of adelgid infestation.

| LEAVES: Needles in Tufts of 12-40 | | # Cedars
Cedrus spp. | MATURE HEIGHT: 80-120 ft. |

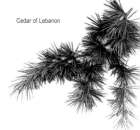

Cedar of Lebanon

An Atlas cedar's pyramidal crown becomes irregular as the tree grows older.

The crown of an older cedar of Lebanon may be composed of broad, flattened sprays of foliage.

Sharp, four-sided, ¾- to 1¼-inch needles arranged in spur shoots of 30 to 40 needles; shiny, green

Depending on the taxonomic source, there are between two and four different species of *Cedrus*. The two universally agreed upon are the Mediterranean *Cedrus lebani,* the **cedar of Lebanon**, and the Himalayan *Cedrus deodara*, the **deodar cedar**. Some botanists consider the **Atlas cedar**, *Cedrus atlantica*, a subspecies of the cedar of Lebanon. Aside from their differing growth habits and needle lengths, the two are quite similar. Cedars are long lived and grow into stately, iconic specimen trees. Through the ages, resinous scented cedar wood has been used for building everything from ships to palaces. Today cedar is still used for decking and lining of chests and closets.

The cedar of Lebanon is the tree most often mentioned in the Bible. For biblical peoples it was the great tree of Solomon's temple, a symbol of strength, long life and fruitfulness. Vast forests of this cedar once stretched from southern Lebanon to Turkey. In Lebanon, the tree now survives in only a few mountain groves, the largest of which contains about a dozen specimens 1,000 to 2,500 years old. In the wild, this majestic tree can attain more than 120 feet in height.

Female 3- to 5-inch cones are barrel shaped and upright. They disintegrate when mature, falling off the tree layer by layer.

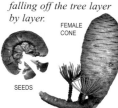

FEMALE CONE

SEEDS

Like female cedar cones, smaller male cones are upright. A mature Atlas cedar's gray-brown bark is broken into small, scaly plates.

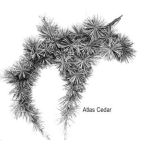

Atlas Cedar

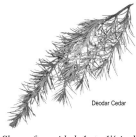

Deodar Cedar

harp, four-sided, ½- to ¾-inch eedles arranged on spur shoots f 19 to 28 needles; range in olor from dull gray green to blue reen to the silver blue of the ariety 'Glauca' (shown here).

Sharp, four-sided, 1- to 1½-inch whorled needles arranged in spur shoots of 15 to 20 needles; color ranges from dark green to glaucous or silvery; stems usually covered in grayish down.

Where to look for Cedars

PW: U. Penn., James G. Kaskey Memorial Park; **PNW:** Morris Arboretum; Laurel Hill Cemetery; **MC:** Barnes Arboretum; **CC:** Longwood Gardens; **DC:** Scott Arboretum, Pinetum; Tyler Arboretum; Haverford College, **DE:** Winterthur.

Snow at the Morris Arboretum highlights this deodar cedar's graceful, drooping habit.

handsome Atlas cedar at the Morris Arboretum shows the horizontal, ide-spreading branches of a mature specimen. It is over 100 years old.

LEAVES: Needles in Tufts of 12-40	# Larches	MATURE HEIGHT 30-80 ft

Larix spp.

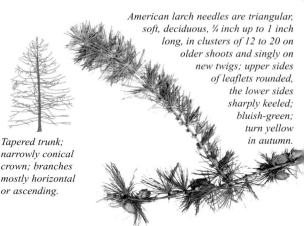

American larch needles are triangular, soft, deciduous, ¾ inch up to 1 inch long, in clusters of 12 to 20 on older shoots and singly on new twigs; upper sides of leaflets rounded, the lower sides sharply keeled; bluish-green; turn yellow in autumn.

Tapered trunk; narrowly conical crown; branches mostly horizontal or ascending.

Group 3

The genus *Larix* in the pine family includes 10 to 15 deciduous conif species spread across North America and Eurasia. Most larch speci are native to boreal forests of the North temperate zone, although o grows as far south as Burma. The **American larch** (*Larix laricina* also known as the tamarack, is most at home in cold climates and found farther north than any other eastern North American conifer. Pennsylvania, the tamarack generally grows from 30 to 60 feet tall, b at the northern edges of its range it tends to be much shorter and grow in pure stands. In the fall, tamarack leaves turn bright yellow and dro from the branches, leaving the tree looking gaunt and dead; but i spring, the tamarack leafs out again with delicate, sparsely clustere pale green needles.

The **European larch** (*Larix decidua*) is a fast growing, early pione tree that colonizes freshly disturbed sites. It occurs naturally on moun tainsides between 5,000 and 6,000 feet, where it is less likely to b shaded out by other trees than it would be at lower elevations. Value for its resin and lumber, it has been cultivated extensively in tree pla tations throughout Europe.

CONES

Tamarack cones (below) are ½- to ¾-inch long, about half the size of European larch cones (left).

The gray to light orange bark of a young tama-rack is thin and smooth. The gray to reddish-brown of an older tree (right) is scaly.

Where to look for Larches

W: Bartram's Garden; **PNW:** Morris Arboretum; **MC:** Ambler Arboretum of Temple University; **CC:** Longwood Gardens, Peirce-du Pont House (state champion); **DC:** Scott Arboretum, near Clothier Hall; Haverford College Arboretum; Tyler Arboretum.

Sharply ascending branches of a young American larch at the Tyler Arboretum suggest that it may be a cultivar.

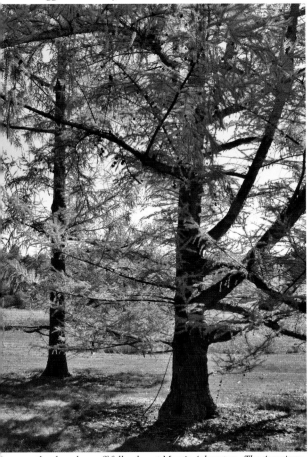

Japanese larches show off fall color at Morris Arboretum. The American larch is less tolerant of cultivation in Philadelphia than its European and Japanese cousins L. decidua *and* L. kaempferi *and is less often planted.*

| LEAVES:
Needles in
Tufts of 15-35 | | # Golden-larch
Pseudolarix amabilis (J.Nels.) Rehd. | MATURE
HEIGHT:
50-100 ft. |

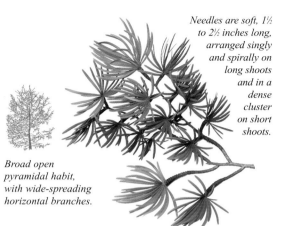

Needles are soft, 1½ to 2½ inches long, arranged singly and spirally on long shoots and in a dense cluster on short shoots.

Broad open pyramidal habit, with wide-spreading horizontal branches.

Group 3

A deciduous conifer, the golden-larch gets its name from its distinctive and stunning golden fall foliage. Not actually a larch, as its Latin genus name *Pseudolarix* ("false larch") suggests, it is in a genus of its own with just one species. Although closely related to the larch, it is also near kin to the fir and the cedar. The golden-larch presently is native only to the mountains of southeastern China, but fifty million years ago it grew in temperate rainforests across both Eurasia and North America, and its direct line may stretch back over 150 million years, making nearly as ancient as the ginkgo.

Where to look for Golden-larches

CC: Longwood Gardens, west of the Peirce-du Pont House (state champion); **DC:** Scott Arboretum, near Clothier Hall; Tyler Arboretum; Chanticleer; Haverford College.

Female cones 1 to 2 inches wide look like miniature artichokes and release winged seeds. The grayish- to reddish-brown bark is broken into scaly plates.

CONE

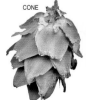

A 60-foot golden-larch at the Morris Arboretum has turned to gold in mid-October.

MATURE HEIGHT: 40-60 ft.	# Austrian Pine *Pinus nigra* J. F. Arnold	LEAVES: Needles in Bundles

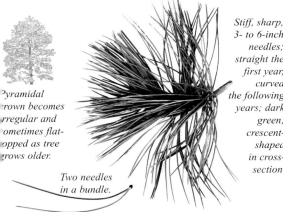

Pyramidal crown becomes irregular and sometimes flat-topped as tree grows older.

Stiff, sharp, 3- to 6-inch needles; straight the first year, curved the following years; dark green; crescent-shaped in cross-section.

Two needles in a bundle.

Introduced to America in 1759, the Austrian pine is widely planted as a landscape tree in the Northeast. This handsome European native is favored for its dense pyramidal outline and long, lustrous, dark green needles. The paired needles of the Austrian pine are stiffer and stouter than those of the red pine and do not snap when bent, as red pine needles do. A hardy tree, it transplants readily, can grow a foot or more a year and thrives in a variety of soils. The platy bark on mature trees is striking. In recent years Austrian pines have been plagued by diplodia tip blight, a fungal disease.

Group 4

Where to look for Austrian Pines

PW: Cobbs Creek Golf Course; **PNW:** Morris Arboretum; **DC:** Scott Arboretum of Swarthmore College; Tyler Arboretum; Chanticleer; Haverford College.

The gray bark is broken into wide vertical ridges. Stalkless 3-inch cones have small prickles on scale tips.

A pair of Austrian pines flank the parking lot entrance at the offices of the Scott Arboretum.

CONE

LEAVES: Needles in Bundles	**Pitch Pine** *Pinus rigida* Mill.	MATURE HEIGHT: 30-50 ft.

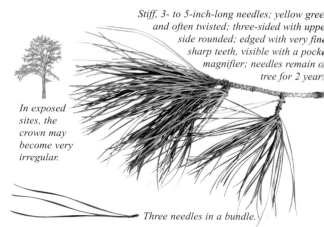

Stiff, 3- to 5-inch-long needles; yellow green and often twisted; three-sided with upper side rounded; edged with very fine sharp teeth, visible with a pocket magnifier; needles remain on tree for 2 years

In exposed sites, the crown may become very irregular.

Three needles in a bundle.

Group 4

The pitch pine thrives in dry, sandy soils and on gravelly, rocky slopes. It is rarely found in more favorable locations because faster-growing tree species crowd it out. The pitch pine is frequently a dominant tree of eastern Long Island, Cape Cod, and the New Jersey Pine Barrens, where it is seldom more than thirty feet tall and often quite shrubby. It survives frequent forest fires, producing new shoots from buds in the bark. These short, leafy shoots and the fact that the pitch pine is the only native, three-needled pine growing in the Northeast make it easy to identify. The closely related shortleaf pine (*Pinus echinata*) has bundles of either two or three needles mixed together.

Pinus rigida is not a major timber tree because it is slow growing and often has multiple or twisted trunks. Its high resin content makes the wood decay resistant and especially durable. It was historically used for ships, railroad ties, waterwheels, and mine props. Because of the tree's irregular growth, large pitch pine boards are fairly rare and therefore expensive.

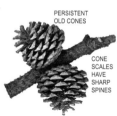

PERSISTENT OLD CONES

CONE SCALES HAVE SHARP SPINES

Older, furrowed bark may hold tufts of needles. The thick bark protects pitch pines from fire. The 1¼- to 2¾-inch cones usually release seeds only after being heated.

Where to look for Pitch Pines

PNW: Morris Arboretum; **DC:** Haverford College; **NJ:** Pinelands National Reserve, including Wharton, Brendan T. Byrne, and Bass River State Forests, among other locations in the Pine Barrens.

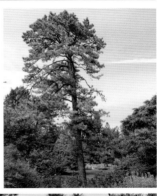

As a pitch pine ages, it may become scraggly and twisted. This specimen at the Morris Arboretum shows its habit under optimal growing conditions.

A dominant Pine Barrens species, pitch pines quickly sprout new growth from their trunks after forest fires that kill competing trees such as oaks.

LEAVES: Needles in Bundles	**Eastern White Pine** *Pinus strobus* L.	MATURE HEIGHT 70-100 ft

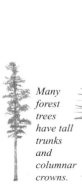

Slender blue-green needles 3 to ___ inches long drop off the tree after 2 to 3 years; triangular in cross section; inner sides marked by 3 to 5 lines of stomata visible with a pocket magnifier; edges very finely toothed.

Many forest trees have tall trunks and columnar crowns.

Five needles in a bundle.

The eastern white pine was the monarch of the vast aboriginal forests of the Northeast. When Europeans first arrived in North America, pure stands of white pine covered large portions of Pennsylvania, New York, and New England. Trees 150 feet tall with trunks free of branches for the first 80 feet were common, and giants towering 240 feet are on record. Many of these great white pines fell before the woodsman's ax and were shipped to England to become masts of British naval vessels. A good tree was worth one hundred pounds sterling—a small fortune in those times.

Group 4

Mature white pines tend to be tall and straight, but when a tree is attacked by the white pine weevil, which kills the lead shoot, side branches take over, creating a forked trunk. In some areas, fire fosters pure white pine stands. Older trees protected by their thick bark survive the flames and reseed the forest floor, where competitors have been eliminated. White pine is widely planted as a specimen tree or in screens. It is not well adapted to urban stresses.

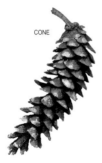

CONE

Bark of older trees is dark grayish brown and broken into long ridges (right). Bark of younger trees is grayish green and smooth. Mature 3- to 7-inch-long cones are reddish brown with scales often whitened at their ends by resin.

Where to look for Eastern White Pines:
NW: Fairmount Park, Henry Ave. and E. Hermits Lane; Cresheim Creek, SW of McCallum St. Bridge; Morris Arboretum; Awbury Arboretum; **MC:** West Laurel Hill Cemetery; **CC:** Longwood Gardens; **DC:** Chanticleer; **DE:** Winterthur, visitor parking lot.

An eastern white pine at Laurel Hill Cemetery has partially trimmed lower limbs.

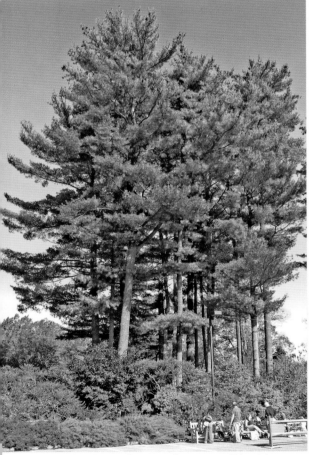

Several trees in this cluster of eastern white pines at Tyler Arboretum are over 60 feet tall. A Massachusetts white pine holds the record as the tallest tree in eastern North America, at nearly 190 feet.

| LEAVES: Needles in Bundles | # Scots Pine *Pinus sylvestris* L. | MATURE HEIGHT 30-80 ft |

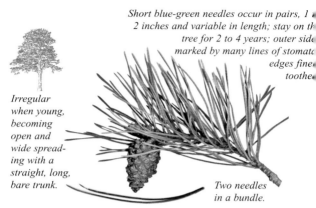

Short blue-green needles occur in pairs, 1 to 2 inches and variable in length; stay on the tree for 2 to 4 years; outer side marked by many lines of stomata, edges finely toothed.

Irregular when young, becoming open and wide spreading with a straight, long, bare trunk.

Two needles in a bundle.

Group 4

The Scots pine is one of the most widely distributed conifers in the world, ranging from Scotland, Ireland, and Southern Spain east to Siberia and as far north as the Arctic Circle. Found from sea level to elevations as high as 8,500 feet, it is easily identified by its blue-green needles that occur in pairs and by its orangish-brown bark on upper limbs. The Scots pine is considered a keystone species of the Caledonian forest in the Scottish highlands. It is one of the largest and longest-lived trees in that region.

Where to look for Scots Pines:
PW: Woodlands Cemetery; **PNW:** Morris Arboretum; Awbury Arboretum; **MC:** Ambler Arboretum of Temple University; **DC:** Scott Arboretum of Swarthmore College; Chanticleer; Haverford College.
Bark on lower trunk is grayish brown with large, thick, scaly plates (below) while upper branches have orange bark. Cones are 1 to 3½ inches long.

CONE

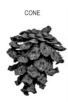

A Scots pine at Morris Arboretum shows characteristic orangish, peeling bark on its upper limbs.

MATURE HEIGHT: 30-100 ft.	**Himalayan Pine** *Pinus wallichiana* A. B. Jacks.	LEAVES: Needles in Bundles

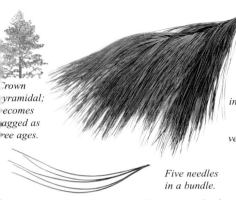

Slender, blue-green needles 5 to 8 inches long stay on the tree for 3 to 4 years; triangular in cross section; inner sides marked by 2 lines of stomata; edges very finely toothed.

Crown pyramidal; becomes ragged as tree ages.

Five needles in a bundle.

The Himalayan pine is considered by many to be the most beautiful of the world's pines. In several respects this Asian species (introduced to North America in 1827) is similar to the eastern white pine, but its features are exaggerated a bit. Like the eastern white pine, the Himalayan pine has five slender needles in a bundle, but they are up to three inches longer than its North American relative's, and they droop gracefully. Its cone, too, is similar to an eastern white pine's, only it is much larger. At maturity the tree can grow well over 100 feet tall.

Group 4

Where to look for Himalayan Pines
PCS: FDR Golf Club; **PW:** U. Penn., James G. Kaskey Memorial Park; St. Andrew's Chapel, 42nd and Spruce Streets (beside a white pine); **PNW:** Morris Arboretum; **DC:** Haverford College Arboretum; Tyler Arboretum; Chanticleer; **DE:** Winterthur.

A mature tree's bark is grayish brown and scaly. The 7- to 12-inch cones hang high on a tree.

CONE

This 30-foot Himalayan pine stands near the Society Hill Towers designed by I. M. Pei.

LEAVES: Needles Single, Flat	**Firs** *Abies* spp.	MATURE HEIGHT: 40-100 ft.

BALSAM FIR NEEDLES

WHITE FIR NEEDLES

Single-trunked, conical to pyramidal.

Leaves flattened, flexible, spirally arranged, often double-ranked, lack stalks; narrow, they flare at bases; may be aromatic when crushed. Balsam fir needles ⅝ to inch long, notched tips, shiny green on top, gray band beneath. White fir needles 1½ to 2½ inches long, pointed or rounded tips, both sides bluish green.

Group 5

Related to the genus *Cedrus* and also in the pine family, the genus *Abies* encompasses 48 to 55 species of firs found in Europe, Asia, North Africa, and the Americas. United States natives, the **balsam fir** (*A. balsamea*), **Frasier fir** (*A. fraseri*), **noble fir** (*A. procera*) and **white fir** (*A. concolor*) are favored choices for Christmas trees because of their aromatic foliage and their ability to retain needles upon drying out. Fir wood is harvested commercially for pulp and for oils often used in "pine"-scented products such as candles.

Firs can be distinguished from other evergreens by needles that attach directly to twigs with suction-cup-like bases, and by upright cones borne mostly on upper branches. The cones disintegrate while still on the tree, releasing winged seeds, so it is unusual to find an intact fir cone on the ground. Remarkably uniform in habit, firs are usually single trunked with regularly spaced branch whorls.

Female fir cones, like these 4-inch white fir cones, stand upright on higher branches.

Mature ½-inch male white fir cones turn from yellow to brown and droop as they mature.

Bark is smooth on young white firs but thick and fissured on older trees (above).

Where to look for Firs

PC: Longwood Gardens, Oak and Conifer Knoll; **DC:** Scott Arboretum; Chanticleer; Haverford College; **DE:** Winterthur, Pinetum (beautiful *A. homolepis*, Nikko fir, as well as Nordmann and white firs).

Needles lack stalks and flare at their bases. When they fall, they leave circular scars.

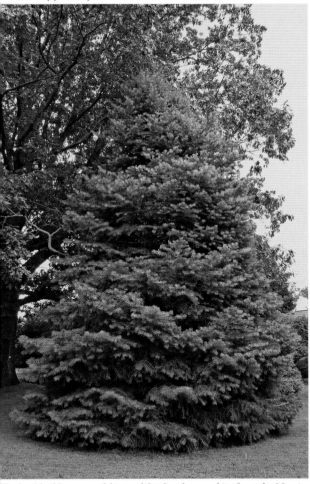

The healthy blue-green foliage of this handsome white fir at the Morris Arboretum attests to the species' ability to thrive far from its native habitat of the mountainous American Southwest and northern Mexico.

| LEAVES:
Needles
Stiff, 4-Sided | | # Norway Spruce
Picea abies H. Karst. | MATURE
HEIGHT:
40-75 ft. |

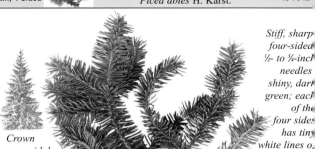

Stiff, sharp four-sided ½- to ¾-inch needles shiny, dark green; each of the four sides has tiny white lines of stomata visible with a hand lens; needles can remain on tree for 6 or 7 years.

Crown pyramidal; becomes ragged as tree ages.

The most common spruce in Europe, the Norway spruce was introduced to North America in colonial times and has been widely planted in the East as an ornamental and a windbreak. It may grow more than 100 feet tall with a trunk over three feet wide. Mature trees are distinguished by beautiful pendulous branchlets, hanging from branches that curve upward gracefully. The species exhibit great natural variation and there are hundreds of cultivars, including weeping types. The Norway spruce is often used as a Christmas tree.

Where to look for Norway Spruces:
PNW: Morris Arboretum (particularly fine specimen); **MC:** West Laurel Hill Cemetery; Welkinweir; **CC:** Longwood Gardens, Lower Reception Suite (several large specimens; tallest is 83 feet); **DC:** Chanticleer.

Bark of a mature tree is gray or reddish gray and scaly. The 4- to 7-inch cones are larger than those of native spruces.

CONE

At West Laurel Hill Cemetery this Norway spruce shows the upturned branches of a relatively young tree.

| MATURE HEIGHT: 30-60 ft. | **Colorado Spruce** *Picea pungens* Engelm. | | LEAVES: Needles Stiff, 4-Sided |

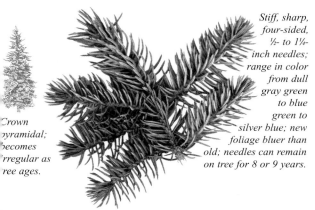

Stiff, sharp, four-sided, ½- to 1¼-inch needles; range in color from dull gray green to blue green to silver blue; new foliage bluer than old; needles can remain on tree for 8 or 9 years.

Crown pyramidal; becomes irregular as tree ages.

Though its natural range is limited to the Rocky Mountains, the Colorado spruce is one of the best known western conifers. Individuals with striking blue colors, called blue Colorado spruce (*P. pungens* var. *glauca*), are propagated by grafting and planted in landscapes throughout the United States and temperate regions worldwide. The silvery blue color is caused by a waxy substance on the needles that serves to conserve moisture. In native stands, the foliage color varies in shades of green and blue. Trees may live 600 years in the wild.

Group 5

Where to look for Colorado Spruces:

Widely planted in residential yards and gardens. **PNW:** Morris Arboretum (particularly fine specimen); **MC:** Welkinweir; **DC:** Chanticleer.

The bark of a mature tree is ashy brown and scaly. The cones, borne near the top of the tree, are from 2 to 4 inches long.

CONE

This Colorado blue spruce at the Morris Arboretum is 64 feet tall. Wild trees in the West can exceed 100 feet.

| LEAVES: Fan-shaped, Parallel Veins | **Ginkgo** *Ginkgo biloba* L. | MATURE HEIGHT: 40-80 ft. |

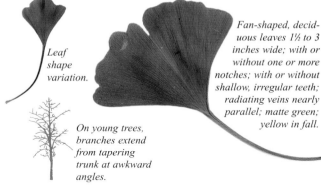

Leaf shape variation.

Fan-shaped, deciduous leaves 1½ to 3 inches wide; with or without one or more notches; with or without shallow, irregular teeth; radiating veins nearly parallel; matte green; yellow in fall.

On young trees, branches extend from tapering trunk at awkward angles.

Group 6

The ginkgo is the sole remaining member of an ancient arboreal order. Its lineage may be traced back 200 million years or more. By the end of the last Ice Age, however, only a few wild ginkgos remained in remote mountain valleys of eastern China. Fortunately, Buddhist monks planted them around their monasteries. In the early 1700s, European visitors brought seeds home to grow. The ginkgo proved to be tolerant of difficult urban growing conditions, and it is now found in cities all over the temperate world.

The ginkgo's seed is considered by some to be a delicacy. People often collect the yellow seeds when they fall to the ground in autumn. Some reports claim that extracts of ginkgo cure coughs and allergies, help circulatory problems, and improve memory. In spring the ginkgo bears inconspicuous male and female flowers on separate trees. Many prefer male trees, because in the fall females drop their malodorous and slippery yellow seeds on sidewalks.

SEEDS

A little less than an inch in diameter, the ginkgo's plum-like seeds turn from green to yellow as they ripen.

On older trees, the reddish-brown bark is deeply furrowed. Ginkgos grow slowly, and relatively small trees may be very old.

Where to look for Ginkgos

CS: Street trees in the city; Independence National Historical Park; Stephen Girard Park; **PW:** Bartram's Garden; Fairmount Park Horticulture Center; Philadelphia Zoo; **NW:** Philadelphia University; **PNE:** Wissinoming Park; **MC:** West Laurel Hill Cemetery; **CC:** Longwood Gardens; **DC:** Haverford College.

Ginkgos flaunt their fall color on the University of Pennsylvania campus.

A stately ginkgo at Longwood Gardens shows the wide-spreading habit of an older tree. Younger trees tend to be gawky and more pyramidal.

| LEAVES: Opposite, Lobed | | # Hedge Maple
Acer campestre L. | MATURE HEIGHT: 25-35 ft. |

Leaf shape variation.

Crown is dense and rounded, with a short main trunk.

Opposite leaves from 2 to 4 inches long with 3 to 5 rounded lobes; each lobe may have 1 or 2 rounded teeth; main veins meet at the top of the stem, bright green to dark green, stem contains white sap.

Group 7

A native of Europe, the hedge maple is widely planted in Britain and on the Continent along roads and in hedgerows. But in the United States, its compact stature makes the hedge maple, and its cousin the Amur maple, ideally suited for street planting under utility wires. Hedge maple twigs often, but not always, have corky wings. The neat three- to five-lobed leaves of the hedge maple turn to various shades of yellow in fall. In recent years, new clones have been selected for dark green, glossy leaves and refined habit.

Where to look for Hedge Maples

PCS: FDR Park, near Broad Street; **PW:** Philadelphia Zoo (large specimen in front of John Penn's house); Woodlands Cemetery; **PNW:** Morris Arboretum; Main Street, Manayunk; **CC:** Longwood Gardens.

The 1-inch-wide fruits develop in April, usually four to a bunch. The bark is brown with numerous orange fissures.

FRUITS

A lovely planting of hedge maples along the edge of a Manayunk street displays golden color in mid-October.

| MATURE HEIGHT: 15-25 ft. | **Amur Maple**
 Acer tataricum ssp. *ginnala* (Maxim.) Wesm. | LEAVES: Opposite, Lobed |

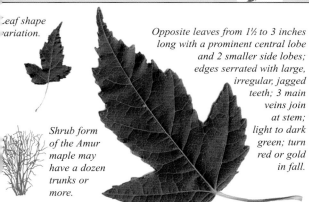

Leaf shape variation.

Shrub form of the Amur maple may have a dozen trunks or more.

Opposite leaves from 1½ to 3 inches long with a prominent central lobe and 2 smaller side lobes; edges serrated with large, irregular, jagged teeth; 3 main veins join at stem; light to dark green; turn red or gold in fall.

A native of northeastern China and Japan, the Amur maple is a small, hardy tree that seldom exceeds 25 feet in height. Often it appears as a shrub with a number of slender trunks; sometimes it displays the habit of a small tree with a short base supporting several large ascending branches. Its fragrant yellow-green flowers bloom as the leaves unfold in April and May. The fruit matures by August, and the wings of the fruit often turn bright red. In autumn the leaves assume brilliant shades of gold, orange, and crimson.

Group 7

Amur maples are among the first trees to leaf out in spring. This beautiful specimen at the Morris Arboretum's Bloomfield Farm drops its leaves in mid-November.

Where to look for Amur Maples
PCS: Marian Anderson Recreation Center, 17th and Fitzwater Streets; **PNW:** Morris Arboretum, Bloomfield Farm; **DC:** Haverford College.

Gray bark may have shallow orange fissures. Wings of 1-inch fruits are translucent.

FRUITS

LEASE: Opposite, Lobed	# Japanese Maple	MATURE HEIGHT:
	Acer palmatum Thunb.	15-25 ft.

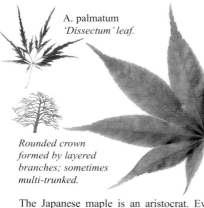

A. palmatum
'Dissectum' leaf.

Rounded crown formed by layered branches; sometimes multi-trunked.

Opposite leaves
from 2 to 5 inches
long and wide;
from 5 to 9 sharp-
pointed lobes, each
finely serrated;
main veins meet at
the top of the
stem; light to
dark green and
light to dark red;
stem may be
red.

The Japanese maple is an aristocrat. Everything about this tree is refined and exquisite, from its slender, sinuous limbs to its delicate, finely cut leaves that turn to brilliant shades of scarlet, yellow, or orange in autumn. Like all patricians, the Japanese maple has a long and illustrious pedigree. It is native to China, Japan, and Korea, but centuries of selection and breeding, first by Japanese gardeners and more recently by western horticulturists, have created the rich varietal palette that we know today, with its hundreds of ornamental cultivars. The Japanese maple was first described by an 18th-century Swedish botanist, Carl Peter Thunberg, in his book titled *Flora japonica* (1784). The tree reached America in the early 1860s when a young American physician, George Rogers Hall, shipped seeds to Boston and to the Parsons Nursery in New York. Many Japanese maples in America today are descended from trees cultivated in this nursery. Japanese maples naturalize easily and are invasive in some areas.

Group 7

FRUITS

The ½- to ¾-inch fruits have incurved wings that often turn red. The bark on older trunks is gray brown and smooth or shallowly fissured.

Where to look for Japanese Maples

W: West Fairmount Park, Shofuso Japanese House and Garden; Spruce Street and St. Mark's Square; **PNW:** Wissahickon Valley Park, Andorra Natural Area; **PNE:** Friends Hospital; **NC:** Saint Joseph's University (state champion); **CC:** Longwood Gardens; **SC:** Chanticleer; **DE:** Winterthur.

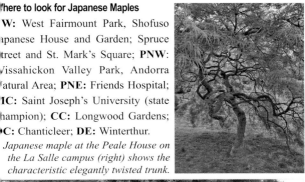

Japanese maple at the Peale House on the La Salle campus (right) shows the characteristic elegantly twisted trunk.

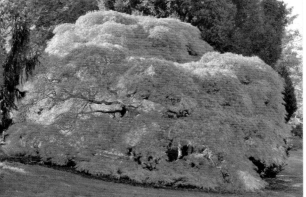

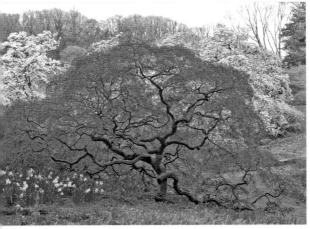

The sublime silhouettes and lacy foliage of cultivars such as these at the Morris Arboretum (above in fall) and at Winterthur (bottom in spring) account for the popularity of the Japanese maple as a garden tree.

| LEAVES: Opposite, Lobed | # Norway Maple
Acer platanoides L. | MATURE HEIGHT:
40-90 ft. |

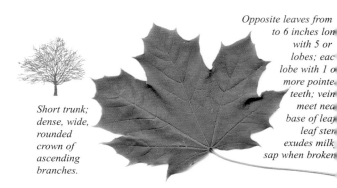

Short trunk; dense, wide, rounded crown of ascending branches.

Opposite leaves from to 6 inches lon with 5 or lobes; eac lobe with 1 o more pointe teeth; vein meet nea base of leaf leaf stem exudes milk sap when broken

The Norway maple was introduced to North America about 1756 b John Bartram, a Quaker botanist who established the first botanica garden and nursery in the United States in Philadelphia. In 179 William Bartram, John Bartram's son, sold Norway maple seeds c seedlings to George Washington. Tolerant of shade, soil compaction and air pollution, this hardy, fast-growing native of Europe and Asi was firmly established as an ornamental by the late 1800s. It wa planted in the 1930s by the thousands to replace trees killed b Dutch elm disease.

Group 7

The Norway maple's common name is somewhat misleading. It natural range reaches only to a portion of southeastern Norway bu extends east across most of Europe into Russia. In fact, it is the mos widespread maple in Europe. Today it is one of the most common– and problematic—urban trees in the Northeast and is no longer rec ommended for planting, as it invades woodlands and disrupts nativ forest regeneration. Its wood is quite weak and prone to breaking.

Wings of Norway maple fruits point away from one another. Wings of other maple species' fruits point downward.

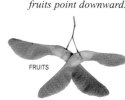

FRUITS

The 3- to 4-inch flower clusters appear befor the leaves in early April. The bark is tightly ridged but not scaly like other maples' bark.

Where to look for Norway Maples

NW: Laurel Hill Cemetery (dark purple-leaved cultivars); Wissahickon Valley Park (abundant and invasive); Northwood Cemetery; **PNE:** North Cedar Hill Cemetery, Frankford (Norway maple allée); **DC:** Tyler Arboretum (cutleaf *Acer platanoides* 'Laciniatum'); **DE:** Winterthur (Norway maples planted to good effect along library wall).

Cultivars such as 'Schwedleri' and 'Crimson King' have purplish or red leaves either in spring or throughout the growing season.

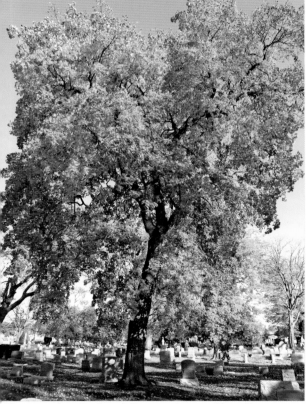

Norway maple at Northwood Cemetery glows a golden yellow on a November afternoon. Unless it is a cultivar, a Norway maple typically bears yellow leaves in fall, not red leaves like those of many other maples.

LEAVES:
Opposite,
Lobed

Sycamore Maple
Acer pseudoplatanus L.

MATUR
HEIGH
50-70 f

Short trunk tending to fork and thick, rounded crown.

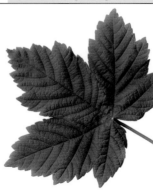

Thick, palmate lobed leaves up 7 inches long a wide; 5 coarse toothed lobe wrinkled, da green abov whitish- purplish-gre below; ding brown in fa

Introduced to North America from Europe, the sycamore maple h been grown as an ornamental in the Northeast for many years. I Latin name means "false sycamore" or "false planetree," and inde its leaves are similar in shape to those of the sycamore and th London planetree. Like the Norway maple, which it resembles in si and habit, it is regarded by some urban foresters as a weed tree an is no longer recommended for planting. It reproduces quickly and i deep-rooted saplings often crowd out native species.

Group 7

The densely rooted sycamore maple tolerates sandy or cla based soils and high salt levels well, but it is subject to disease an wood-boring insects and seldom exhibits good fall color. There a several cultivars of the sycamore maple with striking foliage, such 'Brilliantissimum' with pinkish new leaves that turn to a creamy ye low, 'Leopoldii' with speckled dark and light green leaves, an 'Atropurpureum' with leaves that have purple undersides. The fin grained wood of the sycamore maple is white and polishes to a hig luster. It is used for furniture, flooring, and musical instruments.

FRUITS

Pendulous flower clusters appear in mid-April and produce 1¼- to 2-inch winged keys that mature by late summer.

The grayish-brown bark of t sycamore maple is broken in countless small, flaky scales

here to look for Sycamore Maples
CS: Lemon Hill Mansion; **PW:**
oodlands Cemetery; PNW:
aurel Hill Cemetery, south of W.
unting Park Avenue (cluster of
ees); Awbury Arboretum, near
ashington Lane (old tree);
lifford Park, behind the house.

Large clusters of seeds hang
conspicuously on sycamore maples
in late summer and early fall.

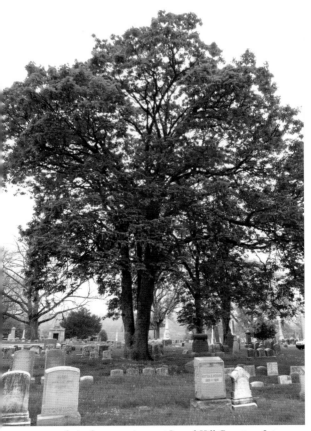

sycamore maple jostles gravestones at Laurel Hill Cemetery. Intro-
uced to New England prior to 1810, the species was probably present at
he Woodlands and Bartram's Garden early in the 19th century.

LEAVES: Opposite, Lobed		**Red Maple** *Acer rubrum* L.	MATUR HEIGH 60-90 f

Leaf color and shape variations.

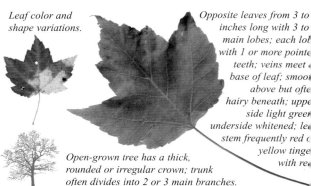

Opposite leaves from 3 to inches long with 3 to main lobes; each lob with 1 or more pointe teeth; veins meet base of leaf; smoo above but ofte hairy beneath; uppe side light greer underside whitened; lee stem frequently red o yellow tinge with re

Open-grown tree has a thick, rounded or irregular crown; trunk often divides into 2 or 3 main branches.

Aptly named, the red maple displays some red in every season. winter its red buds give its rounded or irregular crown a dusty pin ish tinge. In early spring, its small, bright scarlet flowers bloo before the leaves unfold, clothing the tree in a feathery, scarlet ma tle. Its unfurling leaves may also be tinged red; as they grow larg they turn green but retain reddish stems throughout the summer. fall, the red maple's foliage ranges from flaming scarlet to orang gold to pure yellow. Only the sugar maple equals or surpasses th red maple's extravagant autumnal hues.

Few North American trees have a greater north-south range tha the red maple. It grows from Canada to the tip of Florida, where flowers in February, and thrives in a variety of habitats—swamp lowland forests, and rocky uplands. A fine specimen tree, it is ge erally tolerant of most urban conditions and is widely planted o lawns and in parks. It grows fast and may live 150 years or more.

Group 7

Red maple male flowers (left) have long pollen tipped stamens; female flowers (right) have paired stigmas to catch pollen.

Once fertilized by pollen, female flowers quickly develop into winged seeds

Where to look for Red Maples

Red maples are ubiquitous and wide-spread. **PW:** City and Belmont Avenues, directly across from Belmont Reservoir; **PNW:** Morris Arboretum; **DC:** Tyler Arboretum; Chanticleer (part of the remnant forest, one in particular at Spruce Vista); Brandywine River Museum (cultivar 'Burgundy Belle').

The bark of a young tree (right, top) is light gray and smooth. The bark of a mature tree (right, bottom) is darker gray and covered with irregular vertical ridges.

A mature stand of red maples displays gorgeous fall color at the Radnor Corporate Center (above). Younger red maples near the wetland at the Morris Arboretum have a more pyramidal habit (below).

| LEAVES:
Opposite,
Lobed | | **Silver Maple**
Acer saccharinum L. | MATUR
HEIGHT
60-80 ft |

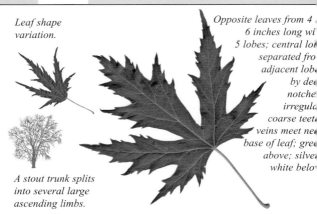

Leaf shape variation.

Opposite leaves from 4 6 inches long wi 5 lobes; central lo separated fro adjacent lob by dee notche irregula coarse teet veins meet ne base of leaf; gree above; silver white belo

A stout trunk splits into several large ascending limbs.

Group 7

The silver maple is named for its deeply notched leaves, which a green above but silvery white beneath. When breezes twist its leave a silver maple is riffled with waves of green and silver. Handsome ar fast growing, it was once widely planted along streets, especially in th Midwest. As the tree ages, though, it often proves to be weak woode and susceptible to limb breakage. For this reason, it is no longer co sidered appropriate for curbside planting.

In the wild the silver maple is most often found along stream creeks, and rivers, frequently growing beside sycamores, riv birches, red maples, and other tree species adapted to riparian hab tats. The silver maple flowers early in spring. Its oblong samar with papery veins mature in May as leaves are unfurling and twi down on mudbanks, where they germinate almost immediatel Their quick growth and easy germination make silver maples usef for riparian restoration and streambank stabilization. Softer than re maple or sugar maple wood, silver maple wood is used for shippin crates, pulp for paper, and inexpensive furniture.

The 1½- to 2½-inch fruits have thin, angled wings. The flaky bark is bro- ken into long, narrow, gray scales.

FRUITS

In spring, samaras hang in clu ters with young green leaves.

here to look for Silver Maples

CS: Old Swedes' Church; Stephen irard Park, 21st and Shunk reets; island in Schuylkill River, ar the Philadelphia Museum of rt; **PNW:** Morris Arboretum; issahickon Valley Park; **PNE:** nnypack Park; Greenwood Cemetery; Palmer Cemetery, Fishtown; agner Free Institute of Science.

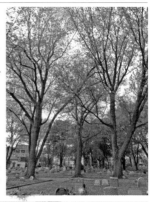

Numerous large silver maples shade tombstones at Palmer Cemetery in Fishtown. Some have forked trunks.

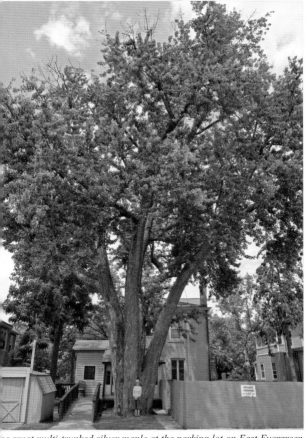

he great multi-trunked silver maple at the parking lot on East Evergreen enue in Chestnut Hill is 65 feet tall and 80 inches in diameter.

| LEALES: Opposite, Lobed | **Sugar Maple** *Acer saccharum* Marshall | MATURE HEIGHT 60-80 ft |

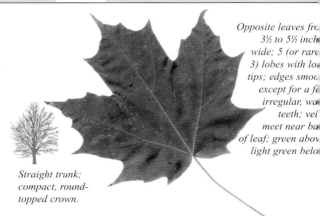

*Opposite leaves fr
3½ to 5½ inch
wide; 5 (or rare
3) lobes with lo
tips; edges smoo
except for a fe
irregular, wa
teeth; vei
meet near ba
of leaf; green abov
light green belo*

Straight trunk; compact, round-topped crown.

Though its range extends as far south as Georgia, we think of th sugar maple as primarily a northern tree. Its fall foliage emblazo New England's villages and mountain slopes with flamboyant di plays of color. In Philadelphia forests and parks, sugar maples a often found alongside hickories, white oaks, and black walnuts. Th are not well adapted to stressful streetside conditions. Intense he radiating from pavements causes leaf scorch, and pollution and sa runoff weakens the trees' resistance to fungal infections and pests.

Cultivars have been selected for form, stress resistance, and fa color, which ranges from red and oranges to yellow. Although maples have sugary sap, sugar maple sap is sweetest and is used make most maple syrup. A grove of producing sugar maples is tapp at the first flow of sap in early spring when the sugar content is hig The sap is then boiled down until it thickens into maple syrup.

On older trees bark is scaly, gray, and deeply furrowed. Wings of fruits are slightly divergent to nearly parallel.

FRUITS

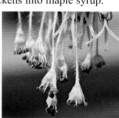

Sugar maples flower in Apr as leaves unfold. Male flow have brown-tipped anthers; female flowers (upper right have forked stigmas.

Group 7

Where to look for Sugar Maples

CS: Fitler Square; Marconi Plaza, Broad Street and Oregon Ave.; **PW:** Woodlands Cemetery; **PNW:** Awbury Arboretum; Morris Arboretum; Wissahickon Valley Park, by the Cedars House Café; **PNE:** Greenwood Cemetery; **DC:** Tyler Arboretum; Devon, Berkeley Road (street trees).

The sugar maple's close relative, the black maple has leaves with shallower sinuses and fewer sharp points on lobes.

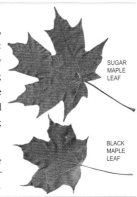

SUGAR MAPLE LEAF

BLACK MAPLE LEAF

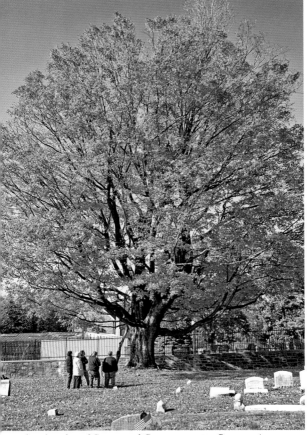

Located at the edge of Greenwood Cemetery next to Ramona Avenue, this magnificent sugar maple is 72 feet tall and 15 feet around at its base.

| LEAVES: Opposite, Lobed | # Royal Paulownia
Paulownia tomentosa (Thunb.) Steud. | MATUR
HEIGHT
30-60 ft |

Often has long trunk topped by rounded crown, sometimes with thick ascending limbs.

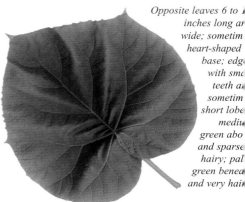

Opposite leaves 6 to inches long an wide; sometim heart-shaped base; edg with sm teeth a sometim short lobe mediu green abo and sparse hairy; pal green benea and very hai

Named in honor of Anna Pavlovna, daughter of Czar Paul I, the roy paulownia was introduced to North America from China via Euro in 1843. It has an extravagant, tropical look, not unlike the catalpa although the two are not related. Its leaves are very large, sometim reaching over a foot in length. Beautiful lavender flowers produ prodigious numbers of seeds. Initially green, the 1- to 1½-inch see pods mature in late summer and fall, turn brown, then crack open winter and the following spring, releasing thousands of tiny wing seeds. A large tree may scatter over 20 million seeds in a season.

The royal paulownia grows extremely fast, colonizing disturbe areas such as empty lots and highway edges. It can survive fir because its roots quickly sprout new stems. In its native Japan an China, it is widely cultivated for lumber, fuel, animal fodder, and so conservation. The wood is also valued in Asia for making furnitu and special coffins that insure the deceased goes straight to heaven

Resembling foxglove blossoms, showy, 2-inch, trumpet-shaped royal paulownia flowers bloom in late April or early May just as the tree's leaves start to unfold.

IMMATURE
SEED
CAPSULES

Mature royal paulownia bark is gray and fissured.

here to look for Royal Paulownias

CS: Logan Circle (new planting placed declining trees); Philadelphia useum of Art; **PW:** 42nd and Spruce s. (big tree); West Fairmount Park, entennial Arboretum; City and Belmont ves., across from Belmont Reservoir; **NW:** Ridge Ave. and Francis St.; **MC:** ongwood Gardens (allée); **CC:** Jenkins rboretum; **DC:** American College.

A large royal paulownia blooms in Centennial Park. Look along railroad tracks in May for their purple flowers.

he Swann Memorial Fountain at Logan Circle in Center City is encir-ed by young royal paulownias that unfurl their purple flowers in May.

| LEAVES: Opposite, Smooth | | # Catalpas *Catalpa* spp. | MATUR HEIGHT 30-60 ft |

Straight trunk and spreading crown with scraggly branches.

Opposite, heart-shape leaves 7 to 12 inch long and 5 to inches wide; ste 4 to 6 inch long; edg smooth or with o or two lobes; mediu green abov slightly pal beneath ar hair

The catalpa looks like a tree you might see in a Central Americ rainforest. Its cascading, heart-shaped leaves are big—up to a fo long, not including their long stems. Its pyramidal flower clusters a large, lush, and showy, with tiers of trumpet-shaped, frilly white blo soms sporting purple stripes, dots, and bright yellow blotches. Th catalpa's fruits are also outsized and tropical looking, resemblin string beans stretched to many times their normal length.

Despite its exotic aspect, the catalpa is a native tree, occurring na urally in forests of the south central United States but widely planted cities because of its rapid growth and tolerance of urban condition Early in the last century, it was popular as a lumber source and wa commonly planted throughout the Midwest as an ornamental. Tw American catalpa species are widely naturalized in Pennsylvania: *C speciosa*, the **northern catalpa**, and the smaller *C. bignonioides*, th **southern catalpa**. The leaf of the northern catalpa has an elongate tapered tip, while the southern catalpa has a shorter, pointed tip.

Group 8

FRUIT

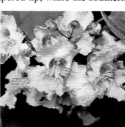

Two-inch flowers bloom in May. The 7- to 20-inch long fruits persist through winter.

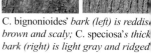

C. bignonioides' bark (left) is reddis brown and scaly; C. speciosa's thick bark (right) is light gray and ridged

Where to look for Catalpas

CS: Along the Schuylkill River; **PNE:** Wissinoming Park; **CC:** Longwood Gardens, next to the business gate (fine southern catalpa); **DC:** Scott Arboretum a southern catalpa that may predate the college); Chanticleer (a northern catalpa near the long border and a southern Aurea' in the pond garden).

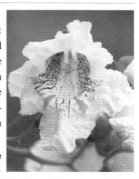

Purple and gold markings on a 2-inch flower lure insects to a nectar reward.

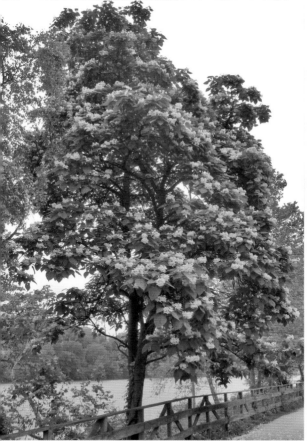

A blooming catalpa stands next to the bike path on the west bank of the Schuylkill River along Martin Luther King Drive. The southern catalpa's flower clusters are denser and showier than the northern catalpa's.

LEAVES: Opposite, Smooth		**Fringetrees** *Chionanthus* spp.	MATURE HEIGHT: 12-30 ft.

Large shrub or small tree, often multi-stemmed but variable.

Leaves opposite, simple, elliptical to ovate to oblong; 3 to 7 inches long, entire; medium to dark green, often lustrous above, paler below; yellow in fall; often with a hairy petiole.

The genus *Chionanthus* consists of about 100 flowering plant species. Most are tropical, but two are native to the Northern Hemisphere's temperate zone: the **white fringetree**, *Chionanthus virginicus*, found in the southeastern United States, and the **Chinese fringetree**, *Chionanthus retusus*, introduced to the West in 1845. These stunning small specimen trees are at their peaks in spring when they are freighted with clusters of fragrant, pure white flowers, each with four thin petals that flutter in the breeze. From a distance a fringetree appears covered with cotton balls. At night it glows with a luminescent radiance in moonlight. Appropriately, the Greek genus name, *Chionanthus*, means "snow flower." Male and female trees both have dramatic flowers, but only females bear the bluish black fruits in fall that birds love to feast on. Relatives of the ash, fringetrees are now being destroyed by emerald ash borers.

Group 8

UNRIPE FRUIT

Oval fringetree fruits are ½- to ¾-inch drupes, which ripen from green (left) to bluish black (below).

Chinese fringetree bark is gray and furrowed, with cracks revealing a bright orange underlayer.

Where to look for Fringetrees

PCS: Fairmount Park, Azalea Garden;
PW: Bartram's Garden; **MC:** Barnes
Arboretum; **CC:** Longwood Gardens;
DC: Scott Arboretum of Swarthmore
College; Chanticleer; Haverford
College; **DE:** Mt. Cuba Center.

The white blossoms of Chionanthus
virginicus *appear in May and early June.*

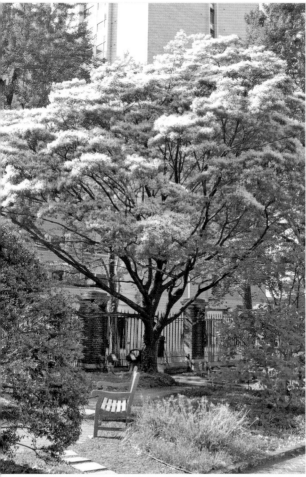

*The Chinese fringetree at the College of Physicians of Philadelphia on
22nd Street is in full bloom in mid-May. It stands next to a smaller
white fringetree (not shown here) that blooms about the same time.*

| LEAVES: Opposite, Smooth | **Flowering Dogwood** *Cornus florida* L. | MATURE HEIGHT: 18-40 ft. |

Fall color variation.

Irregular, rounded crown, often wider than it is tall.

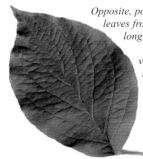

Opposite, pointed, elliptical leaves from 2 to 4 inches long; smooth edges; straight central vein and curving secondary veins following edge contours; dark green, turning red in fall.

If the giant sequoia is the king of North American forests, the flowering dogwood with its graceful branches, delicate blossoms, and crimson fall foliage is the queen. As the author Donald Culross Peattie wrote, "Stepping delicately out of the dark woods, the startling loveliness of a dogwood in bloom makes each tree seem a presence, calling for an exclamation of praise, a moment of worship with our eyes." Sadly, the flowering dogwood is no longer blooming so profusely in the shaded understories of our eastern forests. A virulent fungal disease called dogwood anthracnose, *Discula destructiva*, threatens native dogwoods. However, some cultivars seem less susceptible, especially when they are grown in bright but lightly shaded, breezy locations. They grow best in acidic, moist but well-drained soils, and are not tolerant of urban stresses. The flowering dogwood produces a fine-grained wood that was made into golf club heads, tool handles, and spindles before synthetic substitutes were developed.

Group 8

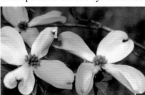

Each cluster of tiny, green dogwood flowers is surrounded by four white, pink, or red petal-like 2-inch bracts (left; lower left). The 1/3-inch, bright red fruits (far lower left) mature in clusters in late summer. The grayish-brown bark (below) is alligatored.

FRUITS

Where to look for Dogwoods

PW: University of Pennsylvania, Hamilton Walk; Bartram's Garden; Woodlands Cemetery; **BC:** Hortulus Farm Garden and Nursery (pine and dogwood allée); **CC:** Longwood Gardens; Jenkins Arboretum; **DC:** Tyler Arboretum; Chanticleer; **DE:** Mt. Cuba Center; Winterthur.

A pink flowering dogwood cultivar at Winterthur has striking burgundy blossoms with white-tipped bracts.

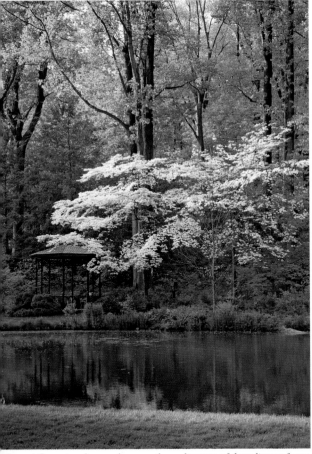

Elegant flowering dogwoods grace the understory of the tuliptree forest at Mt. Cuba Center. They bloom in late April and early May.

LEAVES: Opposite, Smooth	# Kousa Dogwood *Cornus kousa* Hance	MATURE HEIGHT: 20-30 ft.

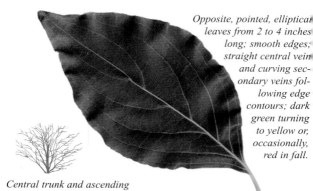

Opposite, pointed, elliptical leaves from 2 to 4 inches long; smooth edges; straight central vein and curving secondary veins following edge contours; dark green turning to yellow or, occasionally, red in fall.

Central trunk and ascending branches create rounded crown.

Group 8

Introduced to North America in 1861, the kousa dogwood is an elegant Asian cousin of the familiar native flowering dogwood (*C. florida*). Botanists theorize that the two species have a common ancestor, but over the millenia the kousa dogwood developed fleshy fruits appealing to monkeys living in China and Japan. The flowering dogwood, on the other hand, had no monkeys in its range and developed hard, red fruits attractive to birds. Like the flowering dogwood, the kousa dogwood has blossoms with showy petal-like bracts, which begin as bud scales protecting the central, tiny green flowers. The kousa dogwood's bracts, though, have pointed tips instead of the broad, notched tips of the flowering dogwood. More resistant to anthracnose, the fungal disease that has killed many flowering dogwoods, the kousa dogwood has gained popularity as a handsome substitute for its North American cousin. A new hybrid of the two, *C. rutgersensis*, is becoming available from nurseries.

FRUIT

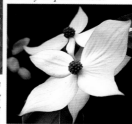

Tiny green flowers are surrounded by 4 to 7 stunning creamy or pink bracts.

The ½- to 1-inch fruits turn red in late summer. Peeling bark creates mosaic patterns of brown, gray, and yellow.

Where to look for Kousa Dogwoods
MC: West Laurel Hill Cemetery;
Barnes Arboretum, near house;
CC: Longwood Gardens; **DC:**
Scott Arboretum; Appleford, allée
along entrance drive; Chanticleer,
Pinetum; Haverford College
Arboretum; **DE:** Winterthur.

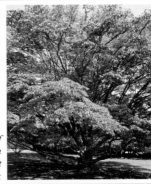

Longwood Gardens has some of
the most beautiful kousa dogwoods in
the country. This large specimen is just
beginning to show its reddish fall color.

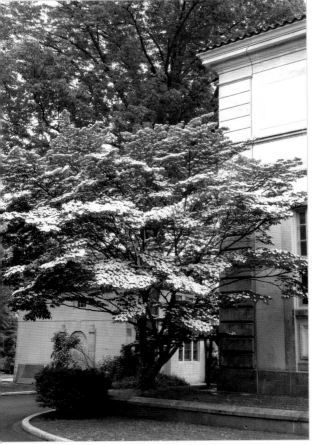

A kousa dogwood in full flower at the Barnes Arboretum blooms in June,
two to three weeks later than its cousin, the native flowering dogwood.

| LEAVES: Opposite, Smooth | | # Cornelian Cherry Dogwood
Cornus mas L. | MATURE HEIGHT 15-25 ft |

Opposite, pointed, elliptical, glossy leaves from 2 to 4 inches long; smooth edges; straight central vein and curving secondary veins following edge contours; dark green; sometimes purplish-red and yellow in fall.

Usually multi-trunked with rounded crown.

Group 8

The cornelian cherry is named for its cherry-like berries. The word "cornelian" is from the Latin *cornus*, the Roman name for this shrub or small tree, native to Europe and western Asia. Actually not a cherry but a dogwood, the cornelian cherry's hard, fine-grained wood was used by the ancient Greeks, Romans, and later Europeans for spear handles and wheel spokes. Its Asian relative, the Japanese cornelian cherry (*C. officinalis*), usually blooms slightly earlier than the cornelian cherry, and its tan bark is more strongly exfoliating.

Cornelian cherry trees are among the very first trees to flower in spring, before their leaves emerge. Each ¾-inch yellow flower cluster produces ⅜-inch red fruits in late summer. The bark is gray brown and flaking.

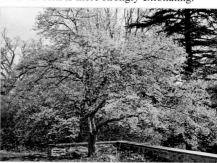

FRUITS

Where to look for Cornelian Cherries PW: University of Pennsylvania, Hamilton Walk; Bartram's Garden. **PNW:** Morris Arboretum **CC:** Longwood Gardens **DC:** Chanticleer.

MATURE HEIGHT: 20-30 ft.	**Japanese Tree Lilac** *Syringa reticulata* (Bl.) Hara	LEAVES: Opposite, Smooth

Opposite, simple, smooth, oval, untoothed leaves, 2 to 5½ inches long without lobes, tapering to a point; central main vein; dark green above, grayish-green and slightly hairy below; unremarkable fall color.

Large shrub or small tree with rounded crown.

The genus *Syringa* includes 20 or 30 shrubs or small trees in the olive family that are native to Europe and Asia. Lilacs were first introduced to the United States during colonial times and were a ubiquitous sight in colonial New England gardens. Today lilacs often invoke a nostalgic feeling for times past. They suffer in warmer climates, and in the United States do not grow further south than North Carolina. The Japanese tree lilac, *Syringa reticulata*, from Japan, Korea, and China, is the largest of the lilacs and most reliably grows into a tree.

Group 8

Where to look for Japanese Tree Lilacs
PCS: Gold Star Park, 613 Wharton St.; **PNW:** Morris Arboretum; **MC:** Barnes Arboretum; **DC:** Chanticleer; Haverford College Arboretum; Tyler Arboretum (lilac collection); Scott Arboretum.

A Japanese tree lilac's white flower panicles bloom from late spring into summer, producing ¼-inch-long seed capsules.

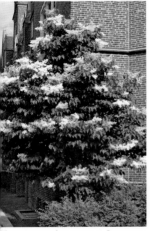

Flower panicles cover a Japanese tree lilac at the University of Pennsylvania in early June.

FRUITS

Katsuratree

Cercidiphyllum japonicum Sieb. & Zucc.

*Color and shape
variations.*

*Straight trunk
or trunks with
ascending
branches.*

*Opposite,
heart-shaped
leaves from
2 to 4 inches
long; edges
with rounded
teeth; main
veins meet at
top of stem;
dark green, turn-
ing to yellow or
gold in fall.*

**Group
9**

Like the ginkgo, the katsuratree belongs to a genus of Asian trees that
were native to the forests of North America before repeated glacia-
tions during the Pleistocene decimated our flora. The genus
Cercidiphyllum returned to North America in the 1860s when
Thomas Hogg, American consul to Japan and the son of a horticul-
turist, sent seeds of the katsuratree from Japan to his brother, who had
taken over his father's Manhattan nursery, and to the Parsons Nursery
in Flushing, N.Y. The Andorra Nursery in Philadelphia was also an
early grower of *Cercidiphyllum*, listing it in its 1901 catalogue.

In Japan and China, the katsuratree achieves a girth and height
greater than any other Asian deciduous tree, and several old trees in
Philadelphia have magnificent, spreading crowns. Its multi-trunked
habit, the rich golds and yellows of its fall foliage, its handsome,
shaggy bark, and its dense rounded crown in maturity make it an
excellent ornamental for lawns and streets. It grows best in moist,
rich soils and shows symptoms of drought early.

*Female trees have split seed pods
on the twigs (below). The ½- to ¾-
inch seed pods form over the sum-
mer, splitting open in late October
to release their thin, winged seeds.*

*Dark brown, shaggy bark on matur-
ing katsuratrees becomes grayish
brown and furrowed on older trees.*

Where to look for Katsuratrees
PW: Fairmount Park, Centennial Arboretum; **PNW:** Morris Arboretum; **MC:** Barnes Arboretum; **DC:** Chanticleer (male and female growing side by side); Scott Arboretum, Isabelle Cosby Courtyard and Magill Walk (weeping cultivar).

Katsuratree fall leaves are usually yellow, but they can turn an apricot hue. They have a sweet, cotton candy smell.

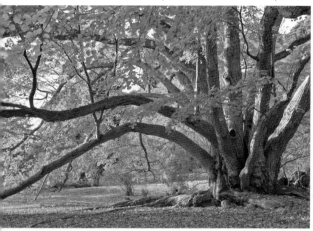

In early October the Morris Arboretum's great katsuratree begins changing color. By month's end, many of its leaves have fluttered to the ground. Katsuratrees are among the first trees to begin losing leaves in fall.

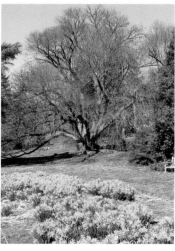

Katsura ½-inch male flowers (above) and female flowers bloom on separate trees before leaves unfold. Thousands of male flowers give a tree a delicate red cast (right) in spring.

| LEAVES: Palmately Compound | **Buckeyes** *Aesculus* spp. | MATURE HEIGHT: 10-90 ft. |

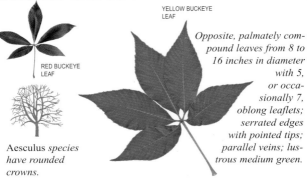

YELLOW BUCKEYE LEAF

RED BUCKEYE LEAF

Opposite, palmately compound leaves from 8 to 16 inches in diameter with 5, or occasionally 7, oblong leaflets; serrated edges with pointed tips; parallel veins; lustrous medium green.

Aesculus *species have rounded crowns.*

The genus *Aesculus*, buckeye, includes seventeen species of trees and shrubs native to Europe, North America, and Asia. All species in the genus have opposite, palmately compound leaves with five or seven leaflets; erect clusters of white, red, or yellow flowers; and spiny or smooth capsules containing large shiny seeds. North America has six native species and Europe just one, *Aesculus hippocastanum*. Mostly smaller trees or shrubs, the North American species of the genus are called buckeyes because their characteristic shiny, dark brown nuts, each with a pale spot, reminded early settlers of deer's eyes. Although the nuts look like the familiar chestnuts sold by street vendors, they are toxic and not fit to eat.

The native **yellow buckeye** (*A. flava*) is a tall tree to 90 feet with yellowish flowers. The **red buckeye** (*A. pavia*), native to the South, is a handsome small tree or shrub with striking upright clusters of red flowers and lustrous, dark green leaves. The **red horsechestnut** (*Aesculus* x *carnea*) is a hybrid, the result of a cross between the red buckeye and its European cousin, the horsechestnut. Larger than the red buckeye, the red horsechestnut may grow 30 to 50 feet tall.

RED BUCKEYE FRUIT

NO SPINES

fruit 1½ to 2½ inches in diameter

A red buckeye's 4- to 8-inch flower clusters (left) are red. A red horsechestnut's 6- to 8-inch clusters (right) are pink.

A yellow buckeye's 6- 8-inch clusters appear after its leaves emerge

Where to look for Buckeyes

W: Bartram's Garden; **PNW:** Awbury Arboretum, in front of the Cope House (large stand of bottlebrush buckeyes); Wissahickon Valley Park, near Environmental Center; **MC:** Barnes Arboretum; Henry Foundation for Botanical Research; **DC:** Scott Arboretum, Pollinator Garden; Tyler Arboretum; Chanticleer; **DE:** Winterthur.

A fine red horsechestnut is one of three at SEPTA's Gravers Station in Chestnut Hill.

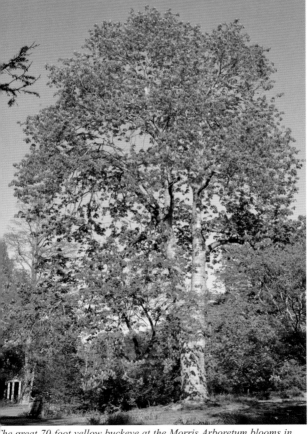

The great 70-foot yellow buckeye at the Morris Arboretum blooms in late April and early May, but its yellowish-green flower clusters are not as obvious and showy as those of a red buckeye or a red horsechestnut.

LEExES: Palmately Compound	**Horsechestnut** *Aesculus hippocastanum* L.	MATURE HEIGHT: 50-85 ft.

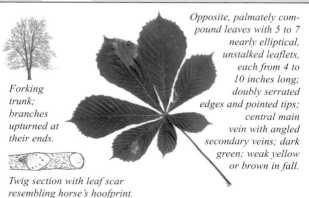

Forking trunk; branches upturned at their ends.

Opposite, palmately compound leaves with 5 to 7 nearly elliptical, unstalked leaflets, each from 4 to 10 inches long; doubly serrated edges and pointed tips; central main vein with angled secondary veins; dark green; weak yellow or brown in fall.

Twig section with leaf scar resembling horse's hoofprint.

Not really a chestnut at all, the horsechestnut is a European relative of the American buckeyes, and is native to the Balkans. In 1746 Peter Collinson, the London cloth merchant and plant enthusiast, sent the first horsechestnut seeds to North America to John Bartram in Philadelphia. No one knows exactly how the horsechestnut got its name. Some say that its fruit may have been the source of a medicine for horses. Another theory suggests that its leaf scars, which look like hoofprints complete with seven nail heads, may have been the inspiration. The shiny, polished nuts in the horsechestnut fruit that drop to the ground in fall look good enough to eat, but they are very bitter and poisonous.

Group 10

Closely related to the horsechestnut are North American species the yellow buckeye, the Ohio buckeye, and the red buckeye. The horsechestnut tree is subject to a fungal leaf disease, which often causes the tree to drop leaves in mid-summer. The native yellow buckeye (*Aesculus flava*) is much more disease resistant.

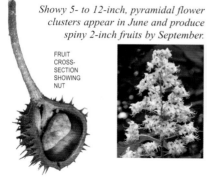

Showy 5- to 12-inch, pyramidal flower clusters appear in June and produce spiny 2-inch fruits by September.

FRUIT CROSS-SECTION SHOWING NUT

Gray bark of older trees is broken into flat scales separated by fissures.

here to look for Horsechestnuts

CS: Rittenhouse Square, lining ain walkways; East Fairmount ark, Lemon Hill Mansion; **PNW:** yck; Awbury Arboretum; Laurel ill Cemetery; **PNE:** Wissinom- g Park; **DC:** Haverford College rboretum; Scott Arboretum (two ecimens planted before 1929).

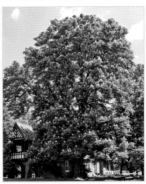

90-foot-tall blooming horsechestnut shades the campus of Carson Valley Children's Aid in Flourtown.

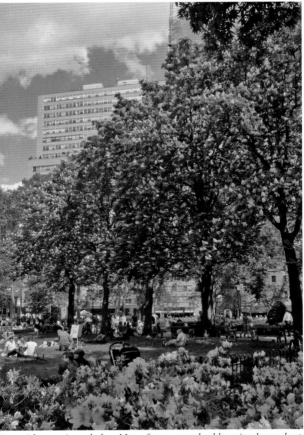

ity residents enjoy a balmy May afternoon under blooming horsechest- uts on Rittenhouse Square. More than twenty mature horsechestnuts ne the walkways of the square and half a dozen more shade the lawns.

LEAVES: Opposite, Lobed		**Paperbark Maple** *Acer griseum* (Franch.) Pax	MATUR HEIGH 20-40 f

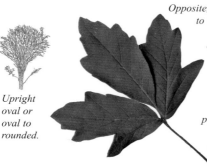

Upright oval or oval to rounded.

Opposite, trifoliate leaves 3 to 6 inches long from end of stem to tip of terminal leaflet, middle leaflets coarsely toothed, lateral leaflets less toothed; dark green above, pale green beneath; lower surface and petiole pubescent.

Group 11

One of a number of trifoliate maples, the paperbark maple is a sma to medium ornamental tree named for its remarkable exfoliati bark. An exquisite specimen tree, it has year-round interest wi striking crimson to orange autumn foliage. The bark can vary fro tree to tree; by the third or fourth year the amount of exfoliation a particular tree will be apparent. Paperbark maples prefer moi well-drained soil and full sun and grow best in the cooler Northea rather than in the South. They are often multi-trunked.

Where to look for Paperbark Maples

PNW: Morris Arboretum; **CC:** Longwood Gardens, Frog Hollow (state champion); **DC:** Scott Arboretum of Swarthmore College, near Sharples Dining Hall (beautiful grouping); Tyler Arboretum; Chanticleer; Haverford College Arboretum.

The beautiful red-brown exfoliating bark can be seen on young trees and may become fissured as the tree ages.

FRUITS

Vivid cinnamon bark makes this paperbark maple at the Scott Arboretum hard to miss

MATURE HEIGHT: 40-75 ft.	**Boxelder** *Acer negundo* L.	LEAVES: Opposite, Compound

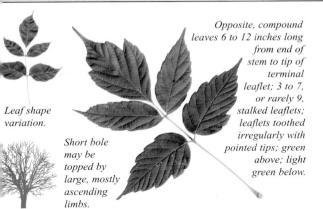

Leaf shape variation.

Short bole may be topped by large, mostly ascending limbs.

Opposite, compound leaves 6 to 12 inches long from end of stem to tip of terminal leaflet; 3 to 7, or rarely 9, stalked leaflets; leaflets toothed irregularly with pointed tips; green above; light green below.

The boxelder is hard to identify as a maple because of its compound leaves; however, the V-shaped samara of the female trees gives it away. In the Northeast, the boxelder is typically found growing in moist soils along waterways or in disturbed roadside soils. It turns dull yellow in fall, tends to be sprawling and crooked, sheds its branches easily, has no shade tolerance, and rarely lives more than 60 years. In the prairie states, the boxelder comes into its own, germinating easily and growing hardily in difficult conditions.

Group 11

Where to look for Boxelders

Boxelders are widespread along streams. **PCS:** Island in Schuylkill River behind Philadelphia Museum of Art; **PNE:** Thomas Scattergood Foundation at Friends Hospital; **DC:** Tyler Arboretum.

Young trees have smooth, gray-brown bark. With age, the bark is broken into narrow ridges and shallow fissures. The profuse 1-inch fruits hang for months on the female trees.

Boxelders grow along the Manayunk Canal, providing shade for the bike path.

FRUITS

| LEAVES: Opposite, Compound | **Ashes** *Fraxinus* spp. | MATURE HEIGHT: 30-80 ft. |

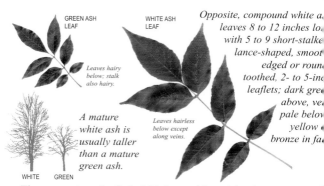

GREEN ASH LEAF

WHITE ASH LEAF

Leaves hairy below; stalk also hairy.

A mature white ash is usually taller than a mature green ash.

Leaves hairless below except along veins.

WHITE GREEN

Opposite, compound white a. leaves 8 to 12 inches lo. with 5 to 9 short-stalke lance-shaped, smoot edged or roun. toothed, 2- to 5-inc leaflets; dark gree above, ve. pale belo. yellow . bronze in fa.

The resonant crack of a ball hitting a white-ash bat has been a fami iar sound in American sports since the 1890s, when the Louisvil Slugger was invented. The **white ash** (*Fraxinus americana*) is th largest of the dozen or so ashes native to the United States. It grow best in fertile soils. Trees 120 feet high were once plentiful in th rich bottomlands of the Ohio River Valley, and trees 80 feet tall a still common throughout the white ash's range, which extends from Nova Scotia to Texas. The **green ash** (*Fraxinus pennsylvanica*), smaller tree than the white ash, is the most widespread American as occurring as far west as Montana. The green ash prefers moist bo tomlands near rivers and streams; however, it will grow in poor, dri soils. Both ashes bear their male and female flowers on separate tree in July. Today ash trees in the Philadelphia region are threatened b the emerald ash borer. This devastating insect can destroy a region al population of ashes in just a few short years. Until a resistant for is found, ashes are not recommended for planting.

Group 11

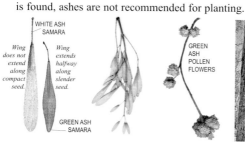

WHITE ASH SAMARA

Wing does not extend along compact seed.

Wing extends halfway along slender seed.

GREEN ASH SAMARA

GREEN ASH POLLEN FLOWERS

Ash's 1- to 2-inch fruits ripen on female trees in clusters. Green ash fruit tips are more pointed than white ash tips.

Pollen of male tree flowers is wind carried to female trees.

A mature white ash's bark is deeply furrowed in a distinctiv interlacing pattern.

‎ere to look for Ashes

CS: East Fairmount Park, Azalea ‎rden and Lemon Hill Mansion; ‎V: Woodlands Cemetery; **PNW:** ‎urel Hill Cemetery; **MC:** ‎lkinweir; West Laurel Hill ‎metery, Belmont section; **DC:** ‎andywine River Museum; ‎anticleer; Haverford College.

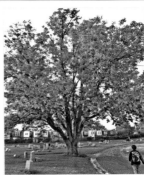

‎rly in October, a white ash at North ‎edar Hill Cemetery is turning color.

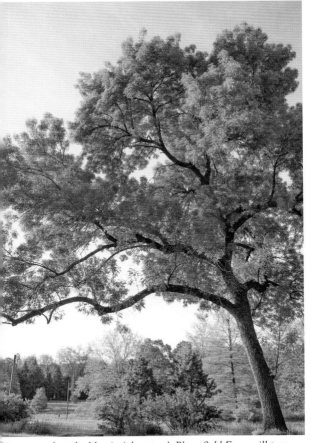

‎his green ash at the Morris Arboretum's Bloomfield Farm will turn ‎llow in fall. Above, the remarkable fall color of the white ash ranges ‎om yellows and oranges to deep purples and maroons.

| LEADERS:
Opposite,
Compound | | **Amur Corktree**
Phellodendron amurense Rupr. | MATURE
HEIGHT
30-45 ft |

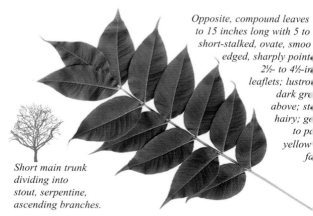

*Opposite, compound leaves
to 15 inches long with 5 to
short-stalked, ovate, smoo
edged, sharply point
2½- to 4½-in
leaflets; lustro
dark gre
above; st
hairy; ge
to p
yellow
fa*

*Short main trunk
dividing into
stout, serpentine,
ascending branches.*

Group 11

The genus *Phellodendron* is derived from Greek words for co
(*phellos*) and tree (*dendron*). Its bark is cork-like but is not used
seal wine bottles. This tree, introduced from China in 1856, has
bold, open habit with large, sinuous branches that, along with
deeply furrowed bark, give it a striking appearance in winter.
fall colors are appealing, too—bright or pale yellows—but the col
is fleeting. It is tolerant of air pollution and free of diseases a
serious pests. The fruits of the Amur corktree are abundant a
attractive to wildlife, helping the tree reproduce easily. However,
has colonized urban parks and invades hardwood forests, outcor
peting natives with its strongly viable seeds. Therefore, many pub
gardens have removed their female plants, and only male clones li
'Macho' are considered for planting. The Amur corktree is one of t
plants used in traditional Chinese medicine; specifically, the bark
thought to have medicinal properties.

*Reddish-brown bark on older trees is
deeply furrowed with corky ridges. The
⅜-inch fruits ripen from green to black.*

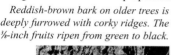

FRUITS

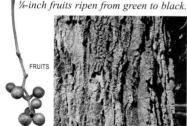

*An Amur corktree briefly turn
bright yellow in the fall.*

here to look for Amur Corktrees

CS: McCall School, 6th Street between Spruce and Pine Streets; **PW:** University of Pennsylvania, Fisher Fine Arts Library; Fairmount Park, Centennial Arboretum; **PNW:** Wylie Street and 19th Street; Morris Arboretum; **CC:** Longwood Gardens.

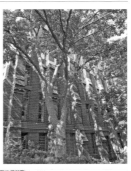

Amur corktrees stand in a row along the side of the Fisher Fine Arts Library at the University of Pennsylvania.

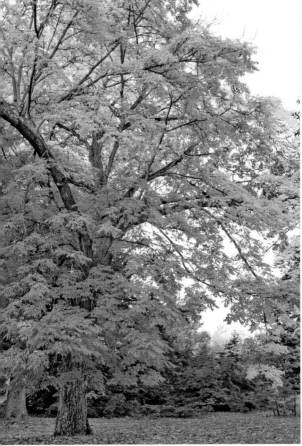

Amur corktree displays its interesting branching structure at the Morris Arboretum. The tree is planted mostly for its bark and its striking winter silhouette, as its yellow fall color persists only briefly.

LEAVES: Alternate, Compound		**Ailanthus** *Ailanthus altissima* (Mill.) Swingle	MATUR HEIGH 50-80 ft

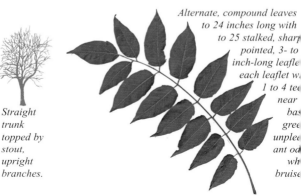

Alternate, compound leaves to 24 inches long with to 25 stalked, sharp pointed, 3- to inch-long leafle each leaflet w 1 to 4 tee near bas gree unplea ant od wh bruise

Straight trunk topped by stout, upright branches.

The ailanthus, the tree that "grows in Brooklyn," is a street-smart tre Brought from China to Philadelphia in 1785 by William Hamilton, was introduced to California by Chinese miners during the gold ru The ailanthus now grows wild from Canada to Argentina. It favors d turbed and urban areas, where it is found in vacant lots and alo fences, railroad tracks, and highways. It tolerates polluted air lad with industrial fumes and traffic exhaust, endures drought and co and thrives in poor soil. An array of survival skills help the ailanth hold its own. It is a prolific seeder, scattering up to 325,000 windblo seeds per tree each year. It secretes toxins that suppress competi plants. Its roots spread fast, wide, and deep, taking advantage of crac in sidewalks and building foundations. It grows upward fast, too, av aging well over a yard per year during its first four years of growth.

Land managers trying to keep the ailanthus, also called the tree heaven, from overwhelming native trees in urban parks and preserv have had only limited success. The ailanthus is seldom planted toda

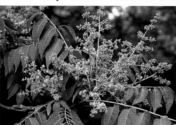

Tiny greenish flowers bloom in 8- to 16-inch-tall clusters in June, with male and female flowers usually on separate trees.

Gray bark on mature trees is roughened, with lighter-colored vertical streaks.

Where to look for Ailanthus

Widespread in vacant urban lots and along rail lines; **PCS:** East Fairmount Park, Lemon Hill Mansion (state champion); **PNW:** Chestnut Hill, Germantown Avenue between E. Gravers Lane and E. Highland Ave. (state champion); **CC:** Longwood Gardens, Peirce's Park (86-foot state champion, an original Peirce tree).

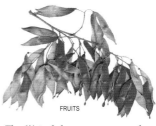
FRUITS

The 1½-inch-long samaras, each containing one seed, hang in large bunches in late summer.

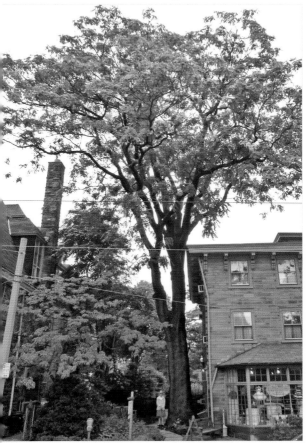

Listed as one of the champion trees of Pennsylvania, this tree of heaven standing close beside a building on Germantown Avenue in Chestnut Hill is almost 70 feet tall with a diameter at breast height of over 50 inches.

LEAVES: Alternate, Compound		# Silktree *Albizia julibrissin* Durazz.	MATURE HEIGHT: 20-35 ft.

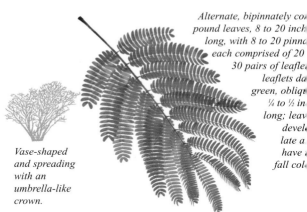

*Alternate, bipinnately compound leaves, 8 to 20 inche
long, with 8 to 20 pinna
each comprised of 20
30 pairs of leafle
leaflets da
green, obliqu
¼ to ½ in
long; leav
devel
late a
have
fall col*

*Vase-shaped
and spreading
with an
umbrella-like
crown.*

Group 12
The genus *Albizia*, which includes trees called silktrees or mimosas,
named for an Italian nobleman, Filippo degli Albizzi, who introduce
Albizia julibrissin to Europe. French botanist André Michaux brought t
tree to America in 1785 from his collections in Persia. It is most easi
identified by the silky flowers that give the tree a tropical look. T
species name *julibrissin* derives from the Persian phrase for "silk flowe
It is fast growing, fruits prolifically, and self-seeds easily. It has natur
ized in the southeastern United States, as well as in Southern Californ
and is considered invasive in some climates. Since the mimosa's leav
slowly close at night, it is called the sleeping tree in Japan.

Historically planted as a specimen tree, the mimosa or silktree is n
common in the nursery industry today because of its invasive tendenci
and susceptibility to disease. Look for it volunteering in vacant lots a
along rail lines and woodland edges.

*Mimosas have smooth gray bark and
5- to 7-inch-long seed pods that form
in late summer and last through winter.*

FRUITS

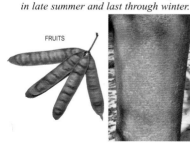

*A mimosa flower's hundreds
thread-like 1-inch stamens ran
in color from light to dark pi*

Where to look for Silktrees

self-seeded along highways and rail lines; **PCS:** Cianfrani Park; Raffie's Restaurant, Pine and Quince Sts.; **PW:** St. Mark's Square and Spruce St. between 42nd and 43rd Sts.; **PNW:** Morris Arboretum; Mount Airy, Stenton Ave. at E. Gowan Ave.

A young mimosa displays the species' typical low-spreading habit at the Morris Arboretum.

Mimosas bear showy flowers, comprised not of petals but of silky, pink stamens that persist from May through August. This tree on Stenton Avenue in Mount Airy is covered with blossoms for weeks in mid-summer.

LEAVES: Alternate, Compound	Japanese Angelica-tree	MAT HEIC
	Aralia elata L.	10-3

Shrub or tree with a few stems or trunks and a few ascending branches; forms thickets.

Alternate, compound leaves up to 60 inch long with dozens toothed, ova pointed, 2- to inch leaflet green and hai above, light gree and pubesce below; yellow fall; prickly stal

Aralia elata or Japanese angelica-tree is the Asian relative of spinosa or devils-walkingstick. The two species are similar, wi five-foot compound leaves consisting of dozens of leaflets that gi the plant an almost tropical look. Both species have a tendency send up shoots covered with wicked, needle-sharp spines from spreading root system. *A. elata* commonly naturalizes, establishi prickly, almost impenetrable stands of saplings, given a wide ber by people and browsing animals. Large, prominent clusters of whi flowers turn into black fruits that are eaten and spread by birds.

Group 12

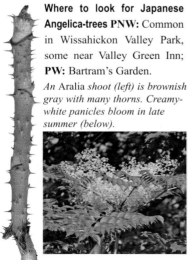

Where to look for Japanese Angelica-trees PNW: Common in Wissahickon Valley Park, some near Valley Green Inn; **PW:** Bartram's Garden.

An Aralia *shoot (left) is brownish gray with many thorns. Creamy-white panicles bloom in late summer (below).*

A multi-trunked Aralia *in Wissahickon Valley Park turns yellow in mid-October.*

| MATURE HEIGHT: 70-80 ft. | # Shagbark Hickory
Carya ovata (Mill.) K. Koch | LEAVES: Alternate, Compound |

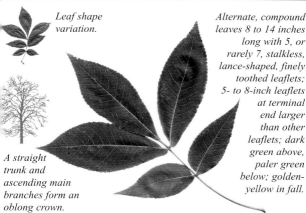

Leaf shape variation.

Alternate, compound leaves 8 to 14 inches long with 5, or rarely 7, stalkless, lance-shaped, finely toothed leaflets; 5- to 8-inch leaflets at terminal end larger than other leaflets; dark green above, paler green below; golden-yellow in fall.

A straight trunk and ascending main branches form an oblong crown.

The distinctive shagbark hickory is the most easily recognized of our hickories, with its gray bark broken into flat plates that continually peel off in long strips. A prodigious nut producer, a mature tree may drop two or three bushels of fruits in a good year—a bonanza for squirrels and for people. Native Americans and early settlers included the shagbark's sweet nuts in many of their recipes. Settlers also made tool handles, furniture, and wagon wheels from its tough, resilient wood, and burned its logs to heat their cabins and cure their meat. Hickory chips are still used today for smoking meats and barbeque.

Group 12

Where to look for Shagbark Hickories
PNE: Pennypack Park, Sandy Run; **BC:** Tyler Formal Gardens, Bucks County Community College, near terrace; Bowman's Hill Wildflower Preserve; **MC:** Scott Arboretum, near the Pinetum; Tyler Arboretum.

The bark's gray plates are loose at one or both ends. The husk of the 1¼- to 2½-inch fruit is grooved.

FRUITS

In late October, a large shagbark hickory turns yellow gold at the Morris Arboretum.

| LEAVES: Alternate, Compound | **Hickories** *Carya* spp. | MATURE HEIGHT 50-80 ft. |

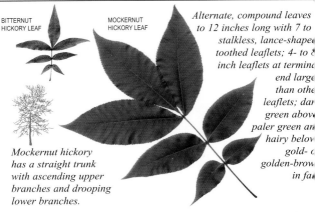

BITTERNUT HICKORY LEAF

MOCKERNUT HICKORY LEAF

Alternate, compound leaves to 12 inches long with 7 to stalkless, lance-shape toothed leaflets; 4- to 8 inch leaflets at termin end large than othe leaflets; dar green abov paler green an hairy belov gold- golden-brow in fa

Mockernut hickory has a straight trunk with ascending upper branches and drooping lower branches.

Hickory trees were an important component of old-growth fores in the Wissahickon Valley. The Lenape Indians used fire to manag the native forests, and fire favored hickories and oaks because their thick bark and deep root systems. After a fire cleared brus from the forest floor, hickory nuts germinated easily. Forest com position changes, caused in part by a reduction of forest fires sinc European settlement, have diminished the hickory population in th Wissahickon Valley.

Group 12

Farmers once let their hogs root under the **pignut hickor** (*Carya glabra*) for its fallen nuts, which are too sour for peopl The pignut is a tough tree, able to thrive in poor soils and dry loca tions. The **mockernut hickory** (*Carya tomentosa*) is the most com mon hickory in the South. Early accounts of life in the coloni describe native Americans making mockernuts into a milky liqu they called *pocohicora*. The most widely distributed of the hicko ries, the **bitternut hickory** (*Carya cordiformis*) has the least-edib nut; many survive to germinate because squirrels dislike them a much as people do. Bright sulphur-yellow buds on branch end make the tree easy to identify in winter.

The 1- to 1½-inch pignut fruits may be pear shaped.

NUT IN HUSK

NUT WITH HUSK REMOVED

The 2-inch mockernut fruit has a thick, dark brown husk and a small, light brown nut.

Seamed, ¾- to 1¼-in bitternut hickory fru open as they ripen.

UNRIPE FRUIT

RIPENED FRUIT

Where to look for Hickories

PCS: FDR Park, near wetland by skatepark (mockernut hickory); **BC:** Henry Schmieder Arboretum of Delaware Valley University, near vernal pools (pignut hickory); Bowman's Hill Wildflower Preserve (mockernut hickories); **CC:** Jenkins Arboretum; **DC:** Chanticleer, Orchard and Bell's Run; Taylor Arboretum; **NJ:** Barton Arboretum of Medford Leas.

A tall bitternut hickory shades the historic Springfield Mills at the Morris Arboretum.

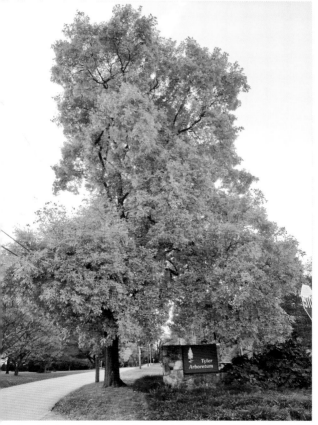

A pignut hickory displays its characteristic honey-gold fall color at the entrance of the Tyler Arboretum in the twilight of a mid-October afternoon. Late to leaf out, pignut hickories can look dead in spring.

LEAVES: Alternate, Compound		# American Yellowwood	MATURE HEIGHT:
		Cladrastis kentukea (Dum. Cours.) Rudd	30-50 ft.

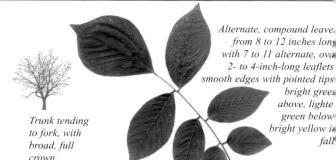

*Alternate, compound leave.
from 8 to 12 inches long
with 7 to 11 alternate, ova
2- to 4-inch-long leaflets
smooth edges with pointed tips
bright gree.
above, lighte
green below
bright yellow i.
fall*

Trunk tending to fork, with broad, full crown.

As the American yellowwood's name hints, its heartwood is bright yellow and the bark of the roots produces a yellow dye that pioneers used to color homespun yarn. Extremely hard, heavy, and fine-grained, the wood was also fashioned into gun stocks by early settlers. Rare in the wild, the American yellowwood is a small, graceful tree with a forking trunk, spreading branches, and a rounded crown. When not crowded by other trees, it can attain a height of 60 feet, but most mature specimens are smaller. Very limited in range, this member of the pea family grows naturally only in the southern Appalachian Mountains of Tennessee and in portions of Missouri and Arkansas. Highly regarded as an ornamental, the American yellowwood has been planted throughout the Northeast and also in Europe, where its seeds were sent nearly 200 years ago. In early to mid-May, the American yellowwood is bedecked with white flowers, which hang in loose clusters twelve to fourteen inches long. Trees will often bloom only every second or third year. By mid-August, the bean-like seedpods are fully developed and begin to ripen. Each pod contains a few flat, hard seeds.

Group 12

SEED PODS

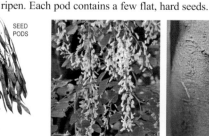

Clustered flowers bloom in May, producing 2- to 4-inch papery seed pods, or legumes, that drop in autumn.

*The smooth bark is silvery gray or brown, and somewha.
resembles beech bark.*

Where to look for American Yellowwoods
PCS: Franklin Square; East Fairmount Park, Azalea Garden; Philadelphia Museum of Art, Anne d'Harnoncourt Sculpture Garden; **PW:** Bartram's Garden; University of Pennsylvania, Arthur Ross Gallery (large specimen in front); **PNW:** Laurel Hill Cemetery; Morris Arboretum; **DC:** Scott Arboretum of Swarthmore College, between Parrish and Clothier Halls.

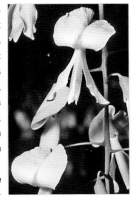

Flowers and leaves unfold together. Each flower's top petal is streaked with yellow.

A flowering American yellowwood in Chestnut Hill adds its fragrance to the air on a May afternoon. It could skip a year before flowering again.

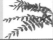

| LEAVES:
Alternate,
Compound | # Honeylocust
Gleditsia triacanthos L. | MATURE
HEIGHT:
40-70 ft. |

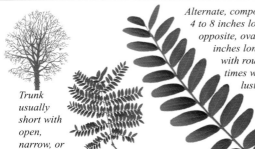

Alternate, compound leaves from 4 to 8 inches long with 18 to 30 opposite, oval leaflets ⅓ to 1½ inches long; smooth edges with rounded tips, sometimes with small points; lustrous, dark green above, dull yellow-green below; yellow in fall.

Trunk usually short with open, narrow, or spreading crown.

Leaves are sometimes doubly compound.

A honeylocust may have distinctive large, sharp, branched spines growing in irregular clumps from its trunk and branches. A medium-sized tree with delicate foliage and slender, sometimes horizontal branches, it is native to states close to the Mississippi River, from the Great Lakes to the Gulf of Mexico. It has been planted beyond its range as far north as Canada. Because it tolerates the harshest urban conditions, such as salt runoff, pollution, and drought, the thornless variety (*Gleditsia triacanthos* var. *inermis*) is widely planted in northeastern cities, and it is a common street tree in Philadelphia. The honeylocust's inconspicuous male and female flowers occur on separate trees in early May as the leaves unfold. On female trees seed pods mature by autumn, often reaching a foot or more in length. The black, beanlike seeds inside the seed pods are enclosed in a sweet, succulent pulp from which the tree derives its name. This pulp is a favorite food of cattle and wildlife, which spread the seeds far and wide. Most cultivated clones are male selections, since the pods are considered messy and a sidewalk hazard.

Group 12

SEED POD

Odorless flower clusters produce 7- to 18-inch-long flat pods with shiny, brown seeds.

The number of thorns on a trunk can vary. Some trunks are densely covered; others have few thorns, if any.

Where to look for Honeylocusts

Widely planted as an urban street tree; **PCS:** FDR Golf Club; Society Hill (street trees); Philadelphia Museum of Art, sculpture garden; **PW:** Bartram's Garden; University of Pennsylvania, Mack Plaza (bosque); **PNW:** Wagner Free Institute of Science (copper varietal); Philadelphia University, White Corners (huge tree).

In the Philadelphia Museum of Art's sculpture garden, honeylocusts shade Sol LeWitt's concrete-block Steps *and* Pyramid *sculptures.*

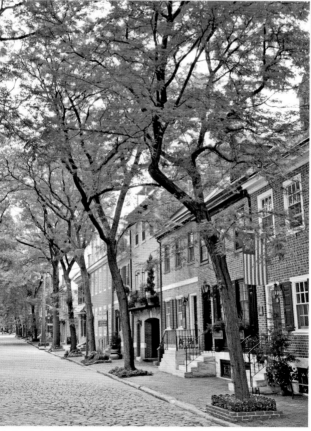

A street planting of thornless honeylocusts in Society Hill shows the slender habit and light texture of this lovely tree. Slow to leaf out in spring, it is among the first trees to drop its leaves in autumn.

LEAVES: Alternate, Compound

Kentucky Coffeetree
Gymnocladus dioicus (L.) K. Koch

MATURE HEIGHT 60-100 f

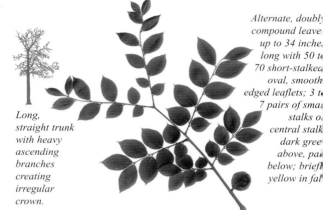

Long, straight trunk with heavy ascending branches creating irregular crown.

Alternate, doubly compound leaves up to 34 inches long with 50 to 70 short-stalked, oval, smooth edged leaflets; 3 to 7 pairs of small stalks on central stalk; dark green above, pale below; briefly yellow in fall.

Group 12

The Kentucky coffeetree is a relatively rare Midwestern species whose range includes Pennsylvania. Its species name, *dioicus*, refers to the fact that male and female flowers bloom on separate trees. A legume, the tree bears large, pea-like pods containing hard seeds that are toxic when raw but at one time were roasted by pioneers to make a coffee substitute. Although sparsely branched when young, it has shown promise as a street tree. A fruitless male clone like 'Espresso' is best for streetside use, as pods of female trees are messy and a slipping hazard.

Where to look for Kentucky Coffeetrees
PCS: Jefferson Square Park; **PNW:** Wissahickon Valley Park, Andorra Natural Area, near dam (state champion); Laurel Hill Cemetery; **CC:** Longwood Gardens, Peirce's Park; **DC:** Scott Arboretum, near allée of swamp white oaks; Chanticleer; Haverford College.

The dark gray bark is scaly and fissured. The 6- to 10-inch long pods each contain 6 or more ¾-inch seeds.

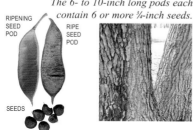

RIPENING SEED POD

RIPE SEED POD

SEEDS

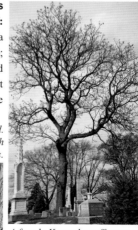

A female Kentucky coffeetree at Laurel Hill Cemetery still bears seedpods in mid-November.

| MATURE HEIGHT: 50-90 ft. | **Black Walnut** *Juglans nigra* L. | | LEAVES: Alternate, Compound |

Alternate, compound leaves 12 to 24 inches long with 9 to 23 nearly stalkless, lance-shaped, sharply pointed, 2½- to 5-inch-long leaflets; finely toothed; lustrous dark green above, paler green and hairy below; yellow in fall.

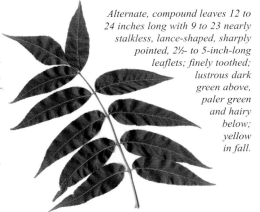

Branching trunk with alternating, heavy limbs; open, irregular crown.

Intolerant of shade, the black walnut secures its ecological niche by producing substances that retard the development of other plants around it. The black walnut was once plentiful in the eastern United States, but almost all the great old-growth forest trees are gone now, felled by lumbermen seeking America's finest cabinetry wood. For generations, walnut was the preferred wood for chairs, tables, desks, and bedsteads. Not a desirable landscape plant because its nuts can be messy, today black walnut is mainly found in natural areas.

Group 12

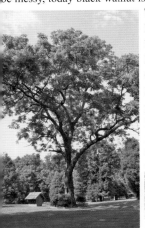

Where to look for Black Walnuts

Bottomlands along streams; **PW:** University of Pennsylvania, James G. Kaskey Memorial Park; Woodlands Cemetery, near house; **BC:** Hortulus Farm Garden and Nursery, swan pond; **DC:** Chanticleer; **DE:** Hagley Museum and Library.

The deeply furrowed bark is broken into intersecting ridges. Each 1½- to 3-inch fruit contains a single, tasty nut.

Open-grown, a very large black walnut stands near a private residence in Montgomery County.

FRUITS

LEAVES: Alternate, Compound	**Panicled Goldenraintree**	MATURE HEIGHT: 30-40 ft.
	Koelreuteria paniculata Laxm.	

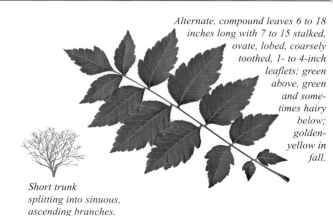

Alternate, compound leaves 6 to 18 inches long with 7 to 15 stalked, ovate, lobed, coarsely toothed, 1- to 4-inch leaflets; green above, green and sometimes hairy below; golden-yellow in fall.

Short trunk splitting into sinuous, ascending branches.

Group 12

Thomas Jefferson was probably the first person to grow a goldenraintree in America, using seeds sent from France in 1809. A native of northeastern Asia, the goldenraintree was planted for thousands of years next to the graves of important Chinese government officials. It is a tough, mid-sized urban tree, able to withstand heat, drought, high winds, salt, and poor soil. It is also an exceptionally beautiful tree, especially in summer when it produces a profusion of yellow blossoms, which yield lantern-like fruits containing shiny black seeds.

Where to look for Goldenraintrees

PCS: 10th Street and Washington Ave.; 18th and North Streets; Headhouse Square; **PW:** Bartram's Garden; Philadelphia Zoo; **PNW:** Awbury Arboretum; **BC:** Hortulus Farm; **MC:** West Laurel Hill Cemetery; **DC:** Chanticleer.

Fissures in the pale brown bark reveal an orangish underbark. After the 1½-inch fruits ripen, they turn papery tan.

FRUITS

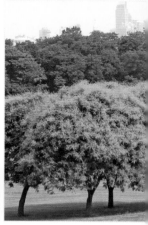

Goldenraintrees are covered with yellow flowers on Fairmount Park's Belmont Plateau in June.

| MATURE HEIGHT: 20-40 ft. | **Amur Maackia** *Maackia amurensis* Rupr. & Maxim. | | LEAVES: Alternate, Compound |

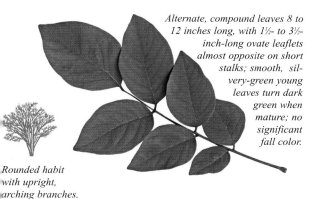

Alternate, compound leaves 8 to 12 inches long, with 1½- to 3½-inch-long ovate leaflets almost opposite on short stalks; smooth, silvery-green young leaves turn dark green when mature; no significant fall color.

Rounded habit with upright, arching branches.

Named for the Amur River where this species was discovered near the Siberian Chinese border, the Amur maackia is a medium-sized tree in the legume family Fabaceae. The Amur maackia has summer-blooming flowers that unfold from silvery buds in late June and July and handsome tan and copper exfoliating bark. Similar to its relative, the black locust, it can tolerate difficult soil conditions, drought, and shade. Currently fairly rare in the trade, the Amur maackia could be more widely used along streets and in other stressful sites.

Group 12

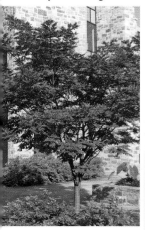

Where to look for Amur Maackias

PNW: Morris Arboretum, Bloomfield Farm (a number of specmens along Northwestern Avenue); **DC:** Scott Arboretum of Swarthmore College; Haverford College Arboretum.

Handsome copper bark exfoliates into curly strips. Off-white flower clusters turn into 3-inch-long seed pods.

FRUITS

An Amur maackia in July at Scott Arboretum bears upright flower panicles beginning to bloom.

| LEAVES: Alternate, Compound | **Sumacs** *Rhus* spp. | MATURE HEIGHT: 15-40 ft. |

SHINING SUMAC LEAF STAGHORN SUMAC LEAF

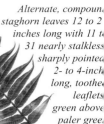

Alternate, compoun staghorn leaves 12 to 2 inches long with 11 t 31 nearly stalkless sharply pointe 2- to 4-inc long, toothe leaflets green abov paler gree below; brigl scarlet an yello in fal

Thin trunk with a few stout, ascending branches.

Wings on stem extend between leaflets.

Sumacs are wanderers and opportunists. These large shrubs or sma native trees invade sunny forest clearings, vacant lots, and untende roadside edges. How do they get there? The sumacs have a compac with the birds. They wave their tempting, red fruit clusters abov snow and pilfering rodents all winter, beckoning hungry birds t come and eat. The birds return the favor by passing the single see enclosed in each small, juicy fruit through their digestive system unharmed and depositing them miles away. Three species of suma are common in southeastern Pennsylvania. They are most noticeabl in autumn as the leaves turn brilliant shades of orange and red.

The **smooth sumac** (*Rhus glabra*), one of the few trees found i all 48 contiguous states, is named for its smooth and hairless twig The **shining sumac** (*Rhus copallina*) is easy to identify by th "wings" on its central leaf stalk and by its lustrous leaves. Th **staghorn sumac** (*Rhus typhina* or *Rhus hirta*) resembles the smoot sumac, but its twigs are hairy and velvety, like dee antlers in their velvet stage.

FRUITS

The smooth sumac's ⅛-inch, red fruits are crowded in upright clusters 6 to 10 inches tall. Eaten by a variety of birds, the fruits were once used to make a cooling drink like lemonade.

Young bark (above) is smooth with lenticels. Mature bark is scaly.

Where to look for Sumacs

Along roadsides, rail lines, and in vacant lots; **PNW:** Wissahickon Valley Park; Carpenter's Woods; **PNE:** Pennypack Park; **PW:** Bartram's Garden; **DC:** Brandywine River Museum.

'Laciniata,' a handsome sumac cultivar, has finely divided leaves.

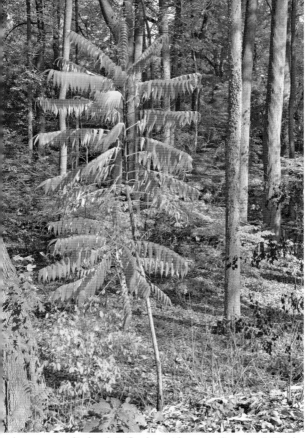

Staghorn sumacs display their flamboyant leaves in Carpenter's Woods. Few other North American trees surpass the sumacs' brilliant fall color.

LEASE: Alternate, Compound		# Black Locust *Robinia pseudoacacia* L.	MATUR HEIGHT 40-80 ft

Alternate, compound leaves from 8 to 14 inches long with 7 to 19 opposite, oval, 1½- to 2-inch leaflets; smooth edges with rounded tips, sometimes with small points; dull blue-green above paler below with some hair on midvein; pale yellow in fall

Trunk tending to fork with irregular, open crown.

The black locust's Latin name honors Jean Robin, gardener Henry IV of France. Robin was among the first to plant the blac locust in Europe, where it is now a weed tree. A member of th legume family, it has white, fragrant, pea-like flowers and frui Nodes on its roots are inhabited by bacteria that transform atmo pheric nitrogen into nitrates usable by plants. Native to the Ozar and the southern Appalachians, it has been established in man northeastern states and is widely planted in temperate are throughout the world. It is a pioneering tree that springs up on di turbed ground and in forest openings but is later succeeded by mo shade-tolerant species. Though adaptable to urban stresses, in lan scape plantings black locusts tend to be fast growing, relative short lived, and susceptible to storm breakage.

Black locust wood is hard, durable, and rot resistant. It was us by pioneers for fence posts and by shipwrights for pegs, which oft outlasted the hull planks they fixed in place. Later, it was cut f cross-arms of telephone and power lines.

Group 12

SEED PODS

Showy, fragrant flowers bloom in clusters in May, producing 2- to 4-inch, flat seed pods.

Thick, deeply furrowed and scaly bar on mature trees is gray or orange brown. Inner bark and shoots are tox

here to look for Black Locusts

long highways and railroad tracks;
CS: Lemon Hill Mansion; St. Richard
f Chichester Church, 18th and Pollock
treets; **PW:** Bartram's Garden, entrance
rive; **PNW:** Awbury Arboretum; **DC:**
hanticleer, near visitor pavilion (gold-
afed cultivar 'Frisia').

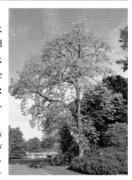

*A black locust blooms at the Morris
Arboretum. Its pendant, white blossoms
perfume the air for two or three days,
attracting hordes of pollinating insects.*

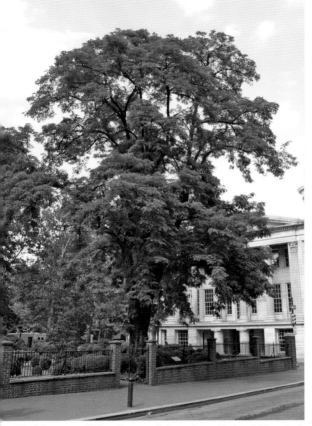

*his black locust on Walnut Street in Independence National Historical
ark shows the rather scraggly habit of an older tree. On rainy days
nd as evening approaches, the leaflets fold and the leaves droop.*

LEAVES:
Alternate,
Compound

Chinese Scholartree

Styphnolobium japonicum Schott

MATUR
HEIGHT
40-75 ft

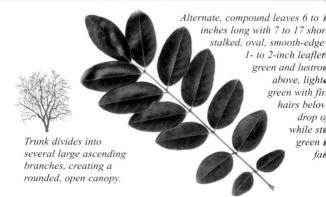

*Alternate, compound leaves 6 to
inches long with 7 to 17 shor
stalked, oval, smooth-edge
1- to 2-inch leaflet
green and lustrou
above, light
green with fir
hairs belov
drop o
while st
green i
fa*

*Trunk divides into
several large ascending
branches, creating a
rounded, open canopy.*

The oldest Chinese scholartree on record in the United States is fro
1811, when seeds from Britain were growing in the Elgin Botanic
Garden, located where Rockefeller Center now stands in Manhatta
A legume like its American cousin the yellowwood, the Chines
scholartree bears showy clusters of fragrant, creamy-white flowe
in mid-summer after most trees have finished blooming. Each flowe
produces a long green pod, which can be messy when it falls. Ver
tolerant of polluted air, heat, and drought, the Chinese scholartree
a handsome and successful street and city park tree.

Group
12

**Where to look for Chinese
Scholartrees PCS:** Society
Hill (street trees); Philadelphia
Museum of Art; **MC:** West
Laurel Hill Cemetery; **CC:**
Longwood Gardens.

*The 3- to 8-inch pods ripen by
October and hang on the tree all
winter. The grayish-brown bark
of old trees is broken into long,
flat ridges with deep fissures.*

FRUIT

*These Chinese scholartrees planted
along West Avenue in Jenkintown a
in full bloom in late July.*

Chinese Toon

Toona sinensis (A. Juss.) M. Roem.

LEAVES: Alternate, Compound

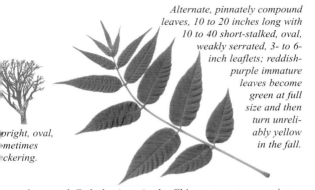

Alternate, pinnately compound leaves, 10 to 20 inches long with 10 to 40 short-stalked, oval, weakly serrated, 3- to 6-inch leaflets; reddish-purple immature leaves become green at full size and then turn unreliably yellow in the fall.

upright, oval, sometimes suckering.

Formerly named *Cedrela sinensis*, the Chinese toon tree was introduced to the West in 1862, although it is not widely cultivated in the United States today. Similar in habit and leaf to the ailanthus, the Chinese toon can be identified by the fact that its leaves do not have teeth or glands near the bases. Chinese toon leaves have a distinctive oniony smell, and the Chinese harvest young shoots and leaves for cooking. The plant is commonly used in traditional Chinese medicine and the wood is considered a "true mahogany" used to make furniture and instruments.

Group 12

Where to look for Chinese Toons

PCS: Old Swedes' Church; **PNW:** Wissahickon Valley Park, Andorra Natural Area; E. Vernon Road between Chew Ave. and Boyer St.; **PNE:** Frankford neighborhood (street trees).

Smooth on young trees, the bark peels and comes off in long strips as the tree ages. Winged seeds fall in 1-inch woody capsules.

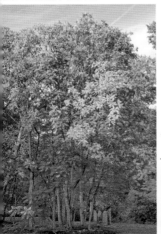

A grove of Chinese toon trees at the Morris Arboretum is beginning to turn golden yellow in mid-October.

FRUIT

| LEAVES: Alternate, Lobed | | # Sweetgum
Liquidambar styraciflua L. | MATUR HEIGH 80-100 |

Leaf shape and color variation.

Alternate, star-shaped leav 3 to 7½ inches wide with 5 7 lobes; edg finely toothe main veins radia from stem to tips points; equ sides; dark, gloss green above, paler belo yellow, orange, purp and red in fa fragrant whe crushe

Young tree has pyramidal crown; older tree, oblong crown (left).

The sweetgum is native to the southeastern United States but occu naturally as far north as southern Connecticut. The sweetgum attai its most impressive proportions in the moist bottomlands of th Mississippi Valley, where specimens more than 130 feet tall and feet in diameter are not uncommon. The sweetgum's Latin nam *Liquidambar styraciflua*, was inspired by the sweet-smelling, ba samic liquid exuded from its bark. From before colonial times, th sap has been used for treating wounds, respiratory ailments, ar dysentery, and as chewing gum.

Sweetgum trees are easy to identify in winter. Their brown, drie seed balls litter the ground beneath the trees, and some remain on th branches. These spiky spheres are composed of many individu seed capsules, each ending in two prickly points. The capsules ar empty in winter, all of the tiny winged seeds having been shaken ou by the wind while the seed ball was still on the tree.

Group 13

DRIED SEED BALL

Pollen-bearing flowers (top) and seed-bearing flowers (bottom) develop in the spring.

The grayish-brown bark of th main trunk is deeply furrowe

Where to look for Sweetgums

CS: Penn's Landing; Weccacoe Park; Girard Park; **PNW:** Manayunk (street trees); Pastorius Park, Chestnut Hill; **MC:** West Laurel Hill Cemetery; **CC:** Longwood Gardens, Pierce's Park; **DC:** Tyler Arboretum, Painter Collection; Chanticleer; **DE:** Mt. Cuba Center (two allées).

Although not very tolerant of stressful urban conditions, these young sweetgums have been planted as street trees along Main Street in Manayunk.

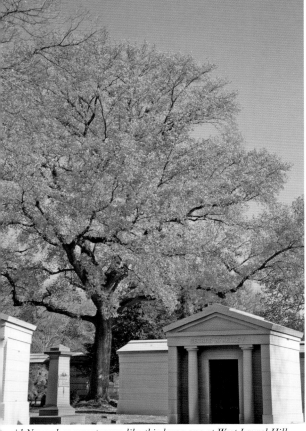

In mid-November, sweetgums, like this large one at West Laurel Hill Cemetery, turn brilliant shades of yellow, orange, red, and burgundy.

| LEAVES: Alternate, Lobed | **Tuliptree** *Liriodendron tulipifera* L. | MATURE HEIGHT 70-150 f |

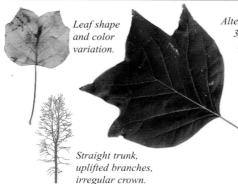

Leaf shape and color variation.

Alternate leaves from 3 to 8 inches long, most with 4 lobes separated by rounded notches; smooth edges; bright green above, paler below; golden yellow in fall.

Straight trunk, uplifted branches, irregular crown.

The tallest hardwood tree in North America, the tuliptree is t monarch of the magnolia family. Also confusingly known as t tulip poplar, the tuliptree can attain a height of well over 150 fe with an absolutely straight trunk 8 to 10 feet in diameter and tota ly clear of branches for 80 or 100 feet. Giants like these may b found growing in the Wissahickon Valley and in Pennypack Par Pioneers used tuliptree wood to make dugout canoes and log cabi because it is light and easy to work. Now, loggers cut it for crate siding, door and window frames, and plywood veneer.

Group 13

A striking ornamental, the tuliptree is widely planted in urban an suburban settings throughout the eastern United States and Europe. It is not, however, highly tolerant of urban stress. Its han some greenish-yellow and orange flowers appear in spring just aft the leaves unfold. Many of the erect, cone-like spikes of samar formed from the flowers remain on the tree after the leaves fa making winter identification easy.

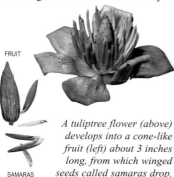

FRUIT

A tuliptree flower (above) develops into a cone-like fruit (left) about 3 inches long, from which winged seeds called samaras drop.

SAMARAS

This is the base of the huge Longwood Gardens tuliptree, t Northeast's tallest at 164.2 fee

Where to look for Tuliptrees

CS: Franklin Square; Girard Park; DR Golf Club; **PNW:** Wissahickon Valley Park; Carpenter's Woods; **PNE:** Pennypack Park; **BC:** Bowman's Hill Wildflower Preserve; Henry Schmieder Arboretum; **MC:** Longwood Gardens (tallest in the U.S.); **DC:** Tyler Arboretum; Scott Arboretum, amphitheater; Chanticleer; Barnes Arboretum; **DE:** Mt. Cuba Center; Winterthur.

Pennypack Park's tuliptree forest contains the city's tallest tuliptree at 143.5 feet.

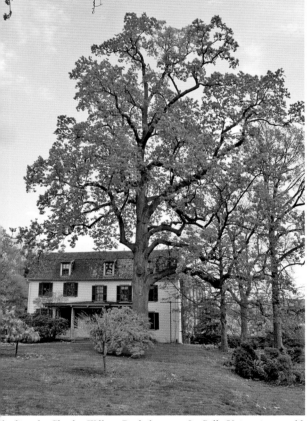

...shading the Charles Willson Peale house at La Salle University, an old tuliptree has thick branches because it has always grown in the open.

LEAVES: Alternate, Lobed		# Mulberries *Morus* spp.	MATUR HEIGHT 20-50 f

WHITE MULBERRY LEAVES

*Alternate, simple, ov
white and red mu
berry leaves are
to 8 inch
long; unlob
or with 2
3 lobe
toothe
stem m
exude mil
juice; centr
vein exten
to t*

*White mulberry
upper leaf surfaces
are shiny and
smooth; the lower,
smooth but may have
hairy veins. Red
mulberry upper leaf
surfaces are rough;
the lower, hairy.*

*Short trunk splits
into stout ascend-
ing branches.*

PAPER MULBERRY LEAF

*Paper mulberry leaves m
have three large, sharply
pointed lobes.*

Group 13

Mulberry trees have been cultivated for millennia. The wife of th
Chinese emperor Huang-ti (2640 BC) encouraged the planting of th
white mulberry (*Morus alba*) to feed silkworms. Pliny (AD 23–7
called the mulberry "the wisest of trees" because it leafs out only aft
the last frost. King James I sent white mulberries and silkworms
the Virginia Colony in 1623 in an unsuccessful attempt to foster si
production. Two centuries later William Prince, a nurseryman
Flushing, New York, imported several white mulberry varieties to se
as ornamentals and to start a silk industry. He did not produce muc
silk, but he firmly established the white mulberry in New York.

Much more aggressive than the native **red mulberry** (*Mor
rubra*), the white mulberry tolerates heat, compacted soil, relativel
high salinity, and air pollution. It also grows faster and taller than th
red mulberry. Another closely related Asian tree naturalized i
Philadelphia is the **paper mulberry** (*Broussonetia papyrifera*). Like th
white mulberry, it spreads rapidly as birds scatter its seeds far and wid

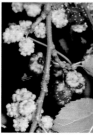

*The bark of both red
and white mulberries
is reddish brown and
fissured. The edible
but messy fruits of
the white mulberry
(left) may be white,
pink, red, or purple.
Red mulberries ripen
in early summer to
orange, red, or purple.*

Where to look for Mulberries
PW: Bartram's Garden; Woodlands Cemetery, behind the house, near river; **CC:** Longwood Gardens, Main Fountain Garden, northwest corner (state champion); **DC:** Haverford College Arboretum.

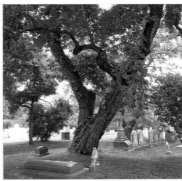

A large white mulberry in the Woodlands Cemetery is about a century old.

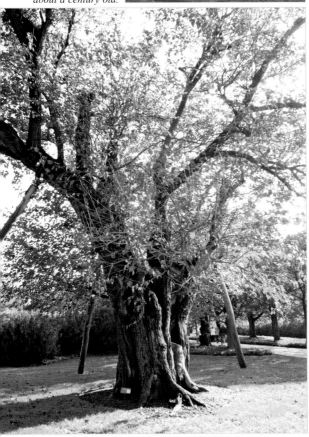

A champion tree of Pennsylvania, this venerable white mulberry at Longwood Gardens with a trunk 8 feet across has supports for its large branches. A mulberry tree can bear male or female flowers or both.

| LEAVES: Alternate, Lobed | | # American Sycamore *Platanus occidentalis* L. | MATUR HEIGHT 60-120 f |

Leaf shape and color variation.

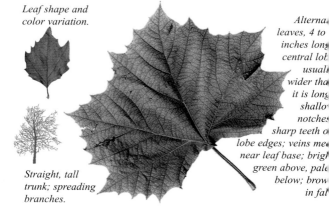

Alterna leaves, 4 to inches long central lob usual wider tha it is long shallo notches sharp teeth o lobe edges; veins me near leaf base; brigh green above, pale below; brow in fal

Straight, tall trunk; spreading branches.

Group 13

The American sycamore's trunk attains a girth greater than that o any other of our deciduous native trees. Nineteenth-century natural ists recorded giant sycamores with trunks more than thirteen feet i diameter growing in the moist bottomlands of the Ohio River Valley Nowadays, however, a mature tree is unlikely to exceed four or fiv feet in diameter and 100 to 120 feet in height.

Easy to spot from a distance, the American sycamore's beautifu upper branches, with their light brown, almost white bark, stand ou in stark contrast to the darker limbs of most other trees. Its outer bar cannot stretch, so it peels off in thin plates as the tree grows. While sycamore ages, its lower trunk gradually changes from mottled ligh grays and browns to a scaly dark brown. The sycamore is more sub ject to defoliation by anthracnose disease than the London planetree

The American sycamore produces a single ¾- to 1¼-inch fruit head on a slender stem. A fruit head consists of hundreds of tiny seeds with hairy tufts.

A mature sycamore's lower trunk is brown and scaly. Bark on its upper trunk and limbs flakes, exposing whitish inner bark.

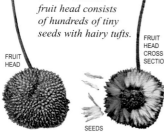

FRUIT HEAD

FRUIT HEAD CROSS SECTION

SEEDS

Where to look for American Sycamores
in river valleys; as street trees in the
city; **PCS:** Washington Square; **PNW:**
Cresheim Creek; Wissahickon Valley
Park, along the creek; St. James the
Lesser Church; Awbury Arboretum;
NE: Palmer Burial Ground, Fishtown;
Greenwood Cemetery; **MC:** West
Laurel Hill Cemetery; **DE:** Mt. Cuba
Center; Winterthur.

*A very large sycamore at the old
Palmer Cemetery in Fishtown measures
5.25 feet in diameter at waist height.*

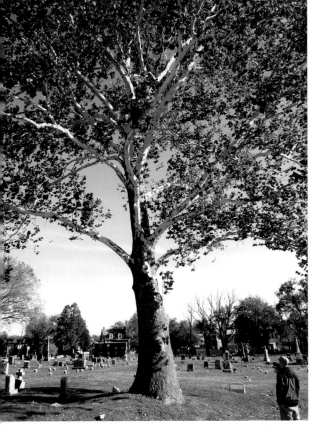

*A handsome American sycamore at Greenwood Cemetery exhibits the
species' typical light upper trunk and limbs and brown lower trunk.*

LEAVES: Alternate, Lobed	# London Planetree	MATURE HEIGHT: 60-120 ft.
	Platanus x *acerifolia* (Aiton) Willd.	

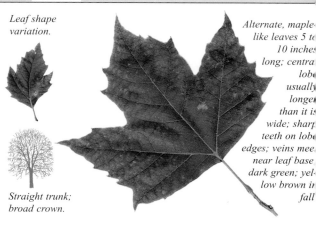

Leaf shape variation.

Straight trunk; broad crown.

Alternate, maple-like leaves 5 to 10 inches long; central lobe usually longer than it is wide; sharp teeth on lobe edges; veins meet near leaf base; dark green; yellow brown in fall

Group 13 A hybrid of the American sycamore and the Oriental planetree of southeastern Europe and western Asia, the London planetree tolerates air pollution, salt, and compacted soil. The hybrid was first observed in England over 300 years ago. Its bark is more olive in color than the white-barked American sycamore, and its fruits hang in clusters of two or three. Today the London planetree is among the most widely planted urban trees in Philadelphia and throughout the temperate world.

In spring, however, while other trees are leafing out, some London planetrees may be attacked by anthracnose, a fungal disease that destroys leaves shortly after they unfurl from their buds. Within a month, a second crop of leaves will replace the blighted first generation, but repeated attacks of anthracnose weaken trees. Several new anthracnose-resistant hybrid cultivars are currently available in the nursery trade.

The London planetree develops 2 or 3 fruit heads up to 1 inch wide on a stalk, whereas the American sycamore develops only one. Each head consists of hundreds of tiny seeds with hairy tufts.

A London planetree's outer brown, gray, or green bark is smooth, peels off in large flakes to reveal lighter inner bark, and does not develop small dark scales like the sycamore

FRUIT HEAD

SEEDS

FRUIT HEAD CROSS SECTION

Where to look for London planetrees

As street trees throughout the city; **PCS:** Bartram's Garden; Columbus Square; 13th and Wharton Sts.; Eakins Oval; Independence Square; Kelly Drive; Rittenhouse Square; Washington Square; Woodlands Cemetery; **PW:** 34th Street, at the Philadelphia Zoo; Clark Park; **PNW:** Chestnut Hill: Meade Street, Winston Road, and West Mermaid Lane.

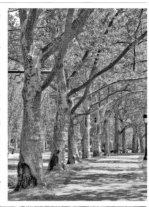

London planetrees line streets around the city, as seen here next to the zoo.

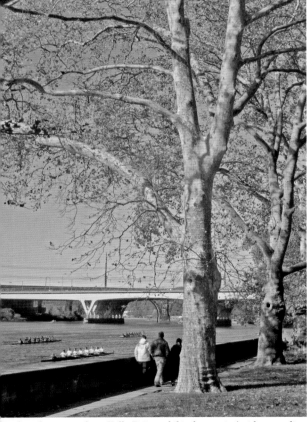

London planetrees along Kelly Drive exhibit the species' wide-spreading branches and tan and cream bark extending all the way to the ground.

Sassafras
Sassafras albidum (Nutt.) Nees

MATURE
HEIGHT:
40-60 ft.

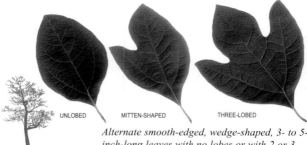

UNLOBED MITTEN-SHAPED THREE-LOBED

Twisting, brittle branches form a ragged crown.

Alternate smooth-edged, wedge-shaped, 3- to 5-inch-long leaves with no lobes or with 2 or 3 lobes; all shapes appearing on one tree; green above, hairless or slightly hairy below; yellow to brilliant scarlet in fall; spicy smell when bruised.

Word of sassafras's curative powers reached the Old World when the first European explorers reported that Native Americans drank sassafras tea to cure fevers and other ills. In the early 17th century, demand for sassafras extract was so great that sassafras bark and roots sold in England for the equivalent of about $130,000 a ton in today's dollars. Like many vaunted panaceas, the sassafras tree did not live up to its proponents' extravagant claims, but people still enjoy sassafras tea and put extracts in gumbos, root beer, and soaps.

Group 13

Sassafras in the South may reach a height of over 80 feet with a trunk more than 4 feet wide. Spreading by root suckers, it colonizes untended, disturbed land with other fast-growing species such as sumacs, black cherries, and ailanthus, preparing the way for forest climax species such as oaks, hickories, and sweetgums. Its distinctive leaves make it easy to identify. Sassafras is valued for its brilliant fall colors and picturesque winter form. Birds devour its fruits and swallowtail butterfly larvae feed on its leaves.

FRUITS

The aromatic, ash-gray bark of a mature tree is deeply fissured with flattened ridges.

In spring, sassafras trees bear small, fragrant pollen flowers (above) and seed flowers, usually on separate trees. Dark blue, ½-inch, berry-like fruits develop from seed flowers on red stalks.

Where to look for Sassafras Trees

Suburban and rural hedgerows; **PW:** Saunders Park, 39th Street and Powelton Ave.; Woodlands Cemetery; **PNW:** Howell Park, Germantown Avenue and Queen Lane (state champion in decline); **SC:** Henry Schmieder Arboretum; **DC:** Tyler Arboretum; Chanticleer.

Pleasant-smelling sassafras leaves may turn splendid shades of yellow, orange, and vermilion in autumn.

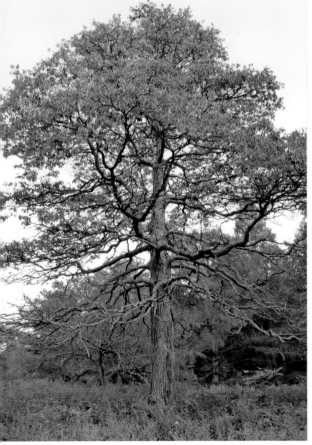

A old sassafras at the Tyler Arboretum is turning color in late October. Sassafras thickets often consist of clones sharing common root systems.

| LEAVES: Alternate, Lobed | 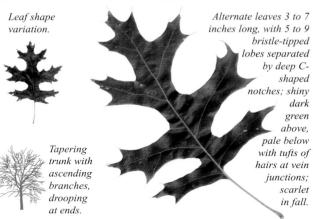 | # Scarlet Oak
Quercus coccinea Muenchh. | MATURE HEIGHT: 80-100+ ft. |

Leaf shape variation.

Alternate leaves 3 to 7 inches long, with 5 to 9 bristle-tipped lobes separated by deep C-shaped notches; shiny dark green above, pale below with tufts of hairs at vein junctions; scarlet in fall.

Tapering trunk with ascending branches, drooping at ends.

Group 13

The scarlet oak begins and ends the growing season with a chromatic flourish. When its delicate new leaves, matted with fine hair, first unfold in spring, they can be bright red. As they develop, they turn to a rich, lustrous green. Once the days begin to shorten in fall, however, the leaves often revert to scarlet hues, and some resolutely cling to their branches throughout the winter. Often planted as an ornamental, the scarlet oak is a fairly fast grower, displaying an attractive pyramidal habit in its youth but developing a more rounded, open crown with age. With a straight, tapering trunk two or three feet in diameter or more, a mature tree may exceed 80 feet in height.

The scarlet oak is frequently found on dry, gravelly, or sandy soils near the shore. It seldom forms pure stands but occurs alongside pitch pines, white pines, post oaks, white oaks, and other broadleaf trees. Its roots grow close to the surface and are often exposed. It is well adapted as a street tree if the soils are well drained.

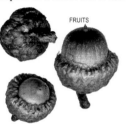

FRUITS

The scarlet oak's reddish-brown ½- to 1-inch acorns have thick, scaly cups. The bitter kernel is white inside.

The bark of a mature scarlet oak is rough, brown or gray, and divided into vertical ridges.

Where to look for Scarlet Oaks

PCS: CAPA High School; FDR Park, near Golf Club; **PNW:** Wissahickon Valley Park, along Walnut Lane; Hunting Park; **PNE:** Curran-Fromhold Correctional Facility, State Road; Martin Luther King Drive; **DC:** Scott Arboretum; Chanticleer; **NJ:** Pinelands National Reserve, particularly in the northeast section.

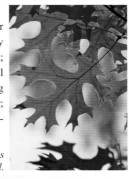

Scarlet oak leaves turn to brilliant scarlets or more muted purples and bronzes in fall.

A scarlet oak standing near the Visitor Center at the Tyler Arboretum is displaying a range of ruddy hues on a mid-October morning. Often confused with black oaks, scarlet oaks have more deeply notched leaves.

| LEAVES: Alternate, Lobed | **Pin Oak** *Quercus palustris* Muenchh. | MATURE HEIGHT 80-100+ ft. |

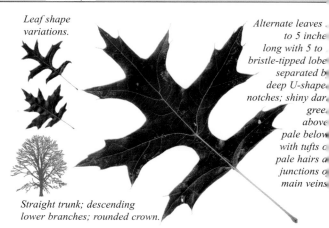

Leaf shape variations.

Alternate leaves to 5 inches long with 5 to bristle-tipped lobes separated by deep U-shaped notches; shiny dark green above pale below with tufts of pale hairs at junctions of main veins.

Straight trunk; descending lower branches; rounded crown.

Group 13 Named for small, thin, dead branchlets often sticking out like pins from its trunk and limbs, the pin oak usually has a single central trunk extending nearly to the top of its crown and many slender branches instead of a few thicker ones. Lower branches often droop, creating some problems when the tree is planted along streets. The pin oak typically retains a few leaves into the winter.

With a straight trunk and finely lobed, glossy leaves, the pin oak is among the most widely planted native oaks in urban landscapes. Adapted to swamp conditions, it is able to withstand occasional flooding and low oxygen levels found in urban soils. It also tolerates drought and is easy to transplant, due to its relatively fibrous and shallow root system. The pin oak's acorns take two years to mature and are almost round with distinctive shallow, saucer-shaped cups enclosing one-quarter or less of the nut.

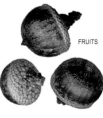

FRUITS

On mature trunks, the grayish-brown bark is divided into narrow, shallow fissures and inconspicuous ridges. The inner bark, visible in fissures, is reddish.

The shallow-cupped acorns range in size from about ½ inch long to ¾ inch long and grow singly or in clusters.

Where to look for Pin Oaks

As street trees; **PCS:** Broad St. and Snyder Ave.; **PW:** West Fairmount Park, Centennial Arboretum, near Horticulture Center (allée); University of Pennsylvania, James G. Kaskey Memorial Park; **CC:** Longwood Gardens, Large Lake, south side; **DC:** Chanticleer, by house drive.

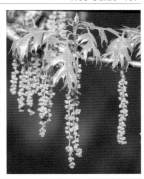

Pin oak pollen flowers are among the first oak flowers to bloom in spring.

Drooping lower branches make pin oaks easy to identify at the Mount Saint Joseph Academy campus in mid-November. Pin oaks planted along streets often have had their lower limbs removed for clearance.

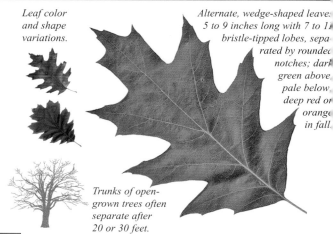

LEAVES:
Alternate,
Lobed

Red Oak
Quercus rubra L.

**MATURE
HEIGHT**
80-100+ ft.

*Leaf color
and shape
variations.*

*Alternate, wedge-shaped leaves
5 to 9 inches long with 7 to 11
bristle-tipped lobes, sepa-
rated by rounded
notches; dark
green above,
pale below,
deep red or
orange
in fall.*

*Trunks of open-
grown trees often
separate after
20 or 30 feet.*

Group 13

The red oak is the most common oak of the Northeast and is a com-
monly planted street tree in Philadelphia. In the open, it may have a
short massive trunk, but in forests, its trunk grows tall and straight,
supporting a rounded crown that commonly reaches 90 feet or more
above ground. Its symmetrical form and rapid growth suit it to city
streets and parks. Loggers favor it because it develops from a
seedling to a timber tree within 40 to 60 years.

The red oak is sometimes confused with the black oak. Its leaves
are usually thinner and less glossy and leathery than black oak leaves.
Its leaf notches, or sinuses, tend to be shallower than those of black
oak leaves. Its acorn cups are shallower, too, enclosing about a quar-
ter or less of their nuts, whereas black acorn cups enclose about half
of their nuts. Bark of a mature red oak tree is generally reddish gray
with pinkish inner bark.

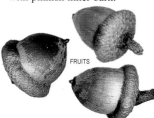

FRUITS

*The sharp-pointed acorns with
saucer-like caps range in size
from ¾ inch to 1 inch long.*

*The dark gray to reddish-brown
bark is deeply furrowed and bro-
ken into flat-topped ridges.*

Where to look for Red Oaks

Commonly planted as street trees around Philadelphia; **PCS:** Franklin Square; **PW:** Cobbs Creek Park; Haddington Woods; **PNW:** Morris Arboretum, woodlands; Wissahickon Valley Park; Carpenter's Woods; Cresheim Creek; Hunting Park; **PNE:** Pennypack Park; **BC:** Bowman's Hill Wildflower Preserve.

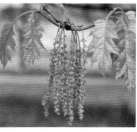

Slender pollen catkins develop in May as the leaves unfold.

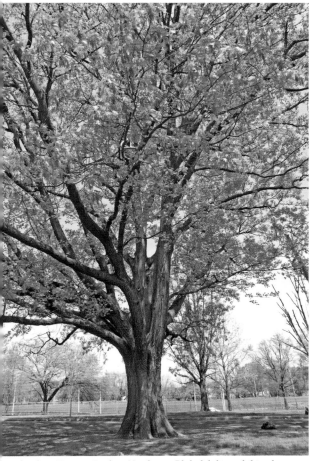

A red oak at Hunting Park in Northwest Philadelphia exhibits the typical specimen habit. Faster-growing than many other oaks, it often develops a stout, short trunk topped by spreading main branches.

LEASES: Alternate, Lobed	**Black Oak** *Quercus velutina* Lam.	MATURE HEIGHT: 80-100+ ft.

Leaf shape variations.

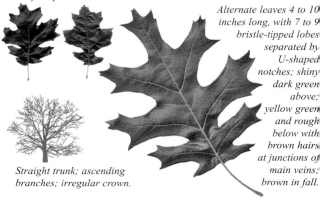

Alternate leaves 4 to 10 inches long, with 7 to 9 bristle-tipped lobes separated by U-shaped notches; shiny dark green above; yellow green and rough below with brown hairs at junctions of main veins; brown in fall.

Straight trunk; ascending branches; irregular crown.

Group 13

The black oak's Latin species name *velutina* is derived from a word meaning "fleece," referring to the velvety surfaces of young leaves and winter buds. The common name refers to the furrowed outer bark, which is often dark gray or nearly black but can also be pale gray. Early settlers made a yellow dye from quercitron, derived from the orange-yellow inner bark.

The black oak's leaves vary greatly in shape from tree to tree and even on the same tree. Regardless of their shapes, they tend to be glossier and more leathery than red oak leaves and usually have shallower notches, or sinuses, than scarlet oak leaves. Nearly as wide as they are long, the oval acorns have cups edged with shaggy scales. The black oak grows in upland stands and is commonly found alongside other species such as tuliptrees, pignut and mockernut hickories, and red, white, post, scarlet, and chestnut oaks in our native woods.

The ½- to ¾-inch-long acorns have bowl-shaped, loosely-scaled cups that enclose about half of the nut.

On mature trunks the bark is deeply furrowed, very thick, and usually dark gray or nearly black.

Where to look for Black Oaks

CS: CAPA High School; **PNW:** Morris Arboretum, woodlands; Wissahickon Valley Park; Carpenter's Woods; Cresheim Creek; **PNE:** Pennypack Park; **BC:** Bowman's Hill Wildflower Preserve; **CC:** Jenkins Arboretum; **DC:** Haverford College Arboretum.

Yellow pollen flowers appear on hairy, 4- to 6-inch catkins in May when the black oak's leaves are half grown.

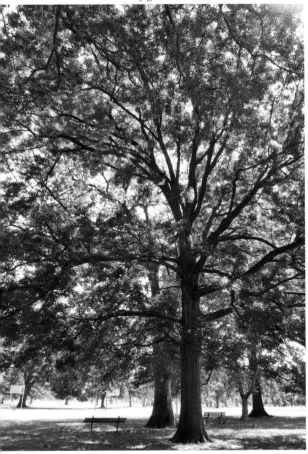

Black oaks growing in good soil out in the open, like these 80-year-old trees in Hunting Park in North Philadelphia, develop spreading, irregular crowns composed of many large ascending branches.

LEAVES: Alternate, Lobed	# White Oak *Quercus alba* L.	MATURE HEIGHT: 80-100+ f

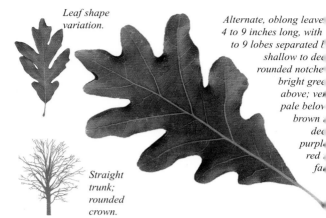

Leaf shape variation.

Alternate, oblong leave 4 to 9 inches long, with to 9 lobes separated t shallow to dee rounded notche bright gree above; ve pale belov brown dee purpl red fa

Straight trunk; rounded crown.

Group 13 The white oak is one of the most majestic North American trees. the open, a mature specimen tree may easily exceed 100 feet height, with massive, gently ascending branches reaching out fro the trunk for 60 feet or more.

The white oak grows slowly but can live 500 years or more. It pu down a deep central taproot, which anchors even a small seedlir firmly in the soil. The sweet, oblong acorns with bumpy, rather tha smooth, scales germinate quickly in the early autumn—if they a not eaten first by squirrels and other wildlife.

The wood of the white oak is the best all-purpose native har wood. Early Americans used it for barrels, furniture, log cabir blockhouses, building beams, and sailing ships. Dense and durabl it makes fine flooring, excellent firewood, and resists rot on conta with the ground.

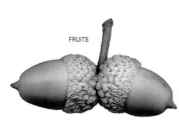

FRUITS

Acorns, ranging in length from about ⅜ to 1¼ inches, mature in late September and October.

The light ashy-gray bark is broken into scaly plates by shallow vertical and horizontal fissures.

Where to look for White Oaks

CS: Independence National Historical Park, Second Bank of the U.S.; FDR Golf Club; **PW:** Saunders Park; St. Andrew's Chapel, 42nd and Spruce; **PNW:** Morris Arboretum; Wissahickon Valley Park; Carpenter's Woods; Corinthian Ave., just south of Girard College; **DC:** Tyler Arboretum; **DE:** Mt. Cuba Center.

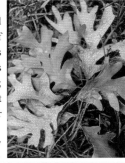

Newly fallen white oak leaves display their characteristic pale undersides.

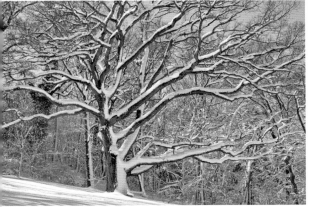

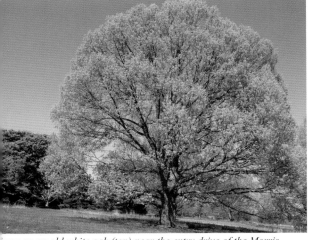

Snow on an old white oak (top) near the entry drive of the Morris Arboretum highlights its beautiful branching structure. Another large white oak graces the entry to the nearby Bloomfield Farm (above).

LEAVES: Alternate, Lobed	**Swamp White Oak** *Quercus bicolor* Willd.	MATURE HEIGHT: 80-100+ f

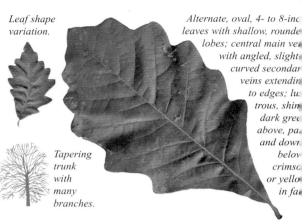

Leaf shape variation.

Alternate, oval, 4- to 8-inc leaves with shallow, rounde lobes; central main ve with angled, slight curved secondar veins extendin to edges; lu trous, shin dark gree above, pa and down belo crimsc or yello in fa

Tapering trunk with many branches.

Group 13 — As its name suggests, the swamp white oak is often found in poor drained soil along stream banks and swamp edges. Because of i habitat adaptations, the swamp white oak is a successful street tre surviving the densely compacted soils and low oxygen environmen of city tree pits. The swamp white oak's Latin species name *bicolo* refers to its leaves. They are a shiny, dark green on top and pal green with white hairs underneath. It is a member of the white oa group, so there are no hairs on the tips of its rounded leaf lobes. I grayish-brown bark peels on the branches. In the wild under ide conditions, the swamp white oak may grow over 100 feet tall an live more than 200 years. In recent decades, it is being more widel planted in Philadelphia as a stress-tolerant street tree.

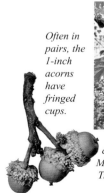

Often in pairs, the 1-inch acorns have fringed cups.

Male flowers hang on catkins in April and early May as the leaves develop. Tiny female flowers sprout in the leaf axils.

The thick gray bark of a old tree is deeply fissure

Where to look for Swamp White Oaks

PCS: Independence Natl. Historical Park, near Natl. Constitution Center; Race Street Pier; CAPA High School; **PW:** West Fairmount Park, Centennial Arboretum, Michaux Grove; **DC:** Haverford College Arboretum (mature allée); Scott Arboretum (allee dedicated in 1881); Brandywine River Museum.

A young swamp white oak by a path in Rittenhouse Square may eventually become an impressive shade tree.

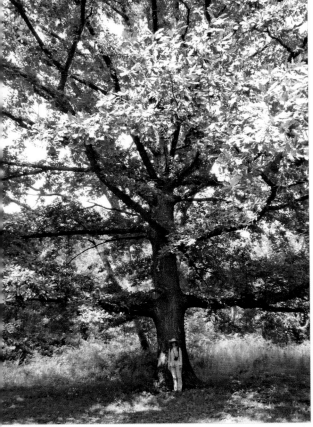

This swamp white oak in a West Fairmount Park oak grove was planted in the 1870s to honor the great French botanist François André Michaux.

| LEAVES: Alternate, Lobed | # Turkey Oak *Quercus cerris* L. | MATURE HEIGHT: 80-100+ ft. |

Leaf shape variations.

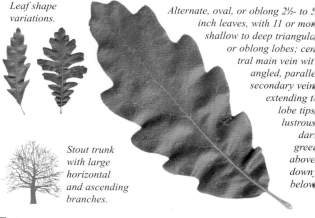

Alternate, oval, or oblong 2½- to 5-inch leaves, with 11 or more shallow to deep triangular or oblong lobes; central main vein with angled, parallel secondary veins extending to lobe tips; lustrous dark green above downy below

Stout trunk with large horizontal and ascending branches.

The Turkey oak (*Quercus cerris*) is a native of southern Europe and western Asia and should not be confused with the American turkey oak (*Quercus laevis*), a small oak indigenous to coastal lowlands of the South. The Turkey oak is named for the country, not the bird. It is common throughout Europe but is rarely found outside of parks and botanical gardens in the United States. Rugged, with stout, spreading branches and glossy, dark leaves, the Turkey oak is a rapid grower and tolerates cold winters, air pollution, poor soil, heat and drought. Once more widely grown, it has potential for greater urban planting.

Where to look for Turkey Oaks

PCS: Columbus Square, 13th St. between Wharton and Reed Sts.;
PW: Cobbs Creek Golf Course, near pro shop (recently damaged in a fire);
PNW: Clifford Park; Fernhill Park.

The 1-inch-long, bitter-tasting acorns are topped by very hairy cups. The gray-brown bark is densely fissured with crisscrossing narrow ridges.

FRUITS

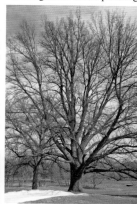

The trunk of this Turkey oak at Cobbs Creek Golf Course measures 57 inches at breast height.

| MATURE HEIGHT: 70-100+ ft. | **Bur Oak** *Quercus macrocarpa* Michx. | | LEAVES: Alternate, Lobed |

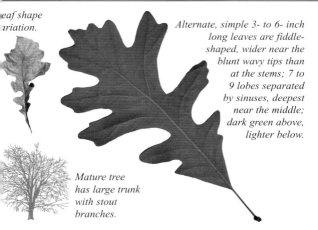

leaf shape variation.

Alternate, simple 3- to 6- inch long leaves are fiddle-shaped, wider near the blunt wavy tips than at the stems; 7 to 9 lobes separated by sinuses, deepest near the middle; dark green above, lighter below.

Mature tree has large trunk with stout branches.

A tree of the prairie states, the bur oak rivals the beauty and majesty of the white oak. Its range extends far north into Canada, and it also grows further West than any other eastern oak—all the way into Wyoming and Montana. When crossing the Midwest, pioneers would roll into lush park-like forest openings, where bur oaks were surrounded by grassy meadows. These prairie openings, maintained by fires set by Native Americans, favored bur oaks with their thick bark and deep roots. Seldom growing taller than sixty feet in open prairie, old-growth bur oaks may tower 160 feet or more in rich bottomlands.

Group 13

Where to look for Bur Oaks

PCS: FDR Park, east of lake; **PW:** Bartram's Garden; **PNW:** Awbury Arboretum; Temple University; **DC:** Haverford College (tree dates to 1834); Scott Arboretum (1876 class tree).

Bur oak acorns are larger than any other oak's—up to 2 inches wide—and nearly covered by cups fringed with hairs. Gray-brown bark is rough and deeply fissured.

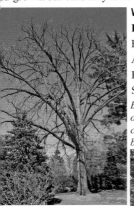

A large bur oak at the Morris Arboretum stands between the parking lot and Gates Hall.

FRUITS

| LEASES: Alternate, Lobed | **English Oak** *Quercus robur* L. | MATURE HEIGHT: 80-100+ ft. |

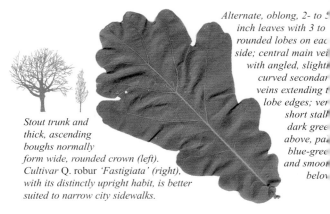

Alternate, oblong, 2- to 5 inch leaves with 3 to rounded lobes on eac side; central main vei with angled, slightl curved secondar veins extending t lobe edges; ver short stall dark gree above, pa blue-gree and smoo belo

Stout trunk and thick, ascending boughs normally form wide, rounded crown (left). Cultivar Q. robur 'Fastigiata' (right), with its distinctly upright habit, is better suited to narrow city sidewalks.

Group 13

In ancient times this oak was associated with Zeus, Thor, and th Druids. A tree in Sherwood Forest hid King Charles II from pursuin Parliamentarians. Its wood was used for centuries in half-timbere buildings and in sailing ships. Its natural range extends from Afric and western Asia to Britain and northwestern Europe. Introduce early to North America, it is tolerant of urban stress and makes a fin street tree in Philadelphia. A cultivar, *Quercus robur* 'Fastigiata,' wit sharply ascending branches, lends itself to narrow urban spaces.

Where to look for English Oaks

PCS: As a street tree in Society Hill; Independence National Historical Park, Rose Garden; **PW:** Woodlands Cemetery; **PNW:** Morris Arboretum; **CC:** Longwood Gardens; **DC:** Haverford College Arboretum.

The 1-inch-long acorns are suspended on stalks from 1 to 4 inches long. The dark gray bark is deeply fissured.

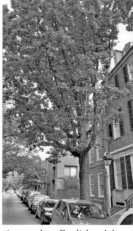

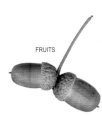

FRUITS

A pruned-up English oak has sharply ascending branches along a street in Society Hill.

| MATURE HEIGHT: 40-50 ft. | **Post Oak** *Quercus stellata* Wangenh. | | LEAVES: Alternate, Lobed |

...af shape ...riation.

Alternate, thick and leathery leaves 4 to 8 inches long, usually with five lobes; central two lobes often squarish, creating cross-like form; edges smooth; dark green with scattered hairs above; grayish, yellow, or white hairs below.

Branches, often low on the trunk, are dense and twisted.

...he post oak is a tough tree that grows where many others do not— ... poor, dry, gravelly, or rocky soils and on "barrens," or sandy ...lains. It tolerates heat and drought and the higher salinity of coastal ...abitats. In fact, at the northern limit of its range—in New Jersey, ...ong Island, and southern New England—the post oak grows only ...ong the coast. As its name suggests, the post oak's rot-resistant ...ood has been used for fence posts and railroad ties. It is adapted to ...ell-drained urban sites.

Group 13

Where to look for Post Oaks

PCS: Independence National Historical Park, next to the American Philosophical Society's Library Hall; **PW:** Bartram's Garden; **PNW:** Morris Arboretum; **NJ:** Pinelands National Reserve, particularly upland sections.

Gray-brown bark is divided into broad plates by fissures. The ½- to ¾-inch acorns have cups with rough scales.

...post oak shades a path by the ...merican Philosophical Society's ...ibrary Hall on 5th Street.

FRUITS

LEAVES: Alternate, Toothed	# Chestnut Oak *Quercus montana* Willd. (*Quercus prinus* L.)	MATURE HEIGHT 80-100+

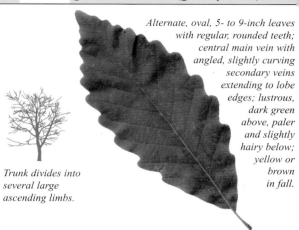

Alternate, oval, 5- to 9-inch leaves with regular, rounded teeth; central main vein with angled, slightly curving secondary veins extending to lobe edges; lustrous, dark green above, paler and slightly hairy below; yellow or brown in fall.

Trunk divides into several large ascending limbs.

Group 14

An exceptionally large chestnut oak, estimated to be about 250 years old, stands in the middle of "Out on a Limb," the canopy walkway the Morris Arboretum. Giants like this have largely passed from the landscape, although the national champion chestnut oak, located in Great Smoky Mountains National Park in Tennessee, is 144 feet tall with a diameter of nearly 6 feet. Normally a chestnut oak reaches 60 or 70 feet at maturity, with a trunk two to three feet in diameter.

Also called the rock oak or mountain oak, the chestnut oak frequently grows on rocky slopes and dry ridges with scarlet and black oaks. Its large taproot makes it well suited to dry and well-drained sites. Though it is difficult to transplant at larger sizes, it is a lovely choice for planting in well-drained urban sites where a tall, long-lived tree is desired. The chestnut oak's sweet acorns are an important food for squirrels, bear, and deer.

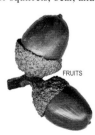

FRUITS

The glossy, brown, 1- to 1½-inch acorns are eaten by squirrels and deer.

The dark gray or brown bark of the chestnut oak is very thick and divided into deep fissures and long vertical ridges.

Where to look for Chestnut Oaks

PCS: Philadelphia Museum of Art, west side; **PW:** Cobbs Creek Golf Course, parking lot near pro shop (line of trees); Cobbs Creek Park; Haddington Woods; **PNW:** Howell Park, Greene Street behind post office; Wissahickon Valley Park, hillsides; Cresheim Creek, south side, west of McCallum; **DC:** Chanticleer.

An enormous state champion chestnut oak behind the Germantown post office in Howell Park is 6 feet in diameter.

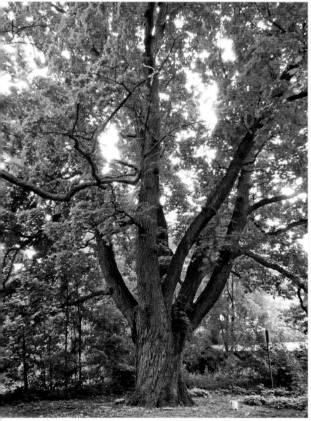

Reaching for the light, a great old chestnut oak at the Awbury Arboretum has a short trunk topped by a cluster of very large ascending branches. Chestnut oaks need direct sunlight and do not thrive in shade.

LEAVES: Alternate, Toothed	# Sawtooth Oak	MATURE HEIGHT: 60-80 ft.

Quercus acutissima Carruth.

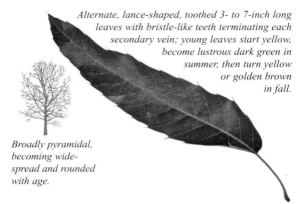

Alternate, lance-shaped, toothed 3- to 7-inch long leaves with bristle-like teeth terminating each secondary vein; young leaves start yellow, become lustrous dark green in summer, then turn yellow or golden brown in fall.

Broadly pyramidal, becoming widespread and rounded with age.

Named for its sawtooth-like serrated leaves, *Quercus acutissima* i
native to eastern Asia. Introduced to the United States in 1872, th
sawtooth oak is found most commonly in the Southeast and up int
the Mid-Atlantic. A handsome, fast-growing shade tree, it has love
ly glossy green leaves that turn yellow or golden brown in fall an
can hold on through the winter. The sawtooth oak produces prolif
ic amounts of bitter acorns that ripen early in fall but are often th
last to be eaten by wildlife. It is highly tolerant of urban conditions

Group 14

Where to look for Sawtooth Oaks
PCS: Washington Square; Municipal Pier 3; Independence Hall; **PNW:** Morris Arboretum; Chestnut Hill, street trees; **CC:** Longwood Gardens.

The 3/4-inch shiny brown acorn nestles in a 1-inch-deep cup covered in bristles.

FRUIT

Dark gray bark is crisscrossed with ridges and furrows.

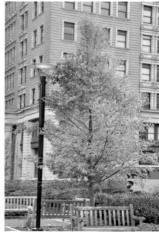

The leaves of a young sawtooth oak on Independence Mall are turning golden yellow in late October.

MATURE HEIGHT: 40-50 ft.	**Black Alder** *Alnus glutinosa* (L.) Gaertn.		LEAVES: Alternate, Toothed

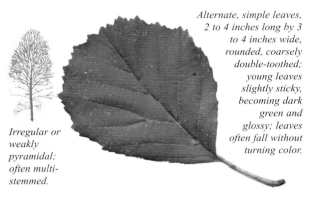

Alternate, simple leaves, 2 to 4 inches long by 3 to 4 inches wide, rounded, coarsely double-toothed; young leaves slightly sticky, becoming dark green and glossy; leaves often fall without turning color.

Irregular or weakly pyramidal; often multi-stemmed.

Also known as the European alder, the black alder is native to Europe, western Asia, and Africa. A water-loving plant, it has been used in Europe for restoration projects because of its quick growth and nitrogen-fixing abilities. When planted along waterways, it will easily self-seed to form stands and may become invasive. A birch family member, the black alder bears birch-like fruits, with female catkins and longer male catkins on the same tree. The buds and young leaves can be sticky, hence the species name.

Group 14

Where to look for Black Alders

PCS: John Heinz National Wildlife Refuge at Tinicum; **PW:** Cobbs Creek Park; Cobbs Creek Golf Course (several large trees); Haddington Woods (dense stand of same-age trees).

Female catkins are round and cone-like (below left), while male catkins (below right) are pendulous.

A stand of black alders borders the Manayunk Canal in Northwest Philadelphia.

Gray bark starts smooth but cracks with age.

MATURE FRUITS

| LEAVES: Alternate, Toothed | **Serviceberries** *Amelanchier* spp. | MATURE HEIGHT: 20-40 ft. |

Shadblow serviceberry leaf shape variations.

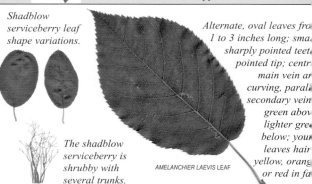

AMELANCHIER LAEVIS LEAF

Alternate, oval leaves fro[m]
1 to 3 inches long; sma[ll]
sharply pointed teet[h]
pointed tip; centr[al]
main vein ar[e]
curving, paral[lel]
secondary vein[s]
green abov[e]
lighter gre[en]
below; youn[g]
leaves hair[y]
yellow, orang[e]
or red in fa[ll]

The shadblow serviceberry is shrubby with several trunks.

The serviceberry genus, *Amelanchier*, includes some three or fou[r] species native to the Northeast. Usually smallish and often multi[-] stemmed, serviceberry species readily hybridize and are not alway[s] easy to distinguish from one another. All have oval, toothed leaves an[d] small white flowers. Also known as shadbushes, serviceberries ar[e] among the first native trees to flower in the Northeast, and their com[-] mon names reflect this fact. They bloom in early spring soon after th[e] ground has thawed, when graveside services were once conducted i[n] northern states for people who died during the winter. The annua[l] appearance of the dazzling white serviceberry blossoms correspond[s] with shad spawning time in northeastern rivers. Amelanchier fruit[s] ripen in June and are quickly devoured by birds and other wildlife.

The **downy serviceberry** (*Amelanchier arborea*), or Juneberr[y,] may be a multi-stemmed shrub or a single-stemmed ornamental tre[e] that can reach 45 feet in height. Usually a multi-stemmed shrub fro[m] 6 to 15 feet tall, the **shadblow serviceberry** (*Amelanchier canaden[-] sis*) commonly grows in bogs and swamps.

Group 14

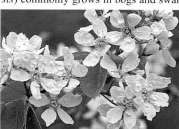

The five-petalled flowers bloom in April in clusters at the tips of new shoots before, or just as, the leaves unfold.

Young bark is a smooth silvery gray but develops dark stripes and fissures with age[.]

Where to look for Serviceberries

Common in woodland understories; **PW:** Bartram's Garden; **PNW:** Awbury Arboretum; **BC:** Andalusia; **DC:** Chanticleer, Asian Woods; Scott Arboretum, Pollinator Garden; **DE:** Winterthur, top of Sycamore Hill beyond fence (allée).

In early summer, serviceberries are hung with bunches of sweet-tasting red and purplish-black fruits.

AMELANCHIER
CANADENSIS
FRUIT

Serviceberries are trees for all seasons. In fall (top), they boast extravagant shades of scarlet, orange, and bronze. In spring (above), they are arrayed with white flowers, as in this allée of mature trees at Winterthur.

| LEAVES: Alternate, Toothed | # River Birch *Betula nigra* L. | MATURE HEIGHT: 50-80 ft. |

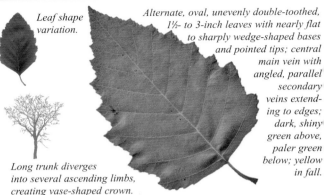

Leaf shape variation.

Alternate, oval, unevenly double-toothed, 1½- to 3-inch leaves with nearly flat to sharply wedge-shaped bases and pointed tips; central main vein with angled, parallel secondary veins extending to edges; dark, shiny green above, paler green below; yellow in fall.

Long trunk diverges into several ascending limbs, creating vase-shaped crown.

The most widely distributed birch in the United States, the river birch grows from New England to the Gulf Coast. In the South, where this heat-tolerant tree reaches its greatest average size in the rich alluvial soil of the lower Mississippi Valley, it is the only naturally occurring birch. A handsome tree with a vase-shaped habit, it can exceed 80 feet in height under ideal conditions.

Group 14

The river birch is appropriately named, for it is extremely well adapted to a riparian way of life. Most birches shed their seeds in fall, but the river birch produces fully ripened fruits called female catkins in late spring or early summer. Shaken by warm breezes, the seed-laden catkins scatter winged capsules—just in time for many to land in receding rivers and streams and be carried by currents downstream to newly exposed mudbanks, perfect places for quick germination. Not surprisingly, the river birch is tolerant of periodic flooding, which helps it survive in dense, airless urban soils. The widely planted clone, 'Heritage,' was selected for its attractive cinnamon- and cream-colored peeling bark.

FEMALE CATKINS

Young tree bark (left) is tan and peeling Mature bark (right) is gray and scaly.

MALE CATKIN

The 2- to 3-inch male catkins, formed in the previous season, release pollen in early spring. The female catkins ripen by early summer.

Where to look for River Birches

CS: Gold Star Park, 613 Wharton Street; FDR Park, lake; Race Street Pier; **PW:** Bartram's Garden; **PNW:** Wissahickon Valley Park; Morris Arboretum, entrance drive; Awbury Arboretum, wetland (large trees); **MC:** West Laurel Hill Cemetery; **DC:** Tyler Arboretum; Brandywine River Museum.

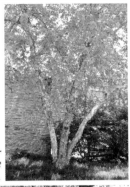

At Haverford College, a multi-trunked river birch exhibits the exfoliating bark that makes young trees especially attractive.

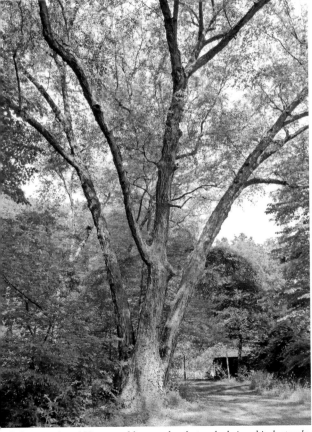

Likely more than 100 years old, a quadruple-trunked river birch stands at the northern end of an intermittent water course close to Washington Lane, at the western side of Awbury Arboretum's Wildflower Meadow.

| LEReaves:
Alternate,
Toothed | | # Cherry Birch
Betula lenta L. | MATURE
HEIGHT:
50-80 ft. |

Leaf shape variation.

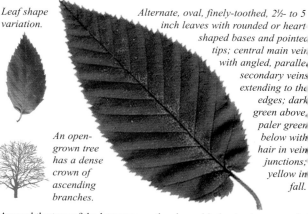

Alternate, oval, finely-toothed, 2½- to 5 inch leaves with rounded or heart shaped bases and pointed tips; central main vein with angled, parallel secondary veins extending to the edges; dark green above, paler green below with hair in vein junctions; yellow in fall.

An open-grown tree has a dense crown of ascending branches.

Around the turn of the last century, the cherry birch, also known as the sweet or black birch, was a valuable tree. A dark-trunked birch species like the river birch, the cherry birch's hard, strong wood was sold as "mahogany birch" for use in cabinetry and furniture. Aromatic sap from cherry birches was distilled to make birch beer and an oil of wintergreen substitute (used in food flavorings that are now derived from synthetic chemicals). If you chew a cherry birch twig, you will taste the wintergreen flavor.

The cherry birch is a medium-sized forest tree with distinctive, black cherry-like bark and elongated lenticels. It is a common species in the native upland forests of Pennsylvania and can be seen mixed with tuliptrees, beeches, oaks, and maples on hillsides by the Wissahickon Creek. It grows best in cooler, mountainous areas from Maine to Georgia. A pioneer species, cherry birches often colonize disturbed land along roadsides and rail lines.

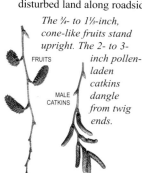

The ¾- to 1½-inch, cone-like fruits stand upright. The 2- to 3-inch pollen-laden catkins dangle from twig ends.

FRUITS

MALE
CATKINS

Gray bark on younger trees is smooth with horizontal pores (left), while bark on older trees is cracked into irregular plates (right)

Where to look for Cherry Birches

PW: University of Pennsylvania, James G. Kaskey Memorial Park; **PNW:** Wissahickon Valley Park; Morris Arboretum; **PNE:** Pennypack Park; **BC:** Bowman's Hill Wildflower Preserve; **MC:** Valley Forge National Historical Park; **CC:** Longwood Gardens; Jenkins Arboretum; **DC:** Tyler Arboretum.

A cherry birch in Wissahickon Valley Park is turning gold in mid-October.

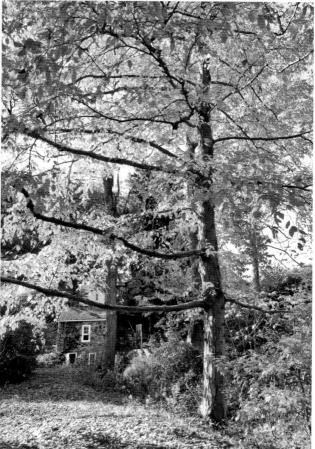

The golden leaves of an older cherry birch with cracked, plated bark at the Tyler Arboretum are bathed in sunlight on a late October afternoon.

LEAVES: Alternate, Toothed	**Paper Birch** *Betula papyrifera* Marshall	MATURE HEIGHT: 50-70 ft.

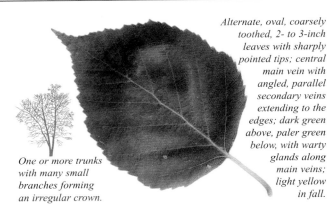

Alternate, oval, coarsely toothed, 2- to 3-inch leaves with sharply pointed tips; central main vein with angled, parallel secondary veins extending to the edges; dark green above, paler green below, with warty glands along main veins; light yellow in fall.

One or more trunks with many small branches forming an irregular crown.

Group 14

The paper birch might be considered the symbol of the great North Woods. In Pennsylvania, it grows naturally in the highlands of the northeast and central parts of the state. To native peoples, the beautiful, flexible bark of the paper birch was a vital raw material for making canoes, baskets, cooking utensils, and ceremonial objects. Unfortunately, the tree does not thrive in southeastern Pennsylvania's heat and urban stress. Arborists are trying to develop hybrids that can contend with warmer conditions and resist destructive boring insects.

Where to look for Paper Birches
PNW: Awbury Arboretum; Morris Arboretum; **BC:** Five Mile Woods Nature Preserve; **CC:** Longwood Gardens; **DC:** Scott Arboretum; Chanticleer; **DE:** University of Delaware Botanic Gardens.

The layered, peeling, papery bark is marked with lines of black pores called lenticels.

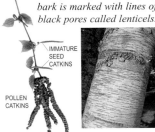

IMMATURE SEED CATKINS

POLLEN CATKINS

A paper birch at the Morris Arboretum has managed to survive hot summers, hardly ideal for this northern species.

| MATURE HEIGHT: 15-30 ft. | **Gray Birch** *Betula populifolia* Marshall | LEAVES: Alternate, Toothed |

Leaf shape variation.

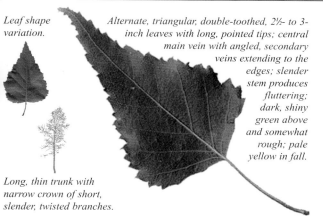

Alternate, triangular, double-toothed, 2½- to 3-inch leaves with long, pointed tips; central main vein with angled, secondary veins extending to the edges; slender stem produces fluttering; dark, shiny green above and somewhat rough; pale yellow in fall.

Long, thin trunk with narrow crown of short, slender, twisted branches.

The gray birch is the Northeast's smallest birch, seldom growing taller than 30 feet. One of the few native birches with a white trunk, it is often mistaken for the paper birch, but is easily distinguished from its larger cousin by its triangular leaves. A prolific seed producer, gray birches grow well in moist soils but also spring up quickly on dry and impoverished soils. Gray birches may develop a single trunk but usually grow as a multi-stemmed tree. Like most birches, they don't live long and are subject to stem boring and leaf miner insect damage.

Group 14

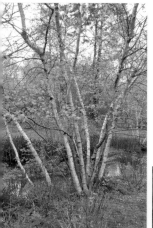

A gray birch at Appleford looks like a paper birch, but its bark peels less and has more black spots.

Where to look for Gray Birches

PNW: Morris Arboretum (*Betula populifolia* 'Whitespire Junior,' a cultivar reputedly less susceptible to boring insects); **MC:** Appleford; **DC:** Chanticleer; **NJ:** Pinelands National Reserve (wetland forests with pitch pine and sassafras).

Bark of young tree (left) is brown; bark of older tree (right) is white. Fruits are ½ to 1 inch long.

FRUIT

| LEAVES: Alternate, Toothed | | # Hornbeams
Carpinus spp. | MATURE HEIGHT: 20-60 ft. |

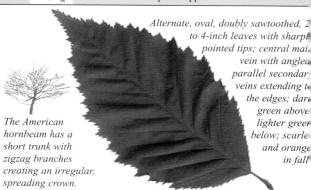

Alternate, oval, doubly sawtoothed, 2 to 4-inch leaves with sharply pointed tips; central main vein with angled parallel secondary veins extending to the edges; dark green above, lighter green below; scarlet and orange in fall

The American hornbeam has a short trunk with zigzag branches creating an irregular, spreading crown.

The **American hornbeam** (*Carpinus caroliniana*) was dubbed "iron-wood" by early settlers, who fashioned its extremely hard wood into serviceable tool handles and plow blades in times when iron was often expensive and hard to obtain. Other common names for the American hornbeam are musclewood and blue beech. With its thin, smooth, bluish-gray bark, it does resemble a small beech or suggest a well-defined bicep. Usually a bushy tree of the eastern American forest understory that grows to 30 feet tall, it occasionally reaches 50 feet. It is useful for planting near buildings or under utility wires.

Group 14

The **European hornbeam** (*Carpinus betulus*), often a larger mature tree than its American cousin, is widely planted in the East. The most telltale difference between the two hornbeams is the superlative fall color of the native variety. Another clue for telling the two species apart is the fruit bract, which is usually untoothed and up to 1½ inches long on *C. betulus*, but is usually toothed and not more than 1¼ inches long on *C. caroliniana*.

The 1- to 1½-inch male pollen catkins (left) mature in spring. The female catkins develop into bunches of leafy bracts (below), each with a single nutlet.

FRUIT BRACT

The American hornbeam's sinuous bark is the inspiration for one of its common names: musclewood.

Where to look for Hornbeams

CS: FDR Park; **PW:** Fairmount Park, Centennial Arboretum; **PNW:** Fernhill Park; **BC:** Andalusia; **MC:** Barnes Arboretum; Ambler Arboretum of Temple University; **CC:** Longwood Gardens; **DC:** Brandywine River Museum; Chanticleer, Carpinus Glade (two) and Pinetum (one fastigiate).

An American hornbeam at the Awbury Arboretum may have developed several trunks after it was cut to the ground and resprouted years ago.

European hornbeam cultivars in Fairmount Park with upright branches look perfectly groomed, making them good choices for street trees.

| LEAVES: Alternate, Toothed | | # Chestnuts *Castanea* spp. | MATURE HEIGHT: 40-80 ft. |

AMERICAN CHESTNUT LEAVES

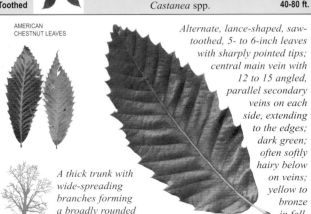

Alternate, lance-shaped, saw-toothed, 5- to 6-inch leaves with sharply pointed tips; central main vein with 12 to 15 angled, parallel secondary veins on each side, extending to the edges; dark green; often softly hairy below on veins; yellow to bronze in fall.

A thick trunk with wide-spreading branches forming a broadly rounded crown.

CHINESE CHESTNUT LEAF

Group 14

A bountiful source of tasty nuts and versatile wood, the stately **American chestnut** (*Castanea dentata*) was once one of our most common and valuable native timber trees. It was nearly eradicated by a fungal disease accidentally brought to New York City from Asia about 1904. The blight was so virulent that by 1930 almost all the chestnuts were dead in the Eastern deciduous forests ranging from Maine to Georgia. Now, except for a few isolated, healthy individuals, only occasional sprouts from stumps remain to remind us that in some parts of the country, one out of every four hardwood trees was once an American chestnut. The total loss from the blight might have been as many as 3 billion trees. In the Wissahickon Valley, the American chestnut has largely been replaced by the chestnut oak (*Quercus prinus*) and the tuliptree (*Liriodendron tulipifera*).

Two Asian species, the **Chinese chestnut** (*Castanea mollissima*) and the **Japanese chestnut** (*Castanea crenata*) are disease resistant and have long been cultivated for their nuts. New hybrids of the Asian and American chestnuts with disease resistance might eventually make the replanting of chestnut forests possible.

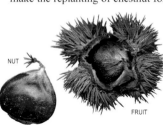

NUT

FRUIT

The spiny 2- to 3-inch fruits of a Chinese chestnut contain 1 to 3 shiny, brown nuts. The gray-brown bark is deeply ridged.

Where to look for Chestnuts

ICS: Independence Square (American); **PW:** Bartram's Garden (American); **PNW:** Morris Arboretum (American, Chinese, hybrid); **MC:** Carson Valley Children's Aid, Flourtown (Chinese); Longwood Gardens (American hybrids, Chinese, Japanese, other hybrids).

Pungent Chinese chestnut flowers bloom in May in 4 to 5 inch panicles.

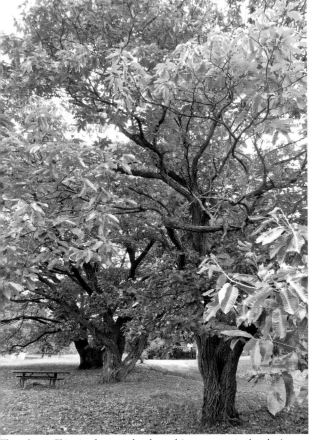

Three large Chinese chestnuts border a driveway next to the playing fields on the campus of Carson Valley Children's Aid in Flourtown.

| LEAVES: Alternate, Toothed | # Hackberry
Celtis occidentalis L. | MATURE HEIGHT: 50-70 ft. |

Leaf shape variation.

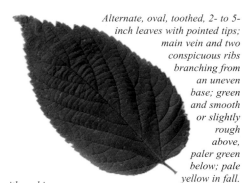

Alternate, oval, toothed, 2- to 5-inch leaves with pointed tips; main vein and two conspicuous ribs branching from an uneven base; green and smooth or slightly rough above, paler green below; pale yellow in fall.

Straight trunk with arching branches and drooping branchlets.

The hackberry was called *bois inconnu* (unknown wood) by earl French settlers, who deemed it a nondescript tree without much to rec ommend it. Often displaying a ragged habit, the hackberry's toughnes and versatility more than make up for its aesthetic shortcomings. I withstands hurricanes and tornadoes better than many other species an springs back quickly from repeated cuttings along power lines. It doe well in full sunlight and also grows in shade. Its roots reach down t moisture up to 20 feet below the surface, making it drought tolerant and yet it also withstands flooding. Growing in various habitats fron eastern forests to prairie oak openings, its natural range extends wes from the New England coast into the High Plains and south as far a Texas. It grows best in well-watered bottomlands, but is present or limestone bluffs, sand barrens, and prairie pothole dunes. It colonize old fields and also reproduces in old-growth forests. Hackberry fruit are without much meat, but are eaten and spread far and wide by many birds, mammals, and reptiles. New hybrid and clonal selections com bine urban stress tolerance with more attractive foliage and form.

FRUIT

The gray bark is smooth or roughened by warty bumps or broken into scaly ridges

Modest female flowers (above) bloom in April. The ⅓-inch fruits (left), which ripen from pink to purple in fall, appeal to birds.

Where to look for Hackberries

CS: Independence Mall; FDR Golf Club, Bellaire Manor; Lemon Hill Mansion; **PW:** Bartram's Garden; University of Pennsylvania, James G. Kaskey Memorial Park; Woodlands Cemetery; **PNW:** Awbury Arboretum; **CC:** Longwood Gardens; **DC:** Scott Arboretum of Swarthmore College.

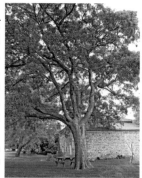

A Woodlands Cemetery hackberry may have had its top branches cut back years ago—a process called pollarding.

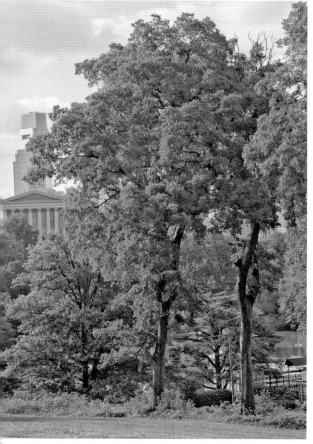

Two tall hackberries along Boathouse Row overlook the Schuylkill River. Hackberry bark often resembles the gray bark of a beech tree.

| LEAVES: Alternate, Toothed | | **Hawthorns** *Crataegus* spp. | MATURE HEIGHT: 10-30 ft. |

COCKSPUR HAWTHORN LEAF WASHINGTON HAWTHORN LEAF ENGLISH HAWTHORN LEA

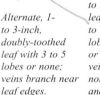

Short trunk with many branches and twigs forming rounded or irregular, flat-topped crown.

Alternate, 1- to 4-inch, simple leaf with sharp teeth more pronounced on top and entire at base.

Alternate, 1- to 3-inch, doubly-toothed leaf with 3 to 5 lobes or none; veins branch near leaf edges.

Alternate, to 2½-inch leaf with 3 to 7 deep lobes with or 3 teeth; veins run te notches and tips.

Hawthorns are a rich and complex genus with hundreds of cultivars varieties, and native and introduced species from Europe and Asia Many of them hybridize freely, so variations abound. Tolerant of hea drought, salt, pollution, and poor soil, hawthorns accent medians parks, and other urban spots with color in spring, fall, and winter.

All hawthorns have alternate, toothed leaves that are sometime lobed. Hawthorns bear clusters of white, pink, or sometimes re flowers. Very appealing to birds, the hawthorns' small, crabapple-lik fruits, or haws, are often red, but can be yellow or even dark blue c black. Many hawthorns have thorns, but some thornless cultivars a being planted today. Four species commonly found in the city are **green hawthorn** (*Crataegus viridis*), **Washington hawthor** (*Crataegus phaenopyrum*), **English hawthorn** (*Crataegus monogy na*), and **cockspur hawthorn** (*Crataegus crus-galli*).

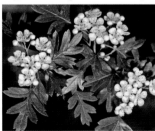

COCKSPUR THORNS

The English hawthorn bears white, red, or pink flowers. Its red or scarlet fruits contain just one seed.

Hawthorn bark is often brown or gray with longitudinal, flaking scales and reddish underbark.

Where to look for Hawthorns

Common in old fields; **PCS:** Hawthorne Cultural Center, 12th and Carpenter Streets; Philadelphia Museum of Art, next to west entrance drive; **PNW:** Morris Arboretum; **CC:** Longwood Gardens, Hillside Garden (state champion); **DC:** Scott Arboretum of Swarthmore College; Chanticleer, on house terrace; **DE:** Mt. Cuba Center.

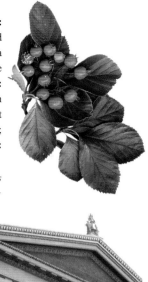

The cockspur hawthorn's ⅜-inch haws are bright red and persist into late fall.

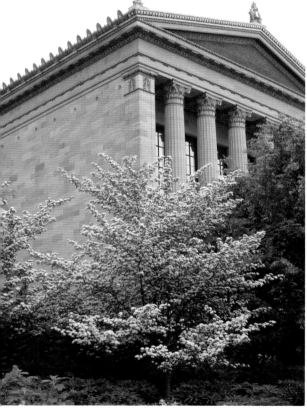

Laden with spring flowers, this hawthorn cultivar blooms in mid-May. The 'Winter King' hawthorn is among the best for landscape use.

| LEAVES: Alternate, Toothed | # American Beech
Fagus grandifolia Ehrh. | MATURE HEIGHT: 60-80 ft. |

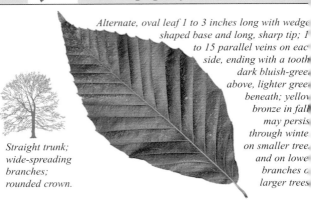

Alternate, oval leaf 1 to 3 inches long with wedge shaped base and long, sharp tip; 1 to 15 parallel veins on each side, ending with a tooth; dark bluish-green above, lighter green beneath; yellow bronze in fall, may persist through winter on smaller trees and on lower branches of larger trees.

Straight trunk; wide-spreading branches; rounded crown.

Group 14

Like its European cousin, *Fagus sylvatica*, the American beech is strikingly handsome tree with smooth, silvery bark that makes easy to recognize, even at a distance. Mature trees average 60 to 8 feet tall. The natural range of the American beech extends from southern Quebec and Ontario to northern Florida and eastern Texas. Vast beech stands once covered portions of the Ohio and lower Mississippi river valleys, and huge flocks of the now-extinct passenger pigeon fed on the beech-nut mast of these primeval forests.

A tree starts producing nuts when it is about 40 years old and bears large numbers of nuts at two- to eight-year intervals. Besides birds, mammals feed on beech nuts, including squirrels, raccoons and bears. The best way to distinguish the American beech from the European is to examine the leaf margins. An American beech leaf is sharply toothed, while a European beech leaf has wavy edges. Also an American beech leaf has more veins than a European beech leaf.

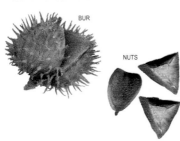

Within each spiny beech bur, or fruit husk, are 2 or 3 polished, brown, triangular, ½- to ¾-inch-long nuts.

The light gray bark is thin and smooth, but broken here and there by bands and blotches.

Where to look for American Beeches

NW: Wissahickon Valley Park; **NE:** Pennypack Park; **BC:** Bowman's Hill Wildflower Preserve; Five Mile Woods Nature Preserve; **CC:** Longwood Gardens; **DC:** American College (large trees along creek); Pendle Hill, Wallingford (state champion); **DE:** Winterthur.

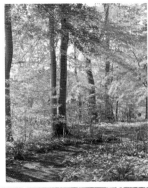

American beeches in the wild are seldom solitary. In the Morris Arboretum woods, they glow gold in November.

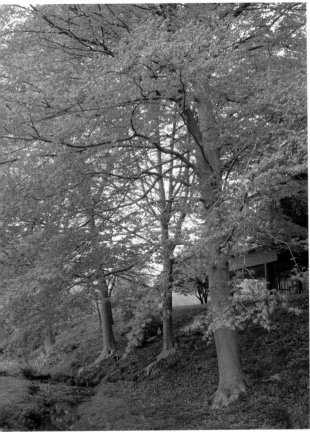

American beeches along the creek at American College have characteristically exposed roots. Smooth beech bark is tempting for graffiti vandals, making beeches the most often tagged trees in public parks.

European Beech
Fagus sylvatica L.

MATURE
HEIGHT:
50-60 ft.

CUTLEAF
BEACH
LEAF

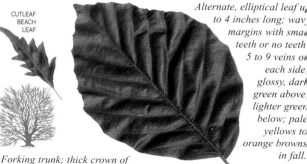

*Alternate, elliptical leaf u,
to 4 inches long; wav,
margins with sma.
teeth or no teeth
5 to 9 veins o.
each side
glossy, dar.
green above
lighter green
below; pale
yellows to
orange browns
in fall.*

*Forking trunk; thick crown of
ascending and descending branches.*

Among the most beautiful of all deciduous trees, the Europea.
beech is distinguished by its glossy, dark green foliage, its smooth
tight, light gray bark, and its sinuous surface roots. It has long bee.
favored by the wealthy, and magnificent old specimens shade th.
lawns of Chestnut Hill and the Main Line. Unlike the America.
beech, there is a profusion of cultivars of *Fagus sylvatica*; weeping
copper-leaved, and fastigiate varieties abound.

Group
14

One the best-known Philadelphia trees was the great weeping
beech (*F. sylvatica* 'Pendula') of the Morris Arboretum. The mai.
old specimen has died, but its progeny, naturally propagated by lay-
ering, surround the spot where the tree once stood and are forming a
circular canopy around the empty central space.

Another European beech cultivar commonly found in Philadelphi.
parks and cemeteries is the cutleaf beech, or fernleaf beech (*F. syl-
vatica* 'Asplenifolia'). It has a dense crown and deeply cut leaves
that turn from lustrous, dark green to golden brown in fall.

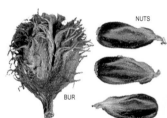

NUTS

BUR

*Bristly, brown fruit husks, ¾ to 1
inch long, enclose from 1 to 3 tri-
angular, edible nuts.*

*European beeches seldom have tap-
roots; instead, they develop interlacing
roots close to the ground's surface.*

Where to look for European Beeches
PNW: Morris Arboretum; **PNE:** Overington Park (copper beech); **BC:** Andalusia (copper beech); Hortulus Farm Garden and Nursery; **MC:** West Laurel Hill Cemetery (weeping); **CC:** Longwood Gardens (impressive allée); **DC:** Chanticleer; Scott Arboretum of Swarthmore College.

The European beech in the Andorra Natural Area of Wissahickon Valley Park is the largest in Pennsylvania.

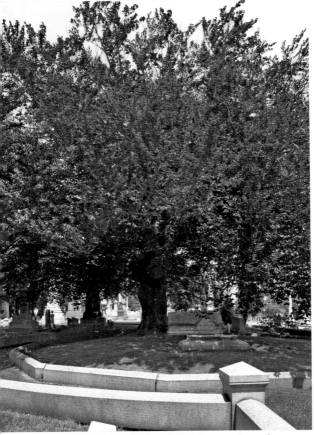

A grand old copper beech at the Laurel Hill Cemetery has a dense canopy of young orange-purple leaves in mid-May. Later in the summer season, these leaves may mature to dark purple, maroon, or green.

| LEAVES: Alternate, Toothed | # Franklinia
Franklinia alatamaha Bartr. ex Marshall | MATURE HEIGHT: 10-20 ft. |

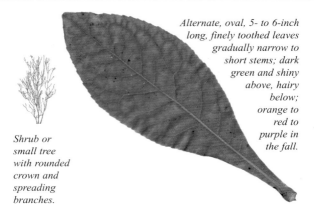

Alternate, oval, 5- to 6-inch long, finely toothed leaves gradually narrow to short stems; dark green and shiny above, hairy below; orange to red to purple in the fall.

Shrub or small tree with rounded crown and spreading branches.

Around 1765, the franklinia or Franklin tree was discovered in Georgia by John and William Bartram. They named the tree after Benjamin Franklin and the Altamaha River, where the discovery was made. Luckily, on a subsequent trip William Bartram brought franklinia seeds back to Philadelphia for propagation; soon after, the species became extinct in the wild. All franklinia trees known today are purportedly descended from Bartram's original tree or trees. Favored for their attractive foliage and striking white flowers, franklinias are finicky and therefore not commonly planted.

Group 14

Where to look for Franklinias

PCS: Pennsylvania Hospital; **PW:** Bartram's Garden; **MC:** Barnes Arboretum; **CC:** Longwood Gardens; Jenkins Arboretum and Gardens; **DC:** Scott Arboretum; American College; **DE:** Mt. Cuba Center.

White 3- to 3 ½-inch flowers bloom in late summer. Handsome, vertically striated bark is gray and light gray.

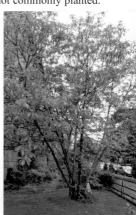

In West Philadelphia, a franklinia at Spruce and 42nd Streets is accompanied by a sign describing its heritage.

| MATURE HEIGHT: 10-30 ft. | **Common Witchhazel** *Hamamelis virginiana* L. | LEAVES: Alternate, Toothed |

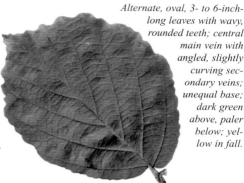

Alternate, oval, 3- to 6-inch-long leaves with wavy, rounded teeth; central main vein with angled, slightly curving secondary veins; unequal base; dark green above, paler below; yellow in fall.

Usually multi-trunked with spreading, crooked branches.

The common witchhazel is a shrub or small understory tree with eccentric habits. It flowers for a month sometime between October and early December, often while its leaves have turned yellow. Its spidery, fragrant little blossoms are unusual, each with four very thin, yellow, crumpled petals. Twin-beaked seed capsules mature on their branches for a year, then forcibly eject their seeds, firing them up to 30 feet in the air. An extract used in lotions is prepared from the witchhazel's young twigs and roots. "Water diviners" claim to be able to locate water in the ground by using branches cut from the tree.

Group 14

These Morris Arboretum native witchhazels are blooming in fall; Chinese species bloom from January through March.

Where to look for Common Witchhazels
PCS: Municipal Pier 53; **PW:** Bartram's Garden; **PNW:** Morris Arboretum; Wissahickon Valley Park; **CC:** Longwood Gardens (state champion); Jenkins Arboretum.

The grayish-brown bark is smooth on young and old trees. Flowers with thin, ½- to ⅔-inch petals bloom in late fall.

| LEAVES: Alternate, Toothed | | # Hollies
Ilex spp. | MATURE HEIGHT: 40-50 ft. |

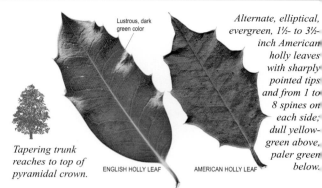

Lustrous, dark green color

Alternate, elliptical, evergreen, 1½- to 3½-inch American holly leaves with sharply pointed tips and from 1 to 8 spines on each side; dull yellow-green above, paler green below.

Tapering trunk reaches to top of pyramidal crown.

ENGLISH HOLLY LEAF AMERICAN HOLLY LEAF

The holly tree has been a symbol of life's persistence for centuries. In ancient British mythology, the Holly King reigned when nights were long and days short. During the Nordic celebration of Yule, a boy decked with holly boughs paraded through the streets. Early Christians associated the thorny leaves with Christ's suffering and the red berries with his blood.

Group 14

Of the 20 species of North American holly, **American holly** (*Ilex opaca*) is the only tree-sized holly growing natively in the Northeast that retains its leaves in winter. American holly leaves are usually a dull, olive green with spiny margins. Holly trees are either male or female, and the female trees bear fruit only when a male tree is nearby. The red fruits persist into the winter and are eaten by birds. American holly and **English holly** (*Ilex aquifolium*), which has darker, shinier leaves than its New World cousin, are grown in parks and gardens along with a number of other *Ilex* species, varieties, hybrids, and cultivars.

FRUITS

The ¼- to ½-inch American holly fruits, each containing a few hard, ribbed seeds, mature in October on female trees. Though birds eat the fruits, they are poisonous to some animals.

The light brownish-gray bark may be rough and warty but is often smooth

Where to look for Hollies

American hollies: **PCS:** Rittenhouse Sq.; **PW:** University of Pennsylvania, Kaskey Memorial Park; Saunders Park; Woodlands Cemetery, just after entrance; **PNW:** Morris Arboretum. *English hollies:* **PNW:** Awbury Arboretum; **MC:** West Laurel Hill Cemetery; **CC:** Longwood Gardens; **DC:** Brandywine River Museum.

White, ¼-inch flowers appear on female holly trees in late May or June.

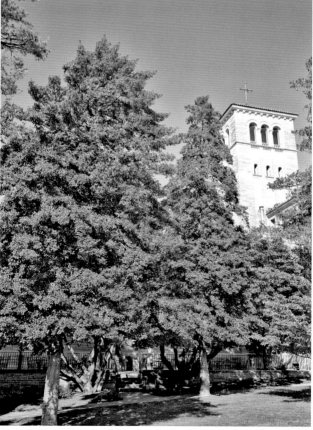

Both females, this pair of American hollies (Ilex opaca) *at Chestnut Hill College strike a festive pose with their red-sequined, green mantles. A male tree must be fairly near them, or they wouldn't bear berries.*

| LEAVES:
Alternate,
Toothed | # Crabapples
Malus spp. | MATURE
HEIGHT:
15-40 ft. |

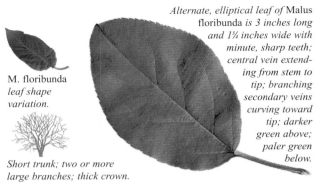

Alternate, elliptical leaf of Malus
floribunda *is 3 inches long
and 1¾ inches wide with
minute, sharp teeth;
central vein extend-
ing from stem to
tip; branching
secondary veins
curving toward
tip; darker
green above;
paler green
below.*

M. floribunda
*leaf shape
variation.*

*Short trunk; two or more
large branches; thick crown.*

In the Northeast, crabapples produce a profusion of spring blossoms surpassed only by the extravagant displays of cherries. Over 800 crabapple cultivars exist and new varieties appear every year. The colors of crabapple flowers range from snow white and pale yellow through shades of pink to deep crimson. One of the most widespread species is the **Japanese flowering crabapple** (*Malus floribunda*), introduced to the U.S. in 1862. Among the first crabapples to flower, it has brilliant, deep rose–colored buds that open to delicate white or pinkish flowers. A native wild crabapple (*Malus coronaria*), known as **wild sweet crabapple**, is a popular ornamental bearing showy white flowers tinged with pink. Crabapples are tolerant of urban stresses and have been widely planted. Diseases such as scab and fireblight have taken a toll on these trees, but new resistant varieties are available. Most crabapples mature at about 25 feet tall, although some grow to heights of over 40 feet.

Group
14

Crabapple flowers (Malus flori-
bunda, *right, and* Malus
'Lemoinei,' *lower right*) *grow in
small clusters and open after
the new leaves have unfolded.
The bark is generally gray or
reddish brown and scaly.*

Where to look for Crabapples

PCS: Rittenhouse Square; **PW:** University of Pennsylvania, James G. Kaskey Memorial Park; Saunders Park, 39th and Powelton Streets; Woodlands Cemetery, just after entrance; **PNW:** Morris Arboretum; **CC:** Longwood Gardens; **DC:** Chanticleer; Tyler Arboretum; Scott Arboretum at Swarthmore College.

Crabapple fruits are usually ½ inch in diameter and vary in color from yellow to orange to bright red.

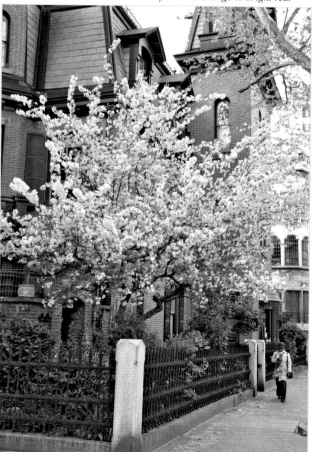

Blooming on a chilly mid-April morning, a crabapple on a street near Rittenhouse Square is a welcome herald of warmer weather to come.

LEAVES:
Alternate,
Toothed

American Hophornbeam

Ostrya virginiana (Mill.) K. Koch

MATURE HEIGHT:
25-40 ft.

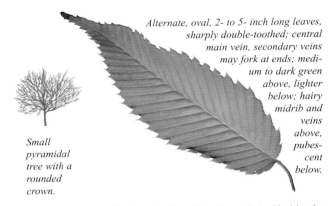

Alternate, oval, 2- to 5- inch long leaves, sharply double-toothed; central main vein, secondary veins may fork at ends; medium to dark green above, lighter below; hairy midrib and veins above, pubescent below.

Small pyramidal tree with a rounded crown.

Native to eastern North America from Canada south to Florida, the American hophornbeam is a relatively small, deciduous understory tree that grows on dry, rocky woodland slopes. Like most other members of the birch family, the hophornbeam has prominent male catkins that persist into winter. Fruits from lovely, light green female flowers ripen in clusters resembling hops—hence the name "hophornbeam". Also called ironwood for its strong wood, hophornbeam wood is used to fashion tools, fence posts, and longbows. The hophornbeam is a pest-free tree that could be used more often in urban settings.

Group 14

Where to look for Hophornbeams

PW: Bartram's Garden; **CC:** Jenkins Arboretum, edge of woodland path; **DC:** Haverford College Arboretum; Scott Arboretum of Swarthmore College; **DE:** Mt. Cuba Center.

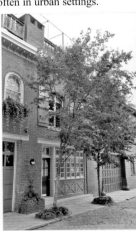

Attractive striated bark peels off in strips. Papery fruits start out yellow green and turn brown in maturity.

FRUITS

American hophornbeams are well suited to narrow sidewalk in Center City Philadelphia.

| MATURE HEIGHT: 25-30 ft. | **Sourwood** *Oxydendrum arboreum* (L.) DC. | LEAVES: Alternate, Toothed |

FALL LEAVES

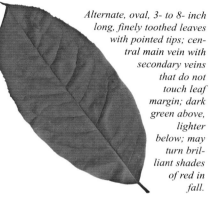

Alternate, oval, 3- to 8- inch long, finely toothed leaves with pointed tips; central main vein with secondary veins that do not touch leaf margin; dark green above, lighter below; may turn brilliant shades of red in fall.

Scraggy in youth, becoming pyramidal with a rounded crown in maturity.

Native to the southeastern United States, the sourwood, or sorrel tree, is a deciduous understory tree that grows well in rocky soils along streams and creeks. The sourwood can be found as far north as southwestern Pennsylvania, but is most common in the southern Appalachian Mountains. Sourwood leaves purportedly have a sour taste—thus the common name. A beautiful small tree for garden use, it boasts showy white panicles of flowers in mid-summer, which attract bees. Sourwood honey is a local delicacy in the South. In fall, leaves turn early to brilliant shades of purple, red, and yellow.

Group 14

Where to look for Sourwoods
PW: Bartram's Garden; **PNW:** Morris Arboretum; Laurel Hill Cemetery; Clifford Park; **CC:** Longwood Gardens; **DC:** Scott Arboretum; Chanticleer (grove).

Grayish-brown bark on older trees is deeply ridged. White, bell-shaped, ⅓-inch flowers bloom on panicles in July.

A twenty-foot-tall sourwood on the Swarthmore College campus is in full bloom in mid-July.

LEAVES:
Alternate,
Toothed

Persian Parrotia
Parrotia persica C.A. Mey

MATURE HEIGHT:
20-40 ft.

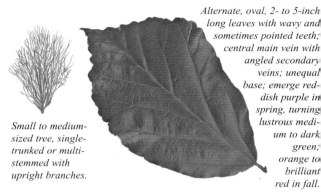

Small to medium-sized tree, single-trunked or multi-stemmed with upright branches.

Alternate, oval, 2- to 5-inch long leaves with wavy and sometimes pointed teeth; central main vein with angled secondary veins; unequal base; emerge reddish purple in spring, turning lustrous medium to dark green; orange to brilliant red in fall.

Named for its origins in what used to be Persia, the Persian parrotia, or Persian ironwood, has a native range limited to a narrow area in northern Iran and Azerbaijan. The parrotia is found specifically in the Alborz Mountains, where it grows alongside beech trees and hornbeams. A member of the family Hamamelidaceae, its leaves and flowers resemble those of the witchhazel. The flowers bloom red in early spring before the tree leafs out. Not showy, they are easily overlooked.

Group 14

A lovely specimen tree, the Persian parrotia boasts beautiful foliage with spectacular yellow-orange and red fall color. As the tree matures, its bark peels in plates, much like a planetree, revealing attractive green, yellow, and pink patches beneath. Underutilized in the landscape trade, the parrotia makes a wonderful choice for suburban gardens, and it is also very well suited to many urban situations. It is hardy and stress tolerant; it thrives in many different soil conditions; it will grow in part shade or full sun; and it is also pest resistant. In short, it is a low maintenance tree, ideal either on a street or in a park setting.

FLOWERS

Opening flowers consist of ½-inch clusters of petalless stamens. Mottled bark is an attractive winter feature.

Leaves turn to brilliant scarlet or yellow orange in late fall and may persist into early winter.

Where to look for Persian Parrotias

PNW: Morris Arboretum, parking lot and Bloomfield Farm; **BC:** Henry Schmieder Arboretum; **MC:** Barnes Arboretum; **CC:** Longwood Gardens; **DC:** Scott Arboretum; Haverford College Arboretum; Chanticleer.

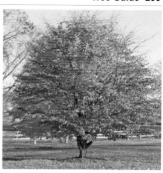

Foliage of a Persian parrotia growing in full sun at the Morris Arboretum mixes scarlet and gold.

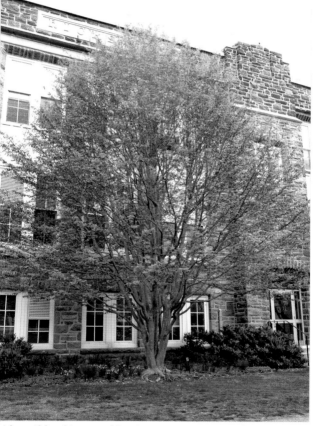

A beautiful multi-stemmed Persian parrotia growing at the Scott Arboretum at Swarthmore College exhibits the bushy, oval form, with many relatively thin, sharply ascending branches, typical of this species.

| LEAVES:
Alternate,
Toothed | | **Poplars**
Populus spp. | MATURE
HEIGHT:
50-60 ft. |

BIG-TOOTH ASPEN LEAF

QUAKING ASPEN LEAF

EASTERN COTTONWOOD LEAF

A quaking aspen with thin trunk and many slender branches.

Alternate, oval, 1½- to 2-inch leaves with short points, small teeth; central main vein with angled secondary veins; flattened stalk; shiny green above, pale green below; yellow in fall.

Alternate, triangular 3- to 5-inch leaves; coarse, rounded teeth but none near tip or stalk; 2 or 3 warty glands where stem attaches; yellow-green above; paler beneath; yellow in fall.

The genus *Populus* in the Salicaceae or willow family is comprised of 25 to 35 species of fast-growing but often short-lived deciduous trees frequently used as hedgerows and screens. Found throughout the northern hemisphere, poplars are not very common in Philadelphia.

The **quaking aspen** (*Populus tremuloides*), known for its shiny leaves that flutter in the slightest breeze, is North America's most widespread tree. A grove of aspens, usually consisting of clones linked by a common root system, is actually one organism. Like some birches, it is among the first trees to spring up in abandoned fields and in areas disturbed by fires, floods, or logging. It eventually gives way to other broadleaf species or conifers.

The **bigtooth aspen** (*Populus grandidentata*) is similar to the quaking aspen, but its range is limited to the East and Midwest.

The **Eastern cottonwood** (*Populus deltoides*) is a water-loving tree that often lines the banks of streams, marshes and rivers. It is not as prominent in the Northeast as it is in the Midwestern states.

Group 14

SEED CATKINS

The 2- to 4-inch seed catkins of the quaking aspen consist of dozens of seed capsules.

Bark of older cottonwoods (left) is gray brown and deeply fissured. Bark on mature quaking aspens (right) is gray green and streaked with dark ridges

Where to look for Poplars

Quaking aspens: **PCS:** Municipal Pier 53; **PW:** 36th St. and Lancaster Ave., N. corner; **DC:** Chanticleer, grove along walkway. *Bigtooth aspens:* **PNE:** Greenwood Cemetery. *Eastern cottonwood:* **PCS:** Island in Schuylkill River near Azalea Garden; **PW:** Bartram's Garden; **CC:** Jenkins Arboretum.

Young bigtooth aspens stand along the southwestern edge of Greenwood Cemetery in Northeast Philadelphia.

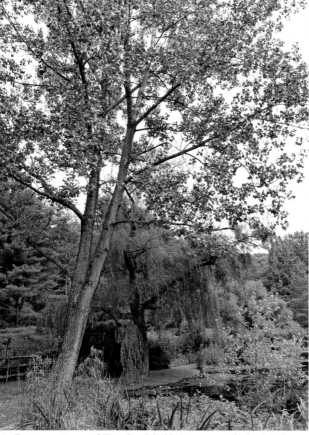

An Eastern cottonwood (Populus deltoides) *grows on the banks of a pond at Jenkins Arboretum. In spring, the ground beneath a cottonwood is littered with catkins that release cottony fluff carrying tiny seeds.*

| LEAVES:
Alternate,
Toothed | | # Wild Cherries
Prunus spp. | MATURE
HEIGHT:
15-80 ft. |

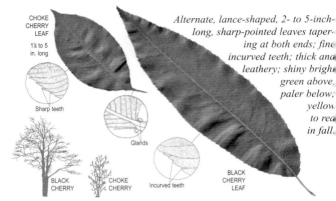

CHOKE CHERRY LEAF
1½ to 5 in. long

Sharp teeth

Glands

Incurved teeth

BLACK CHERRY LEAF

Alternate, lance-shaped, 2- to 5-inch-long, sharp-pointed leaves tapering at both ends; fine incurved teeth; thick and leathery; shiny bright green above, paler below; yellow to red in fall.

BLACK CHERRY

CHOKE CHERRY

Two native wild cherry species are common in the metropolitan area. Adaptable trees, they spring up wherever birds drop their seeds.

Group 14

The **black cherry** (*Prunus serotina*) is a fast-growing tree with an irregular crown of twisting branches. It can grow more than 100 feet tall in the wild and is much sought after for its valuable hard, reddish-brown wood, which is ideal for fine furniture. In May, shortly after its leaves unfold, it produces a profusion of drooping, white flower clusters. By late summer, its fruits are fully mature, having ripened from green to red and then to dark blue or black. Bittersweet tasting, these small cherries can be used to make wine and jelly. In the spring, white nests of eastern tent caterpillars are often prominent on black cherry trees. Although weedy, this species is attractive to wildlife.

The **choke cherry** (*Prunus virginiana*), a small tree usually no more than 20 or 30 feet tall, can be confused with the black cherry, but its leaves are more sharply toothed and it flowers earlier.

BLACK CHERRY FRUITS

Drooping 4- to 6-inch flower clusters cover black cherry trees in May. The pea-sized fruits ripen over the summer.

Bark on a mature black cherry tree is dark gray and broken into peeling scales.

Where to look for Black and Choke Cherries
PCS: Fairmount Park; **PNW:** Morris Arboretum; Wissahickon Valley Park; Awbury Arboretum; **PNE:** Pennypack Park; **BC:** Five Mile Woods; **MC:** Valley Forge National Historical Park; **CC:** Longwood Gardens; **DC:** Tyler Arboretum; Ridley Creek State Park; **DE:** Mt. Cuba Center; **NJ:** Pinelands National Reserve.

Astringent, ⅓-inch choke cherry fruits vary in color from yellow to red to dark purple.

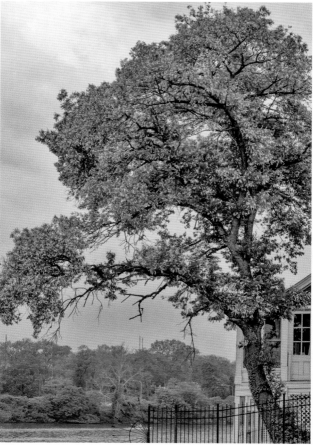

A large black cherry blooming in mid-May overlooks the Schuylkill River next to a boathouse on Kelly Drive. Many of Philadelphia's black cherries grow wild on untended sections of parks and roadsides.

| LEAVES: Alternate, Toothed | **Ornamental Cherries**
Prunus spp. | MATURE HEIGHT:
20-40 ft. |

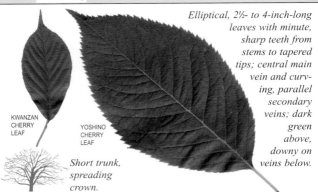

KWANZAN CHERRY LEAF

YOSHINO CHERRY LEAF

Elliptical, 2½- to 4-inch-long leaves with minute, sharp teeth from stems to tapered tips; central main vein and curving, parallel secondary veins; dark green above, downy on veins below.

Short trunk, spreading crown.

Dozens of different species and varieties of ornamental cherries are planted in parks and gardens in and around Philadelphia. Descriptions of three of the most common species follow.

Group 14

The **Yoshino cherry** (*Prunus* x *yedoensis)* is our best-known ornamental cherry tree. Specimens sent from Japan in 1912 still edge the Tidal Basin in Washington, D.C., and line Kelly Drive along the Schuylkill River. It grows up to 50 feet tall and wide and produces light pink buds in mid-April that open to spectacular clouds of almond-scented, white flowers before the leaves unfold.

The **Kwanzan cherry** (*Prunus serrulata* 'Sekiyama' or 'Kwanzan') provides a strong contrast to lighter-colored cherry blossoms when it flaunts its showy pink flowers in late April or early May.

The **Higan cherry** (*Prunus subhirtella*) is one of the longest lived of the ornamental cherries. It grows to 40 feet tall and wide, and produces its pale pink to deep pink or whitish blossoms in April.

The Yoshino's ½-inch, 5-petalled flowers (far left) are pale pink to white; the Kwanzan's double-petalled 2½-inch flowers (left) with 30 petals are deep pink.

The bark of the Kwanzan cherry tree is dark gray and streaked with rough, corky, horizontal lenticels.

Where to look for Ornamental Cherries
PCS: East Fairmount Park, Kelly Drive (Yoshinos); **PW:** West Fairmount Park, Centennial Arboretum; **PNW:** Morris Arboretum; Laurel Hill Cemetery; **BC:** Hortulus Farm Garden and Nursery; **CC:** Longwood Gardens; **DC:** Scott Arboretum of Swarthmore College; Tyler Arboretum; Chanticleer; **DE:** Mt. Cuba Center; Winterthur; Nemours Estate.

First to bloom, 'Okame' cherries line a Chestnut Hill street in early April.

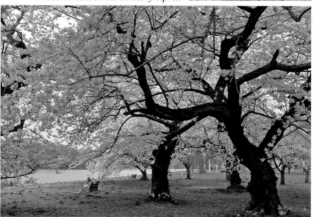

Stunning old Yoshino cherries cluster by Kelly Drive near the Schuylkill. They have bloomed here in early spring for sixty years or more.

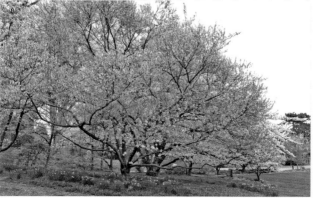

Higan cherries at Scott Arboretum are blooming with the daffodils in mid-April. They are among the most stress tolerant of all cherry species.

| LEAVES:
Alternate,
Toothed | | # Callery Pear
Pyrus calleryana Decne. | MATURE
HEIGHT:
25-50 ft. |

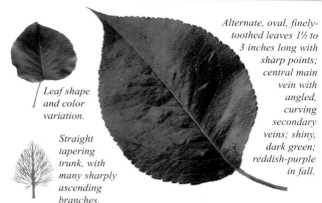

Leaf shape and color variation.

Straight tapering trunk, with many sharply ascending branches.

Alternate, oval, finely-toothed leaves 1½ to 3 inches long with sharp points; central main vein with angled, curving secondary veins; shiny, dark green; reddish-purple in fall.

Group 14

The Callery pear was named for a French priest, Joseph Marie Callery, who collected the species in China in 1858. It was brought to the United States in the early 1900s, and plant scientists selected a cultivar called 'Bradford' that was widely planted in cities after 1963. The Bradford pear is a handsome flowering tree with dark glossy green leaves that turn shades of scarlet, orange, and purple in fall. It is disease free and tolerant of urban conditions. However, as it grows older, its branches tend to break off when strained by wind, ice, or snow, often splitting the trunk. Additionally, because it is becoming highly invasive, it is no longer recommended for planting.

Where to look for Callery Pears

Common as street trees throughout the city; **PCS:** Academy of Natural Sciences of Drexel Univ.; Lemon Hill Mansion; **PW:** Cobbs Creek Golf Course; **DC:** Chanticleer.

The ¾-inch flowers bloom in clusters before leaves emerge. The ⅜-inch fruits ripen from green to brown.

FRUIT

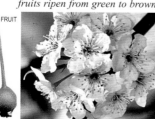

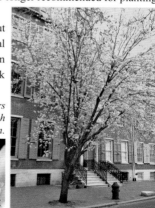

A blossoming Callery pear on a Center City street exhibits a wish-bone structure prone to splitting.

| MATURE HEIGHT: 25-40 ft. | **Japanese Stewartia** *Stewartia pseudocamellia* Maxim. | LEAVES: Alternate, Toothed |

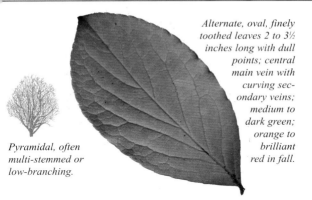

Alternate, oval, finely toothed leaves 2 to 3½ inches long with dull points; central main vein with curving secondary veins; medium to dark green; orange to brilliant red in fall.

Pyramidal, often multi-stemmed or low-branching.

Of the twenty species of stewartias, only two are native to North America; the rest are native in different parts of Asia. The Japanese stewartia (*Stewartia pseudocamellia*) is the most common in the nursery trade and makes a superb specimen tree for any garden. The Japanese stewartia's most spectacular feature is bark that exfoliates in orange, gray, and brown patches. Its conspicuous, white, 2- to 3-inch flowers resemble camellias and bloom in early summer after most trees have finished flowering. Its flowers and bark, along with its brilliant red fall color, make it a tree for all seasons. Japanese stewartias require well-drained soils and will not tolerate drought.

Group 14

Where to look for Japanese Stewartias
PNW: Morris Arboretum; **BC:** Henry Schmieder Arboretum; **MC:** Barnes Arboretum; **CC:** Longwood Gardens (state champion); **DC:** Haverford College Arboretum; Scott Arboretum; Chanticleer; **DE:** Mt. Cuba Center.

Exfoliating stewartia bark is particularly attractive in winter.

A Japanese stewartia turns many shades of red in late October at the Henry Schmieder Arboretum.

FRUIT

LEAVES: Alternate, Toothed		# Willows *Salix* spp.	MATURE HEIGHT: 30-70 ft.

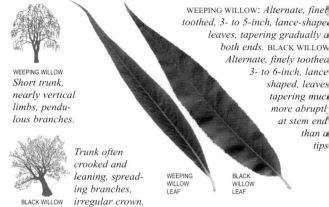

WEEPING WILLOW

Short trunk, nearly vertical limbs, pendulous branches.

WEEPING WILLOW: *Alternate, finely toothed, 3- to 5-inch, lance-shaped leaves, tapering gradually at both ends.* BLACK WILLOW: *Alternate, finely toothed 3- to 6-inch, lance-shaped, leaves tapering much more abruptly at stem end than at tips*

Trunk often crooked and leaning, spreading branches, irregular crown.

BLACK WILLOW

WEEPING WILLOW LEAF

BLACK WILLOW LEAF

Group 14

Willows grow most frequently in moist soils bordering streams, lakes and wetlands. They are useful in riparian restoration plantings. Four arboreal willows are native to Pennsylvania, and many other introduced species are cultivated. Willows frequently hybridize, making species identification especially challenging.

Weeping willows are often hybrid forms of the **white willow** (*Salix alba*), a European tree with corky yellowish- or reddish-brown bark and yellow branchlets. Weeping habits vary from only slightly pendant twig ends to masses of long, flexible twigs hanging straight down.

The native **black willow** (*Salix nigra*) is common along the Schuylkill River. It is sometimes multi-stemmed and has distinctive blackish-gray fissured bark.

Willow bark contains salicin, an aspirin-like compound that is a traditional remedy for fever and inflammation. In landscapes, willows are brittle and weedy and best left to wild, riparian areas.

SEED CATKIN

Black willow bark (top) is gray brown to black and furrowed. Weeping willow bark (bottom) is ridged and corky.

Black willow pollen catkins 1 to 2½ inches long (above) and white willow seed catkins up to 4 inches long (left) appear in spring.

Where to look for Willows

Weeping Willows: **PCS:** Beck and Hancock Streets, SW corner; FDR Golf Club; **PNE:** Palmer Cemetery, Fishtown; Pennypack Park, along the Delaware River; *Black Willows:* **PCS:** Schuylkill River bank, near Fairmount Water Works; **PNE:** Pennypack Park.

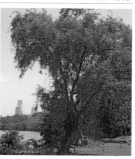

This weeping willow by the Schuylkill River has moderately pendant branches.

This is most likely a black willow, reaching out over the Schuylkill River near the Water Works with downtown Philadelphia in the background.

LEAVES: Alternate, Toothed	**Lindens** *Tilia* spp.	MATURE HEIGHT: 50-100 ft.

Tapering trunk with ascending branches, creating rounded crown.

LITTLELEAF LINDEN LEAF

Alternate, heart-shaped, 1- to 3-inch toothed leaves with sharply pointed tips; green above; paler below, with hairs in vein axils.

SILVER LINDEN LEAF (bottom and top)

Alternate, round to oval, 2- to 5-inch coarsely toothed leaves with sharply pointed tips; unequal base; dark green above, light and hairy below.

Lindens, also known as lime trees, shade parks and avenues in many great cities of Europe and America, perfuming the air in June with the sweet fragrance of thousands of light yellow blossoms. There are more than 30 species of lindens and dozens of hybrids. Four lindens found most commonly in Philadelphia are described here.

Group 14

The **littleleaf linden** (*Tilia cordata*), a European native, has small, heart-shaped leaves and is often planted as a street tree.

The **silver linden** (*Tilia tomentosa*), with leaves that shimmer in breezes, is a striking tree, tolerant of drought. Its common name derives from hairs that create a silvery sheen on its leaf undersides.

The **bigleaf linden** (*Tilia platyphyllos*), like other lindens can live to a great age. One specimen in Hanover, Germany, is over 1,500 years old.

The **American linden** (*Tilia americana*), or basswood, is a Pennsylvania native. *Tilia americana* var. *heterophylla*, known as the white basswood, has leaves with hairy white undersides that resemble the undersides of silver linden leaves.

Round, hard linden fruits hang from leaf-like bracts up to 4 inches long.

FRUITS

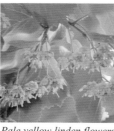

Pale yellow linden flowers up to ¾-inch wide are pollinated by insects in June.

Mature bark is gray to brown broken by vertical fissures into flat-topped, scaly ridges.

BIGLEAF LINDEN LEAF

AMERICAN LINDEN LEAF

Alternate, round to oval, 2½- to 5-inch coarsely toothed leaves with sharply pointed tips; unequal base; dark green above, pale below, with hair in vein axils.

Alternate, heart-shaped, 4- to 10-inch coarsely toothed leaves with sharply pointed tips; unequal base; dark green above, pale and glossy below, with hair in vein axils.

Where to look for Lindens

PCS: Street trees in Society Hill (littleleaf lindens); Washington Square; East Fairmount Park, Azalea Garden; **PNW:** Ridge Ave., near Cathedral Village; Laurel Hill Cemetery; Awbury Arboretum; **MC:** Carson Valley Children's Aid (unique allée); **CC:** Longwood Gardens; **DC:** Scott Arboretum; Tyler Arboretum.

The old multi-trunked American basswood (Tilia americana) at the Awbury Arboretum is over 150 years old.

A littleleaf linden may grow large like this buttress-based tree (left) at Longwood Gardens, but some cultivars (right) make good street trees.

| LEAVES: Alternate, Toothed | 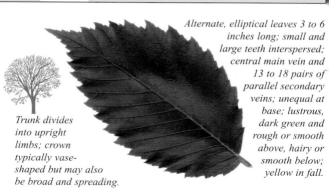 | **American Elm** *Ulmus americana* L. | MATURE HEIGHT: 80-100 ft. |

Alternate, elliptical leaves 3 to 6 inches long; small and large teeth interspersed; central main vein and 13 to 18 pairs of parallel secondary veins; unequal at base; lustrous, dark green and rough or smooth above, hairy or smooth below; yellow in fall.

Trunk divides into upright limbs; crown typically vase-shaped but may also be broad and spreading.

The American elm is one of the most beautiful of all our urban shade trees. Once the signature tree for downtown America, it was the tree of choice to border wide avenues because of its graceful, vase-shaped form and because its limbs arch gradually over adjacent sidewalks, leaving plenty of clearance for the busy streets below.

Group 14

In the early 20th century, American elms lined countless residential streets, city parks, and college campuses throughout the East and Midwest. Since 1930, however, most of the country's large elms have been destroyed by Dutch elm disease. This scourge is caused by a fungus spread through the roots of adjacent trees. It is also carried from tree to tree by bark beetles brought to North America from Europe in logs imported to make veneer. It serves as a reminder of the dangers of planting monocultures—too many of just one species.

The American elm is sometimes confused with its European cousins. The best clues to its identity are its distinctive shape, its double-toothed leaves, and its notched, hair-fringed fruits, or samaras, which erupt from the previous year's buds in early March before its leaves.

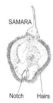

SAMARA

Notch Hairs

Thin, hair-fringed, and notched at the tips, ½-inch American elm samaras ripen in April.

Gray bark on older trees is interspersed with numerous ridges and diamond-shaped fissures.

Where to look for American Elms

PCS: Independence Hall; Rittenhouse Square; Pennsylvania Hospital (Penn Treaty Elm); Girard College (spectacular tree); **PW:** University of Pennsylvania (Penn Treaty Elm); **PNW:** W. Laurel Hill Cemetery; **CC:** Longwood Gardens (state champion); **DC:** Haverford College Arboretum (Penn Treaty Elm).

An American elm by Independence Hall is shedding its leaves in late October.

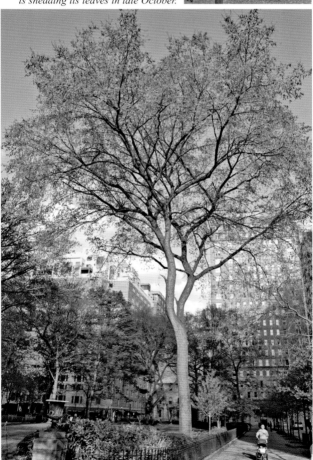

An American elm in Rittenhouse Square catches late April afternoon sunlight. Hundreds of samaras tinge its crown green. As these drop, leaves will sprout.

| LEAVES:
Alternate,
Toothed | | # Foreign Elms
Ulmus spp. | MATURE
HEIGHT:
30-140 ft. |

ENGLISH ELM

Chinese elm
samaras

*Straight,
massive
trunk
with
large,
lateral
branches.*

CHINESE ELM LEAF

*Alternate, ¾- to 2-
inch-long, toothed
leaves nearly
equal at bases;
dark green; with
fruits in fall.*

SIBERIAN ELM LEAF

*Alternate, ¾- to 3-
inch-long, toothed
leaves nearly equal
at bases; green;
smooth above,
slightly hairy below.*

Several non-native elm species grow in Philadelphia parks alongside native American elms. Because some of these introduced elms hybridize freely, they can be hard to identify. New elm hybrids are regularly being introduced. Though many are fine street trees, most do not have the form and grace of the American elm. The first two species listed below are most resistant to Dutch elm disease.

Group 14

The **Siberian elm** (*Ulmus pumila*) has very large, ascending branches with drooping, brittle branchlets that tend to break off.

The **Chinese elm** (*Ulmus parvifolia*), or lacebark elm, has small leaves and beautiful mottled bark. It bears flowers and fruits in fall, unlike other elms that bloom in spring.

The **English elm** (*Ulmus procera*) usually has a tapering, oak-like trunk and big horizontal limbs, both with many sucker shoots.

The **wych elm** (*Ulmus glabra*) is a large elm with arching branches. It may develop burls on its trunk as well as sucker shoots.

The **Dutch elms** (*Ulmus* x *hollandica*), hybrids of *U. glabra* and *U. carpinifolia*, have sharply ascending branches with sucker shoots.

FRUITS

wych
elm

Chinese
elm

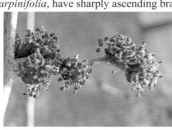

*Petalless ½-inch English elm flower
clusters with black-tipped dangling
anthers appear in March before leaves.*

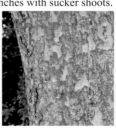

*The Chinese elm's mottled
bark is different from fur-
rowed bark of other elms.*

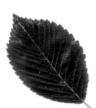

ENGLISH ELM LEAF

WYCH ELM LEAF

DUTCH ELM LEAF

Alternate, 2- to 3½-inch-long, doubly-toothed leaves; dark green and either rough or smooth above, soft and hairy beneath with tufts of white hairs in vein axils.

Alternate, 3- to 7-inch-long, doubly-toothed leaves; may have suggestion of lobes at apex; unequal base; very short stem; dark green, very rough above; hairy below.

Alternate, 3- to 6-inch, doubly- or triply-toothed leaves; very unequal base; dark green, smooth or slightly rough above, hairy below along prominent veins.

Where to look for Foreign Elms

PCS: Marconi Plaza (huge tree); FDR Park (Siberian elm); Kahn Park (Chinese elm); Franklin Square (wych elm); **PW:** Cobbs Creek Golf Course (Chinese elms); Philadelphia Zoo (English elm); **PNW:** Morris Arboretum; Laurel Hill Cemetery (English elms); **CC:** Longwood Gardens (three state champions).

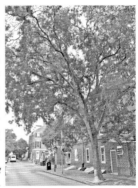

The graceful Chinese elm is pest resistant and tolerant of urban conditions.

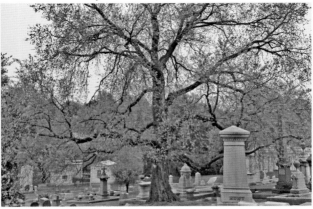

An English elm in Laurel Hill Cemetery bears browning samaras in early May as leaves unfold. Large lateral branches are typical of old English elms.

LEAVES: Alternate, Toothed		**Japanese Zelkova** *Zelkova serrata* (Thunb.) Makino	MATURE HEIGHT: 50-80 ft.

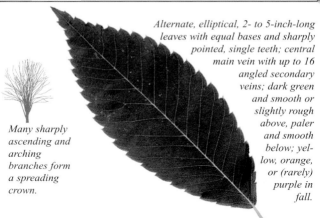

Alternate, elliptical, 2- to 5-inch-long leaves with equal bases and sharply pointed, single teeth; central main vein with up to 16 angled secondary veins; dark green and smooth or slightly rough above, paler and smooth below; yellow, orange, or (rarely) purple in fall.

Many sharply ascending and arching branches form a spreading crown.

Group 14

A member of the elm family, the Japanese zelkova is becoming a popular park and street tree in the United States. Some cultivars have been selected for a graceful vase-shaped habit similar to the American elm. The handsome, mottled bark on younger Japanese zelkovas can resemble that of the Chinese elm. The Japanese zelkova is resistant to Dutch elm disease and other pests and grows well in stressful urban sites, withstanding drought and heat. Popular cultivars include the ascending 'Green Vase' and the more spreading 'Village Green.'

Where to look for Japanese Zelkovas

PCS: City Hall; Franklin Square; **PW:** University of Pennsylvania, Locust Walk; **PNW:** Chestnut Hill, Winston Park; Morris Arboretum; **PNE:** Hetzell Playground, Fishtown; **MC:** Ambler Arboretum of Temple University; **DC:** Chanticleer.

Shiny ¼-inch-long, oval, red-brown buds zigzag along Japanese zelkova twigs (left).

TWIG

Gray-brown bark flakes off and reveals orangish or grayish underbark.

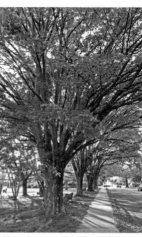

Sharply ascending branches make these Japanese zelkovas in Chestnut Hill easy to identify.

MATURE HEIGHT: 15-20 ft.	**Common Pawpaw**		LEAVES: Alternate, Smooth
	Asimina triloba (L.) Dunal		

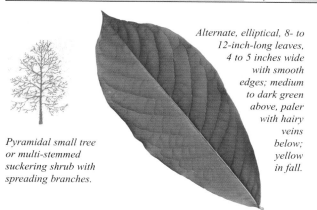

Alternate, elliptical, 8- to 12-inch-long leaves, 4 to 5 inches wide with smooth edges; medium to dark green above, paler with hairy veins below; yellow in fall.

Pyramidal small tree or multi-stemmed suckering shrub with spreading branches.

Known as the common pawpaw, *Asimina triloba* is a native woodland understory tree found in wet bottomlands and along streams in the Northeast, Midwest, and South, from New York west to Nebraska and south to northern Florida and eastern Texas. Spread by suckers, its stands are easily spotted in fall when their large leaves turn yellow. Its edible fruits taste similar to bananas and mangos, hence the many nicknames such as "wild banana" and "banango." The fruits ripen in fall and are eaten raw, chilled, or added to ice cream or fruit drinks.

Group 15

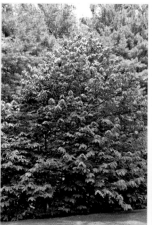

Where to look for Common Pawpaws
PW: Bartram's Garden; **PNW:** Morris Arboretum; **BC:** Bowman's Hill Wildflower Preserve; **MC:** John James Audubon Center at Mill Grove; **CC:** Jenkins Arboretum; **DC:** The Grange Estate; **DE:** Mt. Cuba Center; Winterthur.

1- to 2-inch paw-paw flowers bloom in mid-April. Fruits 1 to 3 inches long ripen from green to brown.

These pawpaw trees at the Jenkins Arboretum are bearing fully developed fruits by mid-July.

FRUITS

| LEAVES: Alternate, Smooth | **Eastern Redbud** *Cercis canadensis* L. | MATURE HEIGHT: 15-40 ft. |

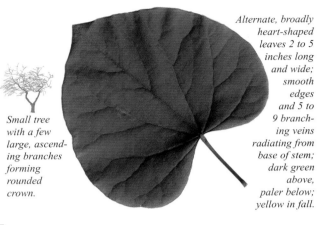

Small tree with a few large, ascending branches forming rounded crown.

Alternate, broadly heart-shaped leaves 2 to 5 inches long and wide; smooth edges and 5 to 9 branching veins radiating from base of stem; dark green above, paler below; yellow in fall.

Group 15

The eastern redbud's time is April, when it flaunts a profusion of purplish-pink pea-like blossoms before its leaves unfold, outlining every branch and twig and even punctuating its trunk with small bouquets. The rest of the year it goes unnoticed because, like the dogwood, it is a small, shade-tolerant, understory species overshadowed in its forest habitat by larger trees. Widely planted as an ornamental, it ranges naturally from Florida to Connecticut and west to Texas but is most widespread in moist bottomlands west of the Allegheny Mountains. The genus *Cercis* includes a half dozen or so species of small flowering trees, including several Asian species, two North American species, and a European species, *Cercis siliquastrum*. Many cultivars of *Cercis canadensis* are available in the nursery trade, from white-flowered cultivars to varieties with purple leaves.

A legume, the redbud bears its seeds in 2- to 3½-inch-long pods.

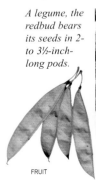

FRUIT

Clusters of purple-pink redbud flowers are often borne on old trunks.

Emerging leaves are sometimes reddish or golden bronze, changing to green.

Where to look for Eastern Redbuds

PW: University of Pennsylvania;
PNE: Palmer Cemetery, Fishtown;
MC: West Laurel Hill Cemetery;
DC: Scott Arboretum of Swarthmore College; Haverford College Arboretum; Chanticleer; Brandywine River Museum; **DE:** Winterthur; Goodstay Gardens.

In mid-April a Chinese redbud (C. chinensis) is in full bloom at the Haverford College Arboretum.

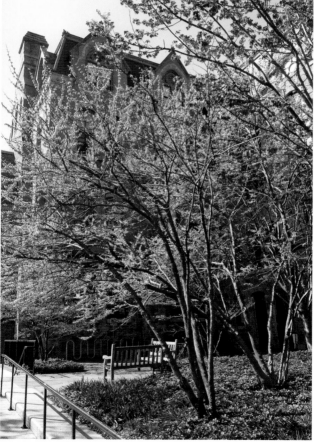

An eastern redbud's extravagant mantle of purplish-pink flowers brightens the University of Pennsylvania's campus on an early April morning.

LEAVES: Alternate, Smooth

Pagoda Dogwood
Cornus alternifolia L.

MATURE HEIGHT: 15-25 ft.

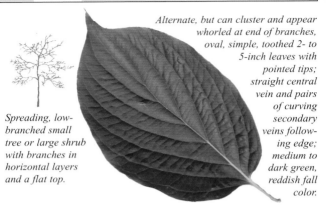

Alternate, but can cluster and appear whorled at end of branches, oval, simple, toothed 2- to 5-inch leaves with pointed tips; straight central vein and pairs of curving secondary veins following edge; medium to dark green, reddish fall color.

Spreading, low-branched small tree or large shrub with branches in horizontal layers and a flat top.

Group 15

The native pagoda dogwood or alternate-leaf dogwood is unusual in the Cornaceae family for not having leaves in opposite pairs. A woodland understory tree native in the eastern United States from Canada down to Alabama, the pagoda dogwood is often found in mature hardwood forests or along woodland and swamp edges. The pagoda dogwood's characteristic horizontal branching makes for a striking habit, which is accentuated in spring when the tree is covered with white flowers. A lovely tree for garden plantings, it is overshadowed by its showier cousin the flowering dogwood, but should not be overlooked.

Where to look for Pagoda Dogwoods
PW: Bartram's Garden; West Fairmount Park, Centennial Arboretum (large specimen); **PNW:** Awbury Arboretum; **MC:** Barnes Arboretum; **CC:** Longwood Gardens (state champion); **DC:** Chanticleer.

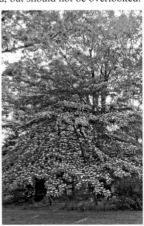

Yellow-white flowers are grouped into 2- to 5- inch inflorescences in spring. The gray bark in older tree is ridged.

A large pagoda dogwood at the Awbury Arboretum produces a profusion of flowers in mid-May.

MATURE HEIGHT: 35-80 ft.	# Persimmon *Diospyros virginiana* L.	LEAVES: Alternate, Smooth

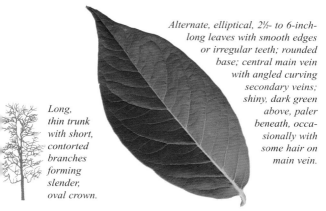

Alternate, elliptical, 2½- to 6-inch-long leaves with smooth edges or irregular teeth; rounded base; central main vein with angled curving secondary veins; shiny, dark green above, paler beneath, occasionally with some hair on main vein.

Long, thin trunk with short, contorted branches forming slender, oval crown.

The Spanish explorer Hernando de Soto sampled a persimmon fruit in 1557 and pronounced it "a delicious little plum." Mouth-puckering in early summer, the persimmon's green or pale orange fruits ripen to blackish purple and become sweet and tasty. Native Americans dried the fruits and also baked their pulp with pounded maize to make bread. Persimmons are thinly scattered among other hardwoods throughout their natural range, which stretches from Connecticut to Florida and west to Kansas and Texas. Persimmons are dioecious, with male and female flowers borne on separate trees.

Group 15

Where to look for Persimmons

Rare in cultivation; **PW:** Bartram's Garden; **PNW:** Fernhill Park; Morris Arboretum; Awbury Arboretum; **BC:** Andalusia; **CC:** Longwood Gardens, Conifer Knoll; **DC:** Chanticleer; Scott Arboretum.

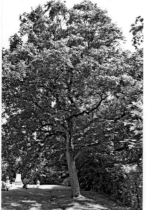

This persimmon at Woodlands Cemetery shows the fuller habit of an old, open-grown tree.

The gray or brown bark is deeply fissured and split into a mosaic of small blocks.

UNRIPE FRUITS

Carolina Silverbell
Halesia tetraptera Ellis

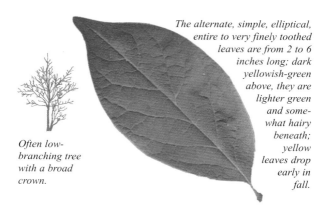

The alternate, simple, elliptical, entire to very finely toothed leaves are from 2 to 6 inches long; dark yellowish-green above, they are lighter green and some-what hairy beneath; yellow leaves drop early in fall.

Often low-branching tree with a broad crown.

Group 15

The Carolina silverbell's name refers to the beautiful silvery white bell-shaped flowers that line its branches in spring, just as its leaves begin to unfold. Despite the fact that its natural range is centered in the deep south—the Carolinas, Georgia, and Alabama—the Carolina silverbell is cultivated successfully in the Northeast well into New England. The Carolina silverbell has been a popular ornamental tree in England since it was introduced there by John Ellis from seeds he received from Charleston, North Carolina, in 1756. Today it has even become naturalized both here and in the English countryside.

Where to look for Carolina Silverbells
PCS: Jefferson Square Park; **PW:** Bartram's Garden; **PNW:** Stenton (especially large specimen); **PNE:** Friends Hospital; **DC:** Tyler Arboretum; **DE:** Mt. Cuba Center.

The 4-petalled, ¾- to 1-inch flowers hang from stems in clusters of 4 or 5. The 1½- to 2-inch, 4-winged seed pods mature in autumn, dry to a reddish brown, and remain into winter.

FRUITS

Blossoms outline every twig of a Carolina silverbell at the Morris Arboretum in early May.

MATURE HEIGHT: 15-25 ft.	**Crape Myrtle** *Lagerstromia indica* L.	LEAVES: Alternate, Smooth

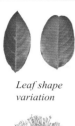

Leaf shape variation

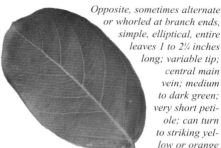

Opposite, sometimes alternate or whorled at branch ends, simple, elliptical, entire leaves 1 to 2¾ inches long; variable tip; central main vein; medium to dark green; very short petiole; can turn to striking yellow or orange fall color.

Large shrub or small tree of variable habit, often multistemmed.

The crape myrtle often tops the list of best loved and most widely planted flowering trees in the South. It flowers prolifically for two months in summer when most other plants have finished blooming. The genus *Lagerstroemia*, crape myrtle, consists of 50 species of trees and shrubs native to Asia, parts of Oceania, and Australia. The common crape myrtle was brought to the United States about 1790 and first planted in Charleston, South Carolina. Hundreds of crape myrtle cultivars are now available, and with the warming trend in the Northeast, cold-hardy crape myrtles are being cultivated with success.

Group 15

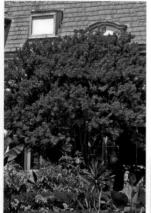

Where to look for Crape Myrtles

PCS: Eastern State Penitentiary, 21st St. and Fairmount Ave.; **PW:** University of Pennsylvania, James G. Kaskey Memorial Park; **DC:** Scott Arboretum; **DE:** Winterthur.

Crape myrtles have multiple trunks with smooth, peeling, tan to gray bark. Crape myrtle's ½-inch seed capsules, containing several ⅛-inch long seeds, are green at first, but ripen to brown.

A crimson explosion, a crape myrtle graces Chanticleer mansion's southside garden in July.

FRUIT

SEEDS

LEAVES: Alternate, Smooth

Osage-orange
Maclura pomifera (Raf.) Schneid.

MATURE HEIGHT: 40-60 ft.

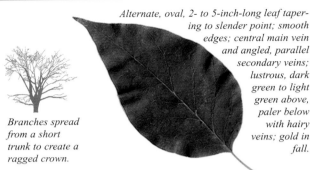

Alternate, oval, 2- to 5-inch-long leaf tapering to slender point; smooth edges; central main vein and angled, parallel secondary veins; lustrous, dark green to light green above, paler below with hairy veins; gold in fall.

Branches spread from a short trunk to create a ragged crown.

Named for its green, heavy, round fruits, which smell a bit like orange peels, the Osage-orange is a small, thorny tree that rarely exceeds 50 feet in height. It grows naturally only in eastern Texas and portions of adjacent Oklahoma, Arkansas, and Louisiana, a region once inhabited by the Osage Indians.

Group 15

The wood of the Osage-orange is hard and heavy, but its limbs are very flexible. The Osage Indians fashioned the wood into beautiful bows that were highly prized by Plains Indians. Early European settlers also valued Osage-orange wood for its strength and resistance to rot. They used it for railroad ties, pulleys, and wagon wheels, and planted the trees in hedgerows as living fences and windbreaks. The Osage-orange leafs out late in the spring. Greenish clusters of tiny pollen and wind-pollinated seed flowers bloom on separate trees in June and July. By late summer, the seed flowers on female trees develop into hairy, coarse, compound fruits 4 to 6 inches in diameter that will ripen and fall to the ground in autumn. New thornless, fruitless cultivars show promise as stress-resistant urban trees.

FRUIT

The bark may be gray to orange brown, often irregularly divided with pale orange furrows.

Where to look for Osage-oranges

PCS: St. Peter's Church, Society Hill; Christ Church, Old City; **PW:** Bartram's Garden; **PNW:** Hunting Park; **PNE:** Pennypack Park, Sandy Run, south of Ryan Ave., near parking area; **DC:** Haverford College Arboretum; Chanticleer; **DE:** Hagley Museum and Library (DE state champion); Winterthur; **NJ:** The Lawrenceville School.

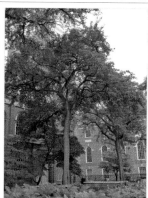

Several old Osage-orange trees grow next to Christ Church in Old City.

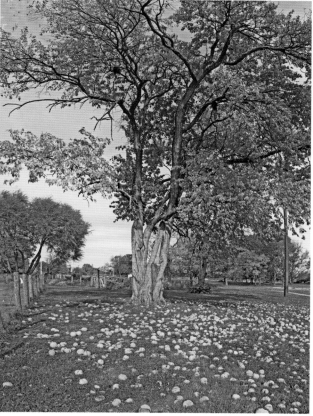

An old female Osage-orange at Hunting Park in North Philadelphia drops a profusion of fruits in November. An Osage-orange fruit weighs up to 3 pounds and contains about 300 seeds embedded in its tough rind.

LEAVES: Alternate, Smooth	**Native Magnolias** *Magnolia* spp.	MATURE HEIGHT: 20-80 ft.

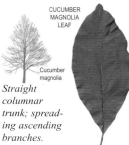

CUCUMBER MAGNOLIA LEAF

Cucumber magnolia

Straight columnar trunk; spreading ascending branches.

Alternate, deciduous leaf; top green; bottom light green and downy; 4 to 10 inches long.

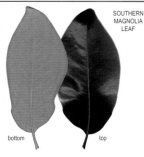

SOUTHERN MAGNOLIA LEAF

bottom top

Alternate, evergreen leaf; top shiny green; bottom rusty brown and hairy; 5 to 10 inches long.

Dozens of different magnolia species and hundreds of cultivars are planted in parks and botanical gardens in the Philadelphia area. Except for the southern magnolia, North American species tend to have less-showy blossoms than their Asian relatives, so Asian species have been more commonly planted as ornamentals. However, more native magnolias are being planted every year. The four most common native species follow.

Group 15

The **southern magnolia** (*Magnolia grandiflora*) is a native of the Deep South with glossy, leathery, evergreen leaves and large, lemon-scented, white flowers that bloom in early to mid-summer.

The **cucumber magnolia** (*Magnolia acuminata*) is the hardiest native magnolia with the most extensive range. It prefers rich stream valleys and forested mountain slopes where it may grow to 100 feet tall.

The **umbrella magnolia** (*Magnolia tripetala*), a native of the Appalachian Mountains, has very large leaves and creamy blossoms.

The **sweetbay magnolia** (*Magnolia virginiana*) is native to the wetlands of the eastern United States and has fragrant white flowers.

Southern magnolia's 2¾- to 4-inch fruits open in fall to reveal scarlet seeds.

Magnolia bark tends to be relatively smooth and gray like beech bark.

The southern magnolia's fragrant 7- to 10-inch flowers appear in early June.

Where to look for Native Magnolias

PCS: Saint Mark's Church; Lemon Hill Mansion; Azalea Garden; **PW**: University of Pennsylvania; Woodlands Cemetery; **PNW**: Laurel Hill Cemetery; Andorra Natural Area; **CC:** Longwood Gardens, **DC:** Chanticleer.

A yellow-flowered Magnolia *'Elizabeth' is a cross between the native cucumber magnolia and the* Magnolia denudata.

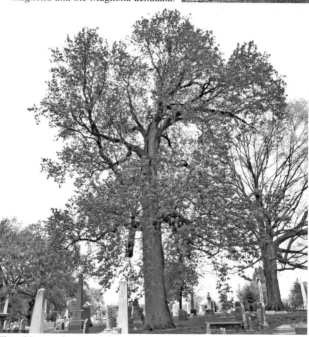

This old cucumber magnolia towering over Laurel Hill Cemetery's gravestones is 80 feet tall with a trunk nearly 6 feet in diameter at breast height.

 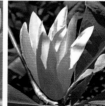

Unlike most Asian magnolia species, native magnolias always flower after their leaves appear. Above are flowers of the cucumber magnolia (left), sweetbay magnolia (middle), and umbrella magnolia (right).

LEAVES: Alternate, Smooth		# Asian Magnolias *Magnolia* spp.	MATURE HEIGHT: 20-40 ft.

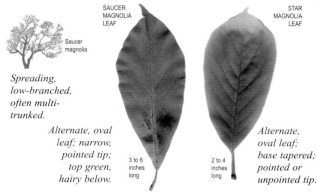

SAUCER MAGNOLIA LEAF

STAR MAGNOLIA LEAF

Saucer magnolia

Spreading, low-branched, often multi-trunked.

Alternate, oval leaf; narrow, pointed tip; top green, hairy below.

3 to 6 inches long

2 to 4 inches long

Alternate, oval leaf; base tapered; pointed or unpointed tip.

Many Asian magnolia species have been long cultivated in the U.S. There are countless hybrids and cultivars, both old and new.

Group 15

The **saucer magnolia** (*Magnolia* x *soulangeana*) is a small, hardy tree growing up to 40 feet tall. Its cup-shaped flowers, ranging in color from white to pink to purple red, bloom in April.

The **star magnolia** (*Magnolia stellata*) is a small magnolia, often multi-trunked and seldom attaining more than 20 feet in height. Its starlike flowers, usually white or pink, bloom in April.

The **Kobus magnolia** (*Magnolia kobus)* is native to Japan, with pink-tinged white flowers that bloom in early spring.

The **Loebner magnolia** (*Magnolia* x *loebneri*) is a hybrid between *M. stellata* and *M. kobus.* Its fragrant, typically white flowers with straplike tepals often resemble those of *M. stellata*.

The **Yulan magnolia** (*Magnolia denudata*) is a native of China with white, lemony-smelling flowers.

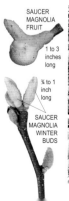

SAUCER MAGNOLIA FRUIT

1 to 3 inches long

¾ to 1 inch long

SAUCER MAGNOLIA WINTER BUDS

Saucer magnolia flowers (left) open in April. Typically, they are pale pink outside with a darker blush toward the base. The bark of a mature magnolia (below) is relatively smooth and pale gray, like beech bark.

Where to look for Asian Magnolias

PCS: Independence National Historical Park, Magnolia Garden; East Fairmount Park, Azalea Garden; **PNW:** Morris Arboretum; **BC:** Andalusia; **MC:** Barnes Arboretum; **DC:** Tyler Arboretum; Scott Arboretum of Swarthmore College; **DE:** Winterthur.

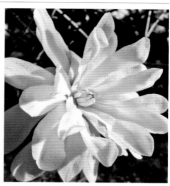

A star magnolia's 3- to 4-inch flower has 12 to 18 petals.

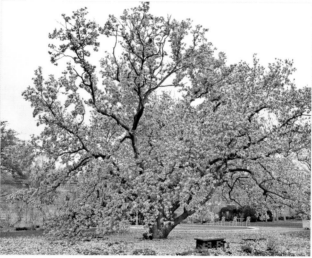

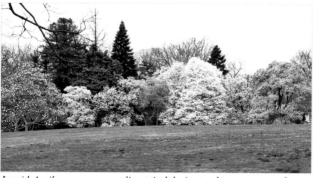

In mid-April a saucer magnolia at Andalusia stands on a carpet of petals (top). In early spring a striking wall of blooming Asian magnolias awaits visitors to the Barnes Arboretum in Lower Merion (bottom).

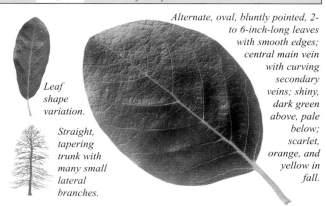

LEAVES:
Alternate,
Smooth

Black Tupelo
Nyssa sylvatica Marshall

MATURE
HEIGHT:
30-80 ft.

Leaf shape variation.

Straight, tapering trunk with many small lateral branches.

Alternate, oval, bluntly pointed, 2- to 6-inch-long leaves with smooth edges; central main vein with curving secondary veins; shiny, dark green above, pale below; scarlet, orange, and yellow in fall.

The black tupelo, sour gum, or black gum grows in moist bottom-lands and along the edges of swampy places, a fact that is reflected in its names. The word "tupelo" is derived from the Creek Indian words for "swamp tree." The tree's Latin genus name, *Nyssa*, refers to a water nymph in Greek mythology. However, black tupelos can also occur in drier, rocky upland sites.

Group
15

The black tupelo grows to its greatest height in the southern Appalachians, but ranges as far north as Ontario and Maine. In spring it bears inconspicuous, greenish-yellow male and female flowers on separate trees. During the summer, small, plum-like fruits develop on long stalks. The fruits ripen from green to blue black; their thin, oily, acidic pulp appeals to many birds and other animals. As if to compensate for its lack of showy spring flowers, the black tupelo puts on a spectacular autumn display in late October, as its dark green, leathery leaves turn to brilliant shades of scarlet, orange, and yellow.

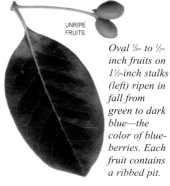

UNRIPE
FRUITS

Oval ⅜- to ½-inch fruits on 1½-inch stalks (left) ripen in fall from green to dark blue—the color of blueberries. Each fruit contains a ribbed pit.

Reddish-gray bark, an inch thick or more, is broken into irregular scaly ridges and plates (below).

Where to look for Black Tupelos

PCS: Philadelphia Museum of Art, west side; **PW:** West Fairmount Park, Centennial Arboretum and Shofuso Japanese Garden; Malcolm X Park, Pine Street side (trunk is over 2 feet in diameter); **PNW:** Morris Arboretum; Wissahickon Valley Park; **PNE:** Pennypack Park, Sandy Run; **DE:** Rockwood Park; Goodstay Gardens.

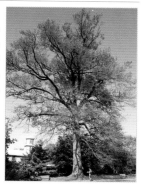

This grand black tupelo at Rockwood Park is a Delaware state champion.

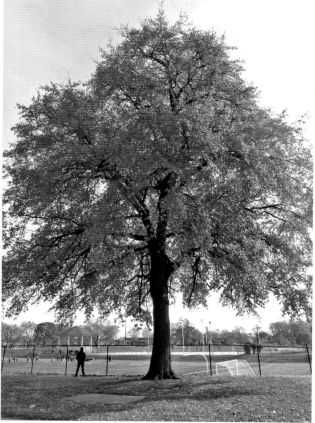

A fine specimen tree, this solitary, open-grown black tupelo stands at a corner of the playing field at Hunting Park. Very few Eastern deciduous trees rival the black tupelo for spectacular fall color year after year.

Willow Oak
Quercus phellos L.

MATURE
HEIGHT:
50-100 ft.

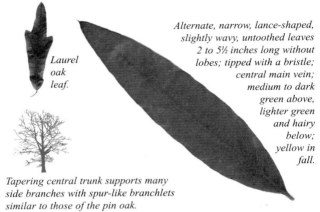

*Laurel
oak
leaf.*

*Alternate, narrow, lance-shaped,
slightly wavy, untoothed leaves
2 to 5½ inches long without
lobes; tipped with a bristle;
central main vein;
medium to dark
green above,
lighter green
and hairy
below;
yellow in
fall.*

*Tapering central trunk supports many
side branches with spur-like branchlets
similar to those of the pin oak.*

In an 1805 letter to Madame de Tessé, Thomas Jefferson noted that the willow oak "combines great irregularity with beauty." Jefferson was perhaps referring to this oak's asymmetrical growing habit as it ages and the delicacy of its narrow, willow-like leaves. The willow oak is a tree most at home in the deep South—Alabama, Mississippi, Louisiana, and Arkansas—but its range extends west into Texas and east from Georgia, up the Atlantic coast to the coastal plains of Pennsylvania and New Jersey. Trees of southern provenance can experience winter injury here, so it is best to plant trees with northern genetic origins.

A willow oak is a fast-growing tree—adding up to two feet a year—and an ideal park shade tree. However, in maturity it may get too large for most urban streets. It also requires acidic soils, making it unsuited for some street situations. Willow oaks planted in alkaline urban soils can exhibit interveinal leaf yellowing. A large willow oak can easily produce over thirty thousand ½-inch acorns annually. The acorns mature in the late summer or early fall of their second year.

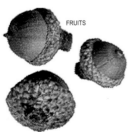

FRUITS

*The dark gray
or dark brown
bark of an
older willow
oak is broken
into thin,
rough, verti-
cal ridges.
The ½-inch
acorns have
shallow cups.*

Group
15

Where to look for Willow Oaks

PCS: Society Hill; Rittenhouse Square; Independence National Historical Park; FDR Park, near Broad Street; **PW:** Bartram's Garden; U. Penn, James G. Kaskey Memorial Park; **PNW:** Hunting Park (huge specimen); **PNE:** Pennypack Park, along the Delaware River.

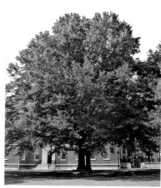

A pair of willow oaks stands near the American Philosophical Society Library in Old City.

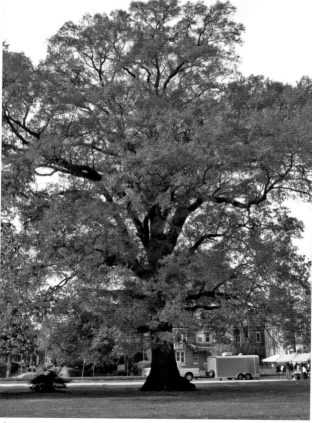

An enormous tree in Hunting Park on Old York Road in North Philadelphia is the city's largest willow oak, with a base over 6 feet wide.

| LEAVES: Alternate, Smooth | # Shingle Oak
Quercus imbricaria Michx. | MATURE HEIGHT: 50-80 ft. |

Leaf shape variation.

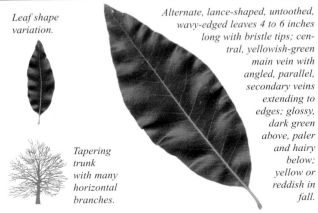

Alternate, lance-shaped, untoothed, wavy-edged leaves 4 to 6 inches long with bristle tips; central, yellowish-green main vein with angled, parallel, secondary veins extending to edges; glossy, dark green above, paler and hairy below; yellow or reddish in fall.

Tapering trunk with many horizontal branches.

Group 15

The shingle oak was named by the French botanist André Michaux (1746–1802), who observed French settlers in Illinois using shingles riven from the tree's logs to cover their cabins. Its leaf looks like a laurel or willow oak's, but is wider and usually longer. Abundant in the Ohio River Basin, the shingle oak is a medium-sized, midwestern tree occasionally planted as an ornamental in the Northeast because of its attractive, dense, and rounded crown. Shingle oak wood is hard and strong, similar to the red oak's. Unlike willow oak, it is tolerant of alkaline soils and has potential for urban plantings.

Where to look for Shingle Oaks

PCS: Independence National Historical Park; **PNW:** Clifford Park, near Thomas Mansion; Wissahickon Valley Park, Houston Meadow; **CC:** Longwood Gardens; **DC:** Haverford College Arboretum.

The ⅓- to ⅔-inch acorn has a cup covering a third of the nut. The gray-brown bark is fissured and ridged.

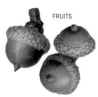

FRUITS

A group of young shingle oaks grow along a sidewalk in Flourtown, Pennsylvania.

| MATURE HEIGHT: 20-30 ft. | # Japanese Snowbell
Styrax japonicus Sieb. & Zucc. | LEAVES: Alternate, Smooth |

Small tree with low horizontal branching and broad crown.

Alternate, simple, oval smooth-edged leaves 1 to 3½ inches long; central main vein with angled secondary veins; glossy, medium to dark green above, hairy below; poor yellow or reddish in fall.

Styrax japonicus
'Emerald Pagoda'

The genus *Styrax* includes about 130 species of shrubs and trees, most of which are native to Asia. *Styrax japonicus*, or Japanese snowbell, is native to Japan, China, and Korea. A graceful garden tree, it is underutilized in the landscape trade. Like its relative the silverbell (*Halesia tetraptera)*, it has a profusion of pendulous, bell-shaped white flowers in spring. In fall the Japanese snowbell's flowers become olive-like fruits called drupes. A number of cultivars exist: pink-flowering, weeping, and larger-leaved varieties. When the gray-brown bark fissures, orange underbark is exposed.

Group
15

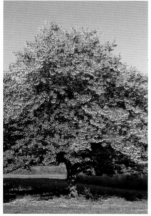

A Japanese snowbell at the Morris Arboretum exhibits the typical, low-branched habit of the species.

Where to look for Japanese Snowbells PCS: Madison Square; **PW:** Fairmount Park, Shofuso Japanese Garden; **PNW:** Morris Arboretum; **CC:** Longwood Gardens (state champion); **DC:** Chanticleer; Haverford College.

The Japanese snowbell's slightly fragrant, ¾-inch flowers bloom in May and produce ½-inch fruits by August.

FRUITS

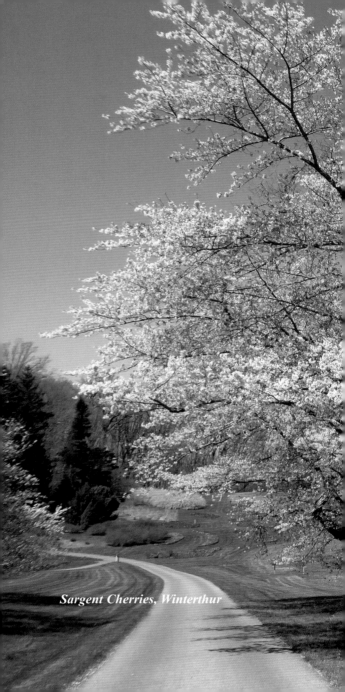

Sargent Cherries, Winterthur

Sources and
Resources

Bibliography

The authors consulted the following sources while writing this book. Several books were particularly helpful and are indicated by asterisks.

American Forests. *The National Register of Big Trees 2000.* Washington, D.C.: American Forests, 2000.

*Barnard, Edward Sibley. *New York City Trees: A Field Guide for the Metropolitan Area.* New York: Columbia University Press, 2002.

*————. *Central Park Trees and Landscapes: A Guide to New York City's Masterpiece.* New York: Columbia University Press, 2016.

Benvie, Sam. *The Encyclopedia of North American Trees.* New York: Firefly Books, 2000.

Brockman, C. Frank. *Trees of North America.* New York: Golden Books, (1968) 1986.

Bonnicksen, Thomas M. *America's Ancient Forests.* New York: John Wiley and Sons, 2000

Callaway, Dorothy J. *The World of Magnolias.* Portland: Timber Press, 1994.

Collingwood, G. H., and Warren D. Brush. *Knowing Your Trees.* Washington, D.C.: The American Forestry Association, 1965.

Coombes, Allen J. *Eyewitness Handbooks: Trees.* New York: DK Publishing, 1992.

Connor, Sheila. *New England Natives.* Cambridge: Harvard University Press, 1994.

Contosta, David R., and Carol Franklin. *Metropolitan Paradise: The Struggle for Nature in the City—Philadelphia's Wissahickon Valley, 1620–2020.* Philadelphia: Saint Joseph's University Press, 2010.

*Dirr, Michael A. *Dirr's Hardy Trees and Shrubs.* Portland: Timber Press, (1997) 1999.

*————. *Manual of Woody Landscape Plants.* Champaign, Ill.: Stipes Publishing, (1975) 1998.

————. *Dirr's Encyclopedia of Trees and Shrubs.* Portland: Timber Press, 2011.

Eastman, John. *The Book of Forest and Thicket.* Harrisburg, Pa.: Stackpole Books, 1992.

*Farrar, John L. *Trees of the Northern United States and Canada.* Ames: Iowa State University Press, 1995.

Foster, David R. *Thoreau's Country.* Cambridge: Harvard University Press, 1999.

Graves, Arthur H. *Illustrated Guide to Trees and Shrubs.* New York: Dover Publications, (1952) 1992.

Harlow, William M. *Fruit Key and Twig Key to Trees and Shrubs.* New York: Dover Publications, (1941) 1959.

Harlow, William M., Ellwood S. Harrar, James W. Hardin, and Fred M. White. *Textbook of Dendrology.* New York: McGraw-Hill, (1937) 1996.

Harrar, Ellwood S., and J. G. Harrar. *Guide to Southern Trees.* New York: Dover Publications, (1946) 1962.

Harshberger, John W. *The Botanists of Philadelphia and Their Work.* Philadelphia: T. C. Davis & Sons, 1899.

Heinrich, Bernd. *The Trees in My Forest.* New York: Cliff Street Books, 1997.

Klein, Jr., William M. *Gardens of Philadelphia and the Delaware Valley.* Philadelphia: Temple University Press, 1995.

Kuitert, Wybe. *Japanese Flowering Cherries.* Portland: Timber Press, 1999.

Lassoie, James P., Valerie A. Luzadis, and Deborah W. Grover. *Forest Trees of the Northeast.* Ithaca: Cornell Cooperative Extension, 1996.

Levine, Adam. *A Guide to the Great Gardens of the Philadelphia Region.* Philadelphia: Temple University Press, 2007.

Little, Elbert L. *National Audubon Society Field Guide to North American Trees: Eastern Region.* New York: Chanticleer Press, (1980) 1996.

Miles, Archie. *Silva: The Tree in Britain.* London: Ebury Press, 1999.

Miller, Howard, and Samuel Lamb. *Oaks of North America.* Happy Camp, Calif.: Naturegraph Publishers, 1985.

Pakenham, Thomas. *Meeting with Remarkable Trees.* New York: Random House, 1996.

*Peattie, Donald C. *A Natural History of Trees of Eastern and Central North America.* Boston: Houghton Mifflin Company, (1948) 1991.

Petrides, George A. *A Field Guide to Trees and Shrubs.* Boston: Houghton Mifflin Company, (1958) 1972.

Phillips, Roger. *Trees of North America and Europe.* New York: Random House, 1978.

Plotnik, Arthur. *The Urban Tree Book.* New York: Three Rivers Press, 2000.

Rhoads, Ann Fowler, and Timothy A. Block. *Trees of Pennsylvania: A Complete Reference Guide.* Philadelphia: University of Pennsylvania Press, 2005.

Sargent, Charles S. *Manual of the Trees of North America: Volume One.* New York: Dover Publications, (1905) 1965.

———. *Manual of the Trees of North America: Volume Two.* New York: Dover Publications, Inc., (1905) 1965.

Schein, Richard. *Street Trees: A Manual for Municipalities.* State College, Pa.: Tree Works, 1993.

*Spongberg, Stephen A. *A Reunion of Trees.* Cambridge: Harvard University Press, 1990.

Symonds, George W. D. *The Tree Identification Book.* New York: Quill, 1958.

Thomas, Peter. *Trees: Their Natural History.* New York: Cambridge University Press, 2000.

Van Gelderen, D. M., and J. R. P. van Hoey Smith. *Conifers: The Illustrated Encyclopedia, Volume 1: A–K.* Portland: Timber Press, 1996.

———. *Conifers: The Illustrated Encyclopedia, Volume 2: L–Z.* Portland: Timber Press, 1996.

Van Gelderen, D. M., P. C. de Jong, and H. J. Oterdoom. *Maples of the World.* Portland: Timber Press, 1994.

Wertz, Halfred W., and M. Joy Callender. *Penn's Woods, 1682–1982.* Wayne, Pa.: Haverford House, 1981.

Wessels, Tom. *Reading the Forested Landscape: A Natural History of New England.* Vermont: The Countryman Press, 1997.

Weygandt, Cornelius. *The Wissahickon Hills.* Philadelphia: University of Pennsylvania Press, 1930.

Young, James A., and Cheryl G. Young, *Seeds of Woody Plants in North America.* Portland: Dioscorides Press, 1992.

Websites

www.americanforests.org
The nation's oldest conservation organization, American Forests protects and restores threatened forests and promotes urban forests.

https://americasgardencapital.org
A website with information and links to the more than 30 gardens across the greater Philadelphia region.

www.arborday.org
The largest nonprofit membership organization dedicated to planting trees, with over one million members, supporters, and partners.

www.floranorthamerica.org
The Flora of North America is a reference for North American plants.

www.growinghistory.wordpress.com
The Philadelphia Historic Plants Consortium disseminates stories and information about the plants and landscapes of Philadelphia.

www.longwoodgardens.org
Longwood Gardens contains 4,600 different types of plants and trees on its 1,077 acres of indoor and outdoor gardens.

www.morrisarboretum.org
The Morris Arboretum of the University of Pennsylvania is a historic public garden and educational institution.

www.na.fs.fed.us/spfo/pubs/silvics_manual/table_of_contents.htm
The U.S. Forest Service's "Silvics of North America" database contains detailed descriptions of hundreds of native tree species.

www.nativetreesociety.org
The Native Tree Society is devoted to the documentation and celebration of trees and forests of the North America and the world.

www.opentreemap.org
PhillyTreeMap is a web-based map database of trees in the greater Philadelphia region.

www.pabigtrees.com
An interactive database of the champion trees of Pennsylvania. The largest known specimens are recorded on this website.

www.phila.gov/ParksandRecreation/aboutus/divisions/Pages/UrbanForestryEcosystemManagement.aspx
The role of the Urban Forestry Group is to understand urban forests and to use the best management practices.

www.philadelphiaencyclopedia.org/archive/trees-2/Trees
A fascinating article by Laura Turner Igoe on how trees have been culturally significant to Philadelphia since its founding.

www.phillywatersheds.org
Using trees, the Philadelphia Water Department is working to improve stormwater management throughout the city.

www.phsonline.org
The Pennsylvania Horticultural Society is a nonprofit focusing on urban horticulture in Philadelphia.

www.plants.usda.gov
The United States Department of Agriculture's website includes a huge database of North American plant species.

www.smokeybear.com/en/for-educators/forest-links
Information on our national forests and other federal wildlands.

www.treephilly.org
Provides Philadelphians with the information and resources they need to plant and care for their own urban forests.

www.urbantreeconnection.org
Works with residents of West Philadelphia and other low-income communities to develop gardening projects on vacant land.

www.usna.usda.gov
The United States National Arboretum includes 7,000 plant species and collections of camellias, hollies, apple trees, and conifers.

www.winterthur.org
Winterthur's gardens and landscapes on 979 acres contain a living collection of more than 7,500 plant species.

Index

Authors' Acknowledgments

Many people have helped us along the way. Patrick Fitzgerald, our editor at Columbia University Press, has supported the project from its outset. Our primary consultant David Hewitt has been an invaluable source of inspiration. Without his guidance we probably could not have completed this book. Very important advice and suggestions have also come from Joel T. Fry and Ken LeRoy. From the outset of the project, Patrice Sutton's enthusiasm and amazing attention to detail has been enormously helpful. Tony Aiello frequently offered his expertise. Jane E. Boyd is a copy editor extraordinaire. We are indebted to the following individuals for supplying descriptions of their institutions' trees: Anne Brennan, Ambler Arboretum of Temple University; Denis Lucey, Awbury Arboretum; Jacob Thomas and Nicole Juday, Barnes Arboretum; Todd Greenberg and Joel T. Fry, Bartram's Garden; Mark Gormel, Brandywine River Museum; Eric Hsu, Chanticleer; Martha Van Artsdalen, Haverford College Arboretum; Mary Tipping, Henry Schmieder Arboretum; Steven Wright, Jenkins Arboretum and Gardens; Tomasz Aniśko, Longwood Gardens; Amy Highland, Mt. Cuba Center; Andrew Bunting, Scott Arboretum; Alison Dame, Tyler Arboretum; Victoria Laubach, Welkinweir; Brian Terraciano, West Laurel Hill Cemetery; Kevin Braun, Winterthur; Jessica Baumert, The Woodlands; John Frett, University of Delaware Botanic Gardens; and Robert Lundgren, University of Pennsylvania. Our field trips have taken us to three states. We were fortunate to encounter a number of plant enthusiasts who generously shared their knowledge. Among them were Susan Edens, National Park Service; Ryan Rebozo, Pinelands Alliance; Tom Kirk, Taylor Arboretum; Kenneth Darsney, Nemours Estate; George Coombs, Mt. Cuba Center; and Dena Kirk, Rockwood Park and Museum.

Credits for Photos, Drawings, Maps, and Text

All photos and text are by Edward Sibley Barnard, Paul W. Meyer, and Catriona Bull Briger. The introductory essay is by David Hewitt. Drawings are by Edward Sibley Barnard. All maps are by Catriona Bull Briger. Photo on page 47, top, is by M. J. Ticcino, property of Valley Forge National Historical Park. Photo on page 54, bottom left, is the property of the Tyler Arboretum.

Dedication

This book is dedicated to our families and to all the "tree nerds"
out there who care about trees as much as we do.

Some of the Best Places to Se

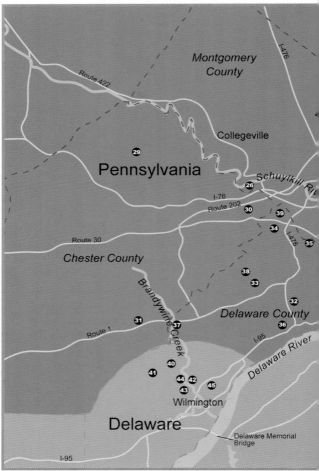